PUBLIC SPACES
What for? Wozu? Pourquoi ?

Kamel Louafi

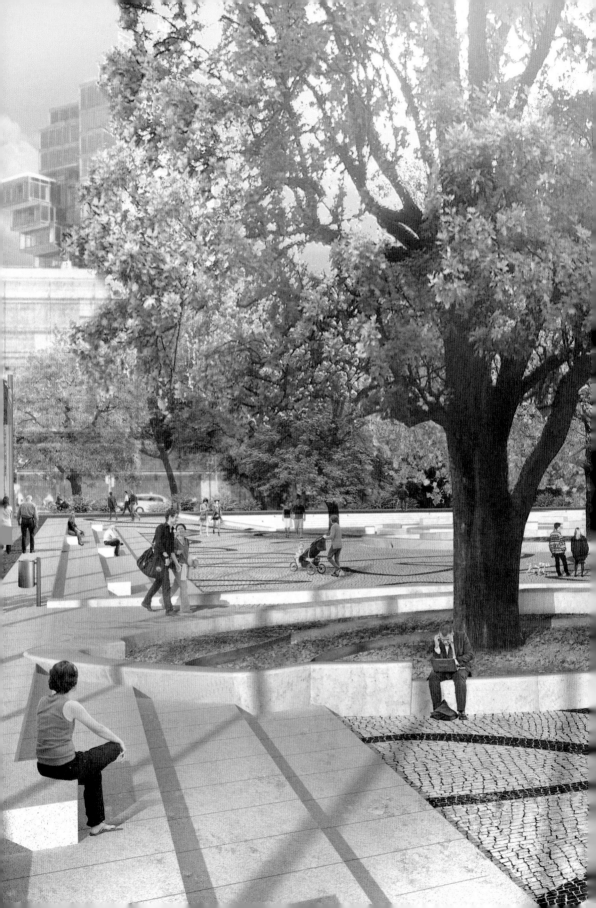

PUBLIC SPACES

What for? Wozu? Pourquoi ?

Kamel Louafi

jovis

INHALTSVERZEICHNIS

Content
Sommaire

ANLASS

Es ist für viele Planer oft unverständlich, nach welchen Kriterien Projekte von der Fachpresse ausge-
wählt und publiziert werden. Neben dem Erfolg der Projekte spielen Sympathien, Lobbyarbeit und
Freundschaft mit Sicherheit eine große Rolle.

Die Entscheidung, unsere Arbeit immer wieder durch Architekturausstellungen sowie das Verfassen
und Publizieren von Büchern und Katalogen der Öffentlichkeit zu präsentieren, war für mich eine Alter-
native, um unsere Arbeiten entsprechend unserer eigenen Auffassung zu kommunizieren. Zugleich
erlaubt uns dies eine freie und öffentliche Auseinandersetzung mit dem Thema der Gestaltung des
öffentlichen Freiraums mit seinen sozialen, politischen, ästhetischen, ökonomischen und visionären
Aspekten.

In der vorliegenden Publikation möchten wir anhand mehrerer Exkurse zum Thema „öffentlicher Raum"
sowie Beschreibungen unserer gestalteten öffentlichen Räume unsere Haltung zeigen. Mit der exem-
plarischen Betrachtung des Platzes der fünf Kontinente in Esch-sur-Alzette in Luxemburg (2013) und
des neuen Rathausvorplatzes in Hannover, dem Trammplatz (2015), vertiefen wir die Auseinanderset-
zung mit der Gestaltung des urbanen Raums, der Landschaftskunst bzw. der Kunst im öffentlichen
Raum. Ergänzt werden die Porträts der beiden Plätze durch kurze Geschichten zu den Merkmalen, dem
Erscheinungsbild, der Funktion, der Nutzung sowie der Rolle von Kunst im öffentlichen Raum.

Our Motive

Many planners often have difficulty understanding the criteria used by the trade press regard-
ing the selection and publication of projects. In addition to a project's success, sympathies, lob-
bying and friendship certainly all play a major role in this.

For me, the idea behind the continuous presentation of our projects at architecture exhibitions
as well as the writing and publication of books and catalogues is that it is an alternative way of
discussing the thoughts and concepts we have about our projects. This also allows us to have
an independent and public debate about the design of public open space, with all its social,
political, aesthetic, economic and visionary aspects.

Our intention in this publication is to show readers our attitude to design through several
digressions about public space as well as descriptions of the public space we have created. By
looking at the Plaza of Five Continents in Esch-sur-Alzette in Luxembourg (2013) and the new
plaza in front of the City Hall in Hannover, the Trammplatz (2015), we hope to stimulate the
investigation of open space design and landscape art, or rather of art in public space. The por-
traits of both plazas are supplemented by short stories about the characteristics, appearance,
function and use of public space, as well as the role art plays within it.

L'opportunité

Beaucoup de planificateurs ont du mal à saisir les critères selon lesquels la presse spécialisée sélectionne les projets pour en faire l'objet d'une publication. Outre le succès des projets en question, les bons rapports et le lobbying ont assurément leur rôle à jouer.

Pour ma part, c'est un choix : communiquer à propos de nos réalisations, que ce soit à travers des expositions d'architecture, ou en rédigeant et publiant des livres et des catalogues, est une alternative dans la transmission de nos idées. C'est ce qui nous permet d'aborder librement et ouvertement le thème de la conception de l'espace public, avec tous ses aspects sociaux, politiques, esthétiques, économiques et visionnaires.

Le présent ouvrage entend expliciter nos positions en proposant plusieurs réflexions sur la notion d'« espace public », ainsi que des descriptions sur les places que nous avons conçues : la Place des cinq continents à Esch-sur-Alzette au Luxembourg (2013) et le nouveau parvis de la mairie à Hanovre, le Trammplatz (2015), illustrent ainsi notre approche conceptuelle de l'espace urbain, l'art paysager ou l'art dans l'espace public. Les portraits de ces deux places sont assortis de « petites histoires » sur ce qui les caractérise, sur leur apparence, leur fonction et utilisation.

EINLEITUNG

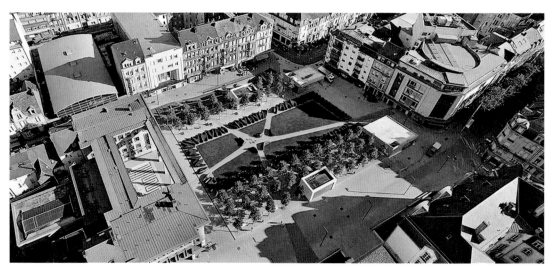

Platz der fünf Kontinente, Esch-sur-Alzette, 2013

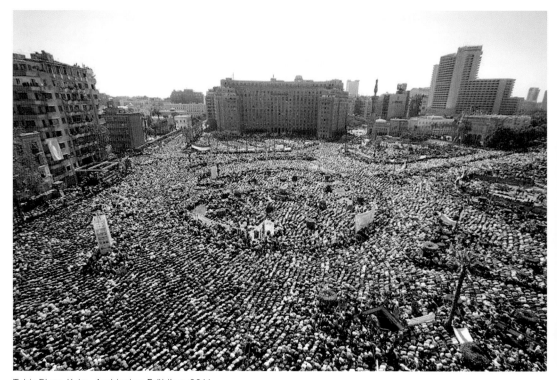

Tahir-Platz, Kairo, Arabischer Frühling, 2011

> *„Wir sehnen uns nicht nach bestimmten Plätzen zurück,*
> *sondern nach den Gefühlen, die sie in uns auslösen."*
>
> *Sigmund Graff, deutscher Aphoristiker und Bühnenschriftsteller, 1898–1979*

Die Bedeutung und Nutzung des urbanen Raums ist durch die sozialen und politischen Bewegungen und Veränderungen weltweit stark in den Fokus der Öffentlichkeit gerückt. Ein beachtliches Dossier der französischen Tageszeitung *Libération* im August 2014 mit dem Titel „Places au peuple" (Plätze des Volkes) lässt keinen Zweifel daran, dass die Plätze in ihre ursprüngliche Nutzung als Agora zurückgekehrt sind, dass sie Orte der Begegnung, der Agitation, des Dialogs sind. „Die Demonstrationen im Gezi-Park im Taksim-Quartier in Istanbul 2013, der Protest gegen den Bau eines Parkhauses in den Grünanlagen der ‚Cité Bois des Pins' in Hydra, Algier, Algerien 2011, der illegale Raubbau der Atlas-Zedernwälder an der Küste von Rabat in Marokko und das Engagement der Bürger für eine nachhaltige Entwicklung, das Engagement der Öffentlichkeit für den Park Al-Azhar in Kairo, Ägypten 2005, der Protest gegen das Besuchsverbot der Parkanlage Horch in Beirut, Libanon 2015, die Proteste auf dem Maidan-Platz in Kiew, die Ablehnung der Bebauung am ehemaligen Flughafen Tempelhof, Berlin durch einen Volksentscheid etc." unterstreichen diese Feststellung und lassen unter anderem erkennen, dass die Diskussion und Auseinandersetzung um die Gestaltung des öffentlichen Raumes zumindest kontrovers geführt werden kann. Die Identifikation der Menschen mit ihrer Stadt und deren Transformation scheint wieder größer und wichtiger geworden zu sein. Sie steht auch in der Tradition der Bürgerbeteiligung, die ein neues Kapitel in der Stadtplanung aufgeschlagen hat. Das Interesse der Allgemeinheit an den urbanen Freiräumen ist auch positiv für den Beruf des Landschaftsarchitekten, dessen Arbeit wieder stärker wahrgenommen wird.

Aber wie weit dürfen Bürger auf die Stadtgestaltung Einfluss nehmen? Wie viel Vertrauen wird dann noch den Planern geschenkt?

Die Ziele der Stadtgestaltung werden oft auf die Nutzungswünsche mehrerer Gruppierungen ausgerichtet und nicht auf die Anforderungen aus Stadtbild, Stadtentwicklung, Wachstum oder architektonischen Gesichtspunkten. Es ist durchaus eine interessante Entwicklung zu versuchen, alle Gruppierungen nach ihren Vorstellungen zu fragen. Ob es jedoch möglich ist, ein gemeinsames „Manifest" zur Stadtgestaltung bzw. Stadtentwicklung daraus abzuleiten, ist fraglich: Der Kiezbewohner – falls es ihn gibt – ist meist gegen große Veränderungen aus Angst vor Verdrängung. Unternehmer sind oft auf das Thema der Erreichbarkeit (Verkehrsanbindung) und der Parkplatzmöglichkeiten fixiert, was für sie das Normalste der Welt ist. Historiker sind eventuell fixiert auf das alte, nicht mehr vorhandene Stadtbild. Die genannten Gruppierungen vertreten so viele unterschiedliche Interessen, dass daraus kaum eine einheitliche Ableitung für die Stadtentwicklung stattfinden kann. Die Frage ist: Was will die Stadtverwaltung? Eine Stadtentwicklung mit repräsentativem Stadtcharakter? Die Stärkung der europäischen Stadt mit einer bestimmten Höhe an Verdichtung? Und wie hoch? Die Stadtplaner sollten ein Leitbild entwickeln, um ein Planungsgerüst zur Gestaltung eines bestimmten Areals aufzuzeigen, sodass die Wettbewerbsteilnehmer adäquate Gestaltungsentwürfe liefern können, sei es für verdichtete oder landschaftlich geprägte Räume.

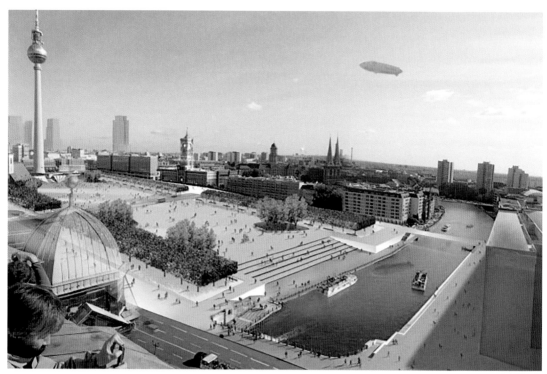

Vision Esplanade, Berlin-Mitte. Chipperfield, Graft, Kiefer, 2009. Viel Platz zum Flanieren

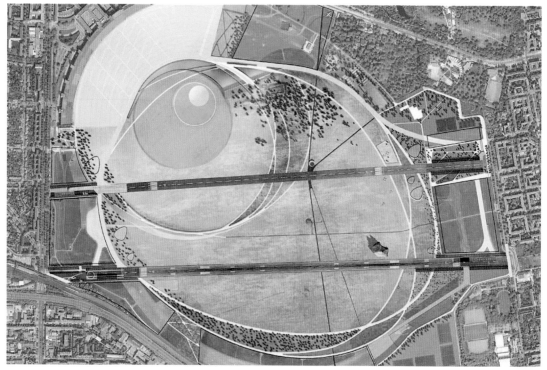

Parklandschaft Tempelhof Berlin/Tempelhof Parkland. Entwurf von GROSS.MAX. landscape architects, Edinburgh, 2010

Oftmals wird die souveräne Gestaltung seitens der Landschaftsarchitekten auch durch die projekt-begleitende Partizipation der Bevölkerung und andere Verfahren, die erst nach der Konzeptionsphase einsetzen, stark beeinträchtigt. Der Gestaltungsfreiheit der Planungsbüros wird durch diese soziopoliti-sche Entwicklung Grenzen gesetzt – vielleicht, weil die Mitsprache oft sehr spät und zum Teil erst realisierungsbegleitend einsetzt. Dies wirkt sich stark negativ auf die allgemeine Beziehung zwischen Nutzern und Planern aus.

Auch wenn die Planer noch so viele Konzepte und Gerüste entwickeln, kein Konzept kann standhalten, wenn Politik und Verwaltung keine Rahmenbedingungen schaffen zur Einhaltung getroffener Beschlüs-se nach den Grundsätzen und Richtlinien für Wettbewerbe auf den Gebieten der Raumplanung, des Städtebaus und des Bauwesens (GRW).

Manchmal gelingt die Planung auch im Einklang mit Bürgerinitiativen. Beim Park am Gleisdreieck in Berlin beispielsweise gelang es noch vor zehn Jahren, für das Wettbewerbsverfahren ein Gesamtmani-fest zu verabschieden. Die Parkfläche und die Randbebauung am Gleisdreieck wurden in den wesent-lichen Grundzügen und Nutzungszonierungen entsprechend der städtebaulichen Abstimmungen zwischen der VIVICO, der Senatsverwaltung (Planungsbüros Albert Speer & Partner / Kamel Louafi 2001–2004) und der Arbeitsgruppe Park am Gleisdreieck (PAG) verwirklicht. Das Atelier Loidl, Gewin-ner des ersten Preises für die Realisierung des Parks am Gleisdreieck, konnte das Projekt in der Planung und Realisierung innerhalb dieser städtebaulichen Vereinbarung trotz Einbindung von bzw. in konstruktivem Dialog mit Bürgerinitiativen realisieren.

Beim ehemaligen Berliner Flughafen Tempelhof entwickelte sich 2011 eine viel intensivere Debatte, welche die stadt- und landschaftsplanerischen Konzepte schließlich in Gänze kippte. Es wurde deutlich, dass sich die Bürgerinitiativen mittlerweile sehr bewusst sind über ihren Einfluss, Projekte verändern oder gar stoppen zu können. Einer der innovativen landschaftsarchitektonischen Beiträge vom schotti-schen Planungsbüro GROSS.MAX wurde einfach durch ein Volksbegehren für immer gestoppt. Im September 2011 gründete sich im östlich an die Parkfläche angrenzenden Schillerkiez unter dem Namen „100 % Tempelhofer Feld" eine Bürgerinitiative mit dem Ziel, die Nachnutzungspläne des Senats mittels eines berlinweiten Volksentscheides zu kippen und eine Bebauung des Geländes zu ver-hindern – was sie auch erreichten. Nach Vorstellung der Initiative sollte die Freifläche weder mit einem Neubau der Landesbibliothek und mit Wohn- und Gewerbeimmobilien versehen noch für die Inter-nationale Gartenausstellung genutzt werden, sondern in ihrem natürlichen Zustand belassen werden. Die Unterschriftensammlung für das Volksbegehren gegen die Bebauung des Tempelhofer Feldes lief bis zum 13. Januar 2014 und brachte rund 185.000 Unterschriften. Der Volksentscheid über den Erhalt des Tempelhofer Feldes fand am 25. Mai 2014 statt: 64 Prozent der abgegebenen Stimmen waren für den Volksentscheid, 36 Prozent dagegen. Das notwendige Abstimmungsquorum von mindestens 25 Prozent wurde mit 30 Prozent überboten.

2011 startete die Stadt Leipzig einen Gestaltungswettbewerb für ein Freiheits- und Einheitsdenkmal. 38 Entwürfe wurden eingereicht. Dass eine Jury den bunten, verspielten Entwurf „Siebzigtausend" von M+M, München und Annabau, Berlin auf Platz eins setzte, löste in der Bevölkerung heftige Diskus-sionen aus. Der Entwurf sah bunte Würfel zum Wegtragen vor. Menschen, die im Herbst 1989 auf die Straße gegangen waren, fühlten sich verhöhnt. Und auch mit dem geplanten Standort des Denkmals auf dem Wilhelm-Leuschner-Platz wurden die Leipziger nicht warm. Das sei „das zentrale Nichts Leip-zigs", lästerten Kritiker. Über den gesamten Ring waren die Demonstranten gezogen – aber nicht über den Leuschner-Platz.
Der Streit um das Einheitsdenkmal beschäftigte sogar die Justiz. Nachdem der Entwurf „Siebzigtau-send" bei der Bevölkerung nicht gut angekommen war, schob die Stadt eine zweite Wettbewerbs-phase ein – an deren Ende die Würfel vom ersten auf den dritten Platz heruntergestuft wurden.

Wettbewerb zum Leipziger Freiheits- und Einheitsdenkmal
M+M, Marc Weis, Martin de Mattia, München; Annabau Architektur und Landschaft,
Sofia Petersson und Moritz Schloten, Berlin, 2012, 1. Preis

Berliner Freiheits- und Einheitsdenkmal
Johannes Milla, Stuttgart und Sasha Waltz, Berlin, 2010, 1. Preis

M+M und Annabau wandten sich an die Vergabekammer des Freistaats und das Oberlandesgericht mit dem Ergebnis: die Stadt müsse die zweite Phase des Wettbewerbs wiederholen. So weit kam es aber nicht, denn die Stadtratsfraktionen von SPD, CDU und Bündnis 90/Die Grünen beantragten, das Vergabeverfahren zu beenden. Vor der Sommerpause 2014 wurde das gesamte Projekt dann gestoppt, das heißt eliminiert. Alle Parteien und Bürgerinitiativen „bekannten" sich danach öffentlich für ein Leipziger Einheitsdenkmal, aber anscheinend nicht nach den bisher praktizierten demokratischen Regeln des Wettbewerbswesens in Deutschland und Europa.

Berlin folgte diesem Prinzip der Revidierung von Wettbewerbsergebnissen. 2016 stoppte, wer auch immer, das bereits in der Planung fortgeschrittene Projekt für das Berliner Freiheits- und Einheitsdenkmal. Die Choreografin Sasha Waltz, die zusammen mit dem Architekten Johannes Milla den Wettbewerb gewonnen hatte, schien sehr früh die Kompliziertheit dieses Projekts geahnt zu haben und war längst aus der Arbeitsgemeinschaft ausgestiegen.

Heute, in einer globalisierten und medial veränderten Welt spielt auch die Interkommunikation eine viel größere Rolle als noch vor einigen Jahren. Es ist einfacher geworden, Projekte, Erfahrungen, Konzepte sowie innovative Ansätze zu kommunizieren. Auch die Ergebnisse von Vorentwürfen können während einer Präsentation durch Blogger rasend schnell über die sozialen Medien verbreitet werden, wodurch sich die Anzahl der Befürworter oder Gegner innerhalb der Präsentation erhöhen kann und somit auch oft die weitere Vorgehensweise beeinflusst werden kann.

Eine wesentliche Tendenz bei Freiraumgestaltern ist auch, dass wir uns ab und an für Erneuerungen und neue Entwicklungen selbst im Wege zu stehen scheinen. Ein bestimmter Automatismus in den Gremien und Jurysitzungen ist zu beobachten: Die Fachjury ist fast immer darauf bedacht, einen Entwurf zu prämieren, der alles ermöglicht. Die Politiker vertrauen ihren Sachverständigen, deren Aufgabe es leider oft ist, die Arbeiten auszusortieren, deren Entwurfsidee sie für „problematisch" erachten – oft sind dies jedoch gerade Entwürfe mit mutigen Ansätzen. Die eigene Erfahrung, das bereits Bekannte wird oft zum Maßstab für die Beurteilung einer Arbeit, selten wird die Anerkennung einer Innovation in Betracht gezogen. Erfreulicherweise werden ab und zu auch wieder „mutige" Entwürfe zur „Probeausführung" zugelassen. Jahrelang galten die Entwürfe der kürzlich verstorbenen Zaha Hadid als „schwierig", heute möchten viele Bauherren ihre Visionen von Architektur weltweit umsetzen.

Bemerkenswert ist, dass die Position und Bedeutung der Landschaftsarchitekten, wie sie 1997 in der Veröffentlichung *Vor der Tür* von Stefan Bernard und Philipp Sattler[1] beschrieben wurde, noch heute gültig ist:
„Das Bild von Landschaftsarchitektur in der Öffentlichkeit und deren Berufspraxis divergieren zum Teil erheblich. Noch immer wird Landschaftsarchitektur mit romantisch-antiquierten Vorstellungen verbunden, die um die Fixpunkte ‚Englischer Landschaftspark', ‚Stadtökologie' oder ‚Blütenpracht' kreisen. [...] Weiterhin sind Landschaftsarchitekten damit konfrontiert, als ‚Grünplaner' apostrophiert, mit den ‚Laplas' [Landschaftsplanern] in einen Topf geworfen oder als ‚Gartenarchitekten' hinter den Blumenzaun zurückgedrängt zu werden. Mitverantwortlich dafür ist ein Verständnisproblem, das mit der Berufsbezeichnung zusammenhängt: Landschaftsarchitektur als eine bauende Disziplin in der und für die Stadt zu vermitteln, erweist sich als schwierig. Als Vertreter einer zahlenmäßig kleinen Profession haben es Landschaftsarchitekten schwer, ein Bild des Berufsstandes zu vermitteln, das allgemein tragfähig und gleichzeitig flexibel genug ist, um auch individuell angemessen interpretiert zu werden."

1 Stefan Bernard/Philipp Sattler: *Vor der Tür: Aktuelle Landschaftsarchitektur aus Berlin.* 1997, S. 7 f., http://www.wasistlandschaft.de/was-ist-landschaftsarchitektur/aussenpraesenz.html

Constanze A. Petrow schreibt bereits 2004 in der Fachzeitschrift *Garten+Landschaft* [2]: „Wenn es nicht gelingt, Landschaftsarchitektur als Teil der Baukunst zu vermitteln, werden wir als ewige ‚Grünplaner' ein Schattendasein führen und sind im Lokalteil gut aufgehoben."

Bemerkenswert waren auch die Rückfragen beim Wettbewerb 2015 für das Museum des 20. Jahrhunderts am Kulturforum in Berlin bezüglich der Verpflichtung, eine Arbeitsgemeinschaft mit Landschaftsarchitekten einzugehen. Es wurde oft von Architekten gefragt: „Wir haben als Hochbauarchitekten immer wieder Außenplanungen selbst gemacht, müssen wir für die Bewerbung einen Landschaftsarchitekten hinzuziehen?" Oft wird bei solchen „Planungsgemeinschaften" auch der Landschaftsarchitekt erst ganz am Ende des architektonischen Entwurfs vom Architekten gebeten, die Resträume mit Grün zu füllen, anstatt von vornherein gemeinsam und interdisziplinär die städtebauliche Einbettung des Entwurfs zu entwickeln.

In der Ausstellung „DEMO:POLIS – Das Recht auf öffentlichen Raum" der Akademie der Künste vom 12. März bis 29. Mai 2016 wurden Werke von Künstlern sowie Hochbauarchitekten gezeigt. Landschaftsarchitekten, deren Aufgabe es seit eh und je ist öffentliche Räume zu planen, spielten in dieser Angelegenheit jedoch leider keine Rolle und wurden komplett ausgeschlossen – mit Ausnahme eines Landschaftsarchitekten (Mitglied der Akademie der Künste), der ein privates Projekt präsentieren konnte, sowie des Brooklyn Bridge Park von Michael Van Valkenburh Associates. Weder der BDLA (Bund Deutscher Landschaftsarchitekten) noch Fachzeitschriften wie *Garten+Landschaft* thematisierten diese Vorgehensweise.

Letztendlich tragen auch wir selbst als Landschaftsarchitekten oder als Berufsverband zu diesem Zustand bei. Die Online-Ausstellung des BDLA (Bund Deutscher Landschaftsarchitekten) „100 Jahre Landschaftsarchitektur – Gebaute Umwelt in Geschichte und Gegenwart" sollte einen Rückblick auf die wesentlichen Projekte des letzten Jahrhunderts bieten. In ihr wurde die Weltausstellung EXPO 2000 in Hannover mit einem schriftlichen Beitrag des BDLA als ein wichtiger Baustein in der Landschaftsarchitektur aufgeführt, aber die Entwürfe der Verfasser und Gestalter der Gärten der Weltausstellung Dieter Kienast (†) und Kamel Louafi – beide nicht Mitglied des BDLA – wurden darin, aus welchen Gründen auch immer, bislang ignoriert. Der Titel „100 Jahre Landschaftsarchitektur des BDLA – Gebaute Umwelt in Geschichte und Gegenwart" würde besser zu den Ausstellungsinhalten passen.
Hier unterscheiden wir uns diametral von den Hochbauarchitekten. Diesen würde überhaupt nicht in den Sinn kommen, einen wesentlichen und bedeutenden Beitrag der Architektur aufgrund einer fehlenden Mitgliedschaft zu ignorieren. In der Architektur ist das Handeln viel mehr von der Sache selbst bestimmt. Landschaftsarchitekten treten häufig gleichermaßen wie „Fachplaner" auf, um „Baumpläne" anzufertigen. Sie wagen kaum, eine eigene Position zu äußern, um den Kontakt mit den Architekten nicht zu belasten und mögliche Aufträge bloß nicht zu gefährden. Wir müssen uns nicht messen mit den Hochbauarchitekten und nicht automatisch die Konfrontation suchen, aber oft gelingt es den Landschaftsarchitekten nicht, klarzustellen, dass Landschaftsarchitektur ein wesentlicher Bestandteil der Stadtentwicklung ist.

Wenn die Verbände und Fachjournalisten die Bedeutung der eigenen Profession nicht klar und deutlich definieren können, müssen die Landschaftsarchitekten selbst mit ihren eigenen Mitteln durch Publikationen und Ausstellungen ihre Beiträge und die Bedeutung ihrer Profession verdeutlichen.

2 Constanze A. Petrow, in: *Garten+Landschaft*, Mai 2004, S. 11

Introduction

"We do not yearn for particular places,
but rather for the feelings they evoke in us."
Sigmund Graff, German aphorist and playwright, 1898–1979

The importance of urban space and its use have very much become the focus of public atten-
tion around the world due to social and political movements and transformations. According to
a substantial dossier in the French daily newspaper Libération in August 2014, "Plazas for peo-
ple leaves little doubt that plazas have returned to their original usage as an agora, that they are
now places for meeting, for agitation and for dialogue". The demonstrations in Gezi Park in the
Taksim neighbourhood of Istanbul in 2013, the protest against the construction of a parking
garage in open areas of Cité Bois des Pins in Hydra, Algiers in 2011, the illegal exploitation of
atlas cedar forests along the coast of Rabat in Morocco and the involvement of citizens there for
sustainable development, public involvement for Al-Azar Park in Cairo, Egypt in 2005, protests
against a usage ban at Horch Park in Beirut, Lebanon in 2015, protests at Maidan Plaza in Kiev,
the rejection of additional buildings at the former Tempelhof Airport in Berlin as a result of a
referendum, etc. all emphasise this determination and are a recognition, among other things,
that discussions and debates about the design of public space can be, at very least, controver-
sial. The identification people have with their city and it's transformation appears to have
become greater and more important. This belongs to the tradition of citizen participation and
has opened a new chapter in urban planning. The public interest in urban open space should be
seen in a positive light by landscape architects, as it puts public space squarely within the pub-
lic domain.

But how much influence should citizens be allowed to have in the design of a city? How much
will planners then be trusted, or be given credit?

The objectives of urban design are often directed at the wishes of several groups and not at the
demands of the cityscape, urban development, growth or architectural points of view. It is cer-
tainly an interesting development to try and ask all of these groups about their preferences.
Whether it is possible to derive a common "manifesto" for urban design or urban development
from this is questionable, however: Local residents – if there really is such a thing – are seldom
in favour of big changes because of a fear of being driven out. Companies are often fixated on
the issues of accessibility (transport connections) and parking, which are the most normal
things in the world for them. Historians are often fixated on old images of the city that may not
even exist anymore. There are so many different interests for these groups that it is nearly
impossible to find a uniform concept of urban development. The question is, what does a city's
administration really want? Urban development with a representative urban character? The
improvement of a European city which provides a certain level of density? And if this is the case,
just how high should the density be? Urban planners need to develop a model in order to show
a planning framework for the design of a particular area, so that competing planners are able to
deliver adequate designs, for both densely built areas and public open space.
A landscape architect's sovereign design of a project is often greatly affected by the project-
related participation of citizens and other procedures that start after the conceptual phase.
The freedom of design that planning offices have is often limited by these socio-political pro-
cesses – especially because this co-determination often occurs at a very late point in time,
when the first phases of a project are already being built. This has a very negative effect on the
overall relationship between users and planners.
Even if planners have developed numerous concepts and frameworks, none are likely to survive
if politicians and administrators haven't developed a framework that provides for compliance

with decisions already made according to the principles and guidelines for competitions in the fields of spatial planning, urban design and construction (GRW).

Sometimes planning efforts manage to be consistent with the wishes of citizens' initiatives. At Gleisdreieck Park in Berlin, for example, it was possible to create an overall manifesto for the design competition ten years ago. The main features and zoning of the park and its perimeter were determined as a result of coordination between the VIVICO, Berlin's Senate Administration (planning offices Albert Speer & Partner / Kamel Louafi, 2001–2004) and the Gleisdreieck Park Working Group (PAG). Atelier Loidl, which won first prize in the design competition, was able to successfully plan and build the park while adhering to these urban planning guidelines, despite the involvement of diverse citizens' initiatives.

At the former Tempelhof Airport in Berlin, a much more far-reaching debate was initiated in 2011, which eventually overturned an entire urban planning and landscape architectural concept for the park. This is proof that citizens' initiatives are now very confident about the power they have to change or even halt projects. An innovative submission made by the scottish landscape architecture office GROSS.MAX was completely stopped by a referendum. In September 2011 the Schillerkiez neighbourhood to the east of the park founded a citizens' initiative entitled 100% Tempelhofer Feld, which had the goal of holding a Berlin-wide referendum to topple the city government's plans for the subsequent use of the airfield and to prevent any further development of the site. The goals of this initiative were to prevent the construction of a new municipal library, all residential and commercial development as well as the use of the site for an international horticultural exposition. The initiative's founders simply wanted the park to be left as it was, for use by the public. The petition for the referendum on the development of the Tempelhofer Feld closed on 13 January 2014 and had approximately 185,000 signatures. The referendum for the preservation of Tempelhofer Feld was held on 25 May 2014, and 64 per cent of the votes cast were in favour of the referendum, whereas 36 per cent were against it. The necessary quorum for the vote was 25%, which was successfully surpassed at 30%.

In 2011 the city of Leipzig held a design competition for a Memorial for Freedom and Unity. A total of 38 entries were submitted. The jury's choice of a colourful and playful design entitled Seventy Thousand, designed by M+M from Munich and Annabau from Berlin sparked a heated debate among the city's residents. The design called for movable cubes to be installed on the plaza's new paving, which could be carried away if desired. People who had demonstrated in the autumn of 1989 felt like they were being made fun of, however, and residents were also not fond of the memorial's planned location at Wilhelm Leuschner Plaza. Critics complained that this site was the "centre of nothing" in Leipzig, as the huge crowds of demonstrators who had walked along the city's ring roads in 1989 had not used this particular plaza.

The dispute about the unity monument eventually even involved the judiciary. Because the Seventy Thousand design was not well received by residents, the city decided to introduce a second competition phase, at the end of which the 'cubes' were pushed from first place back to third. M+M and Annabau appealed to the state's public procurement committee and the court of appeals. The result was that the city was forced to repeat the second phase of the competition. This didn't actually happen, however, as city council factions of the various political parties sought to terminate the entire procurement procedure. The whole project was then halted, i.e. eliminated, before the summer break in 2014. All the political parties and citizens' initiatives involved in the project publicly reaffirmed their interest in a unification memorial, although they were apparently not interested in doing this in accordance with the previously practised democratic rules for competitions in both Germany and Europe.

Berlin followed this principle of revising competition results. In 2016 someone within the city administration stopped planning for the Berlin Monument to Freedom and Unity, which was already at an advanced stage. Choreographer Sasha Waltz, who together with architect

Johannes Milla had won the competition, appeared to have sensed this project would be complicated and dropped out of the team at an early stage.

Today, in our medially transformed world, intercommunication plays a much bigger role than it did only a few years ago. In a globalised world it is more simple to communicate information about projects, experiences, concepts and innovative approaches. Even the results of preliminary designs can be rapidly spread during an initial presentation by bloggers, thereby increasing the number of supporters and opponents during the presentation and potentially influencing the following course of action.

A significant trend in open space design is the fact that when working on redevelopments and new projects we sometimes appear to hinder ourselves. A certain automatism in committees and jury sessions is evident: Juries are quite focused on finding a design that can do just about everything. Politicians often give their experts on the juries the unenviable task of weeding out projects whose design ideas appear to be "problematic" to them. It is exactly these projects that often have the boldest approaches, however. But they will be assessed from a "practical experience" standpoint and recognition of their innovation is seldom given. One's own experience, that which is familiar, often becomes the benchmark for assessment of a project. Fortunately, courageous designs are occasionally chosen for a "test run". For years Zaha Hadid, who unfortunately died in early 2016, designed projects that were considered "difficult", whereas today many clients are anxious to turn her visions of architecture into reality.

Is also remarkable that the position and importance landscape architects have, as described in a publication by Stefan Bernard and Phillip Sattler entitled *Vor der Tür* (At the Door)[1] in 1997, remains the same today:
"The image the public has of landscape architecture as opposed to its actual professional practice diverges greatly. Landscape architecture is still associated with outdated romantic ideas that revolve around fixed points like the English landscape garden, urban ecology and the splendour of flowers. [...] Landscape architects continue to be confronted with this, thought of as 'green planners' and lumped together with 'landscape planners' or pushed back into the garden as 'garden architects'. A lack of understanding with regard to the name of the profession is partially to blame for this: Conveying the idea that landscape architecture is a discipline involved with actual construction in and for cities is difficult. As representatives of a numerically small profession, landscape architects have a hard time imparting an image of the profession that is generally accepted while being flexible enough to be properly interpreted in an individual sense."

In the May 2004 edition of the professional journal *Garten+Landschaft*, Constanze A. Petrow wrote[2]: "If we fail to communicate the idea that landscape architecture is a part of architecture, then we will be eternally damned to leading a shadowy existence and to only being mentioned in the local section of newspapers."
Noteworthy are also the queries about the obligation to have landscape architects in design teams for a competition for the Museum of the 20th Century at the Kulturforum in Berlin in 2015. Architects often asked questions such as "As architects we have often done the planning of the external spaces ourselves, do we really need to add a landscape architect to our team as part of

1 Stefan Bernard/Philipp Sattler: *Vor der Tür: Aktuelle Landschaftsarchitektur aus Berlin.* 1997, p. 7 f.,
http://www.wasistlandschaft.de/was-ist-landschaftsarchitektur/aussenpraesenz.html
2 Constanze A. Petrow, in: *Garten+Landschaft*, May 2004, p. 11

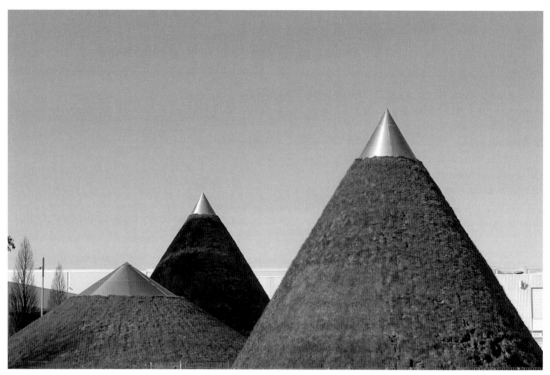

Kegelgärten EXPO 2000, Dieter Kienast

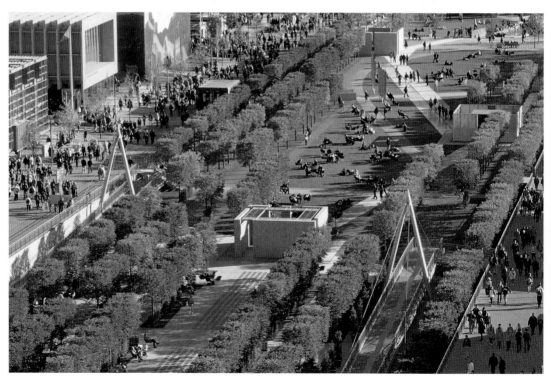

Gärten im Wandel EXPO 2000, Kamel Louafi

the application?" Landscape architects are often asked to be part of such planning teams at the tail-end of an architect's design considerations, so that they can fill in the left-over space, as opposed to working together in an interdisciplinary fashion to develop an overall integration of the design.

At the exhibition DEMO:POLIS – The Right to Public Space at Berlin's Akademie der Künste, which ran from 12 March–29 May 2016, projects by artists and architects were shown. Landscape architects, whose task it has always been to design public space, played no role in this matter and were almost completely excluded. One landscape architect, who was a member of the Akademie, was able to present a private project and Brooklyn Bridge Park by Michael Van Valkenburgh Associates was also included. Neither the BDLA (the Federation of German Landscape Architects) nor professional journals like Garten+Landscape chose to discuss this issue. Ultimately, however, landscape architects and the professional association both contribute to this state of affairs. The BDLA's online exhibition entitled 100 years of Landscape Architecture – The Built Environment in the Past and Present is intended to provide a review of the key projects of the last century. Although the online exhibition has a written statement about the EXPO 2000 World's Fair in Hannover, calling it an important element of landscape architecture, the designs of the organiser and designer of the gardens at the World's Fair, Dieter Kienast (†) and Kamel Louafi, both of whom are not members of the BDLA, were for some reason not mentioned. Perhaps a more fitting title for the contents of the exhibition would be 100 years of BDLA Landscape Architecture – The Built Environment in the Past and Present.

This is where there is a diametrical difference between us and regular architects, who would never even consider ignoring an essential and significant contribution to architecture because of a lack of membership. Activity and behaviour in architecture are much more concerned with the issue itself. Landscape architects, on the other hand, often crop up as "specialist planners" in order to produce "planting plans". They hardly dare to claim a position for themselves in order not to worsen the relationship with the architect or to endanger the acquisition of any additional contracts. We don't have to compare ourselves to architects or automatically seek confrontation, but landscape architects are often not able to explain the fact that landscape architecture is an essential component of urban development.

If professional associations and specialist journalists are not able to clearly define the significance of their own profession, it is up to landscape architects themselves to use their own means to better illustrate the contributions they have made and significance they have within the profession through their own publications and exhibitions.

Introduction
« Nous ne sommes pas nostalgiques de telle ou telle place, mais des sentiments que les places déclenchent en nous. »
Sigmund Graff, écrivain et dramaturge allemand, 1898–1979

Dans la mouvance sociale et politique qui caractérise le monde entier, la signification et l'utilisation de l'espace urbain font l'objet d'une attention particulière. Le quotidien français Libération y consacra en août 2014 tout un dossier intitulé « Places au peuple », montrant que les places retrouvent de toute évidence leur fonction originelle d'« agora », qu'elles sont bien des lieux de rencontre, d'agitation, de dialogue : les manifestations dans le jardin Gezi, près de la place Taksim, à Istanbul en 2013 ; les protestations algériennes contre la construction à Hydra d'un parking dans les espaces verts de la « Cité Bois des Pins », à Alger, en 2011 ; la déforestation illégale des cèdres de l'Atlas sur le littoral marocain près de Rabat ; l'engagement public des citoyens pour le développement du parc Al-Azhar au Caire, en 2005 ; les manifestations contre l'interdiction d'accès au parking Horch à Beyrouth en 2015 ; les insurrections sur la place Maidan à Kiev ; le vote des Berlinois contre les projets de construction sur l'ancien aéroport de Tempelhof, etc. – autant d'exemples qui relèvent d'un même constat et qui prouvent combien les questions autour de l'aménagement de l'espace public peuvent donner lieu à de vives controverses. L'identification des individus avec leur ville et ses transformations semble plus grande, plus significative. Elle s'inscrit dans une notion de participation citoyenne qui ouvre un nouveau chapitre de l'urbanisme. L'intérêt général pour les friches urbaines a des retombées positives sur le métier des architectes paysagistes, car il remet l'espace public au centre.

Mais jusqu'où les citoyens peuvent-ils influencer l'aspect de leur ville ? Quelle confiance est encore accordée aux planificateurs ?

Les buts de l'urbanisme portent souvent sur l'utilisation souhaitée par les différentes communautés et non sur les exigences de physionomie et d'évolution de la ville, de croissance ou de perspectives architecturales. Il est certainement intéressant d'interroger les communautés sur leurs idées. On peut cependant se demander s'il est possible d'en tirer un « manifeste » urbanistique commun : dans certains quartiers populaires, les grands changements et, davantage encore, l'exclusion font souvent peur. Le monde de l'entreprise pense en termes d'accessibilité (connectivité) et de stationnement, qui sont pour lui la norme suprême. Les historiens s'intéressent éventuellement à l'ancienne image, désormais inexistante, de la ville. Toutes ces fractions ont des intérêts tellement différents qu'il est quasiment impossible d'en dégager une seule et même idée urbanistique. La question est : que peut la préfecture ? Une évolution urbaine avec un caractère représentatif ? Le renforcement de la ville européenne avec un certain taux de densité ? Et de combien ? Les urbanistes doivent développer une image directrice avec une structure de planification d'un espace donné, de sorte que les participants aux concours puissent fournir des projets adéquats, que ce soit pour des espaces reculés ou publics.

Il arrive souvent aussi que la conception autonome et réfléchie des architectes paysagistes soit fortement perturbée par l'intervention de la population ou d'autres processus de participation qui n'adviennent qu'après la phase de planification. L'évolution sociopolitique impose des limites à la liberté conceptuelle des bureaux de planification – peut-être parce que la participation n'intervient que très tard ou parfois seulement au moment de la réalisation, ce qui a un impact très négatif sur l'ensemble des relations entre utilisateurs et planificateurs.

Ces derniers ont beau développer des projets et des structures, aucun projet ne peut tenir si les politiques et l'administration ne créent pas les conditions assurant la garantie des décisions prises selon les principes et directives des concours dans le secteur de l'urbanisme et de l'architecture.

Parfois, la planification peut se faire en accord avec les initiatives citoyennes. Il y a 10 ans, dans le cas du parc Gleisdreieck à Berlin, par exemple, la procédure du concours respectant un manifeste général. Pour l'essentiel des structures et des intentions d'utilisation, la superficie du parc et les constructions en bordure du Gleisdreieck correspondent aux accords urbanistiques entre la VIVICO, la municipalité (planificateurs Albert Speer & Partner / Kamel Louafi 2001-2004) et le groupe de travail « Park am Gleisdreieck » (PAG). L'atelier Loidl, lauréat du concours pour la réalisation de ce parc, a pu réaliser le projet dans la ligne des accords passés avec l'urbanisme, même si les initiatives citoyennes étaient impliquées.

Pour ce qui est de l'ancien aéroport berlinois de Tempelhof, un débat d'une tout autre envergure a commencé en 2011 qui a fini par faire complètement basculer les conceptions urbanistiques et paysagistes envisagées. On a pu voir à cette occasion que les initiatives citoyennes sont très conscientes de leur influence et qu'elles ont le pouvoir de changer voire de bloquer certains projets. Une contribution innovante dans le domaine de l'architecture paysagiste, élaborée par le bureau écossais GROSS.MAX, a été définitivement stoppée par référendum. En septembre 2011, dans le quartier Schiller, à l'est de la zone en question, une initiative nommée « 100 % Tempelhof » s'est créée dans le but d'empêcher, par un référendum à l'échelon berlinois, les plans de réhabilitation de la Ville et l'aménagement du terrain. Selon les idées de cette initiative, l'espace libre ne devait servir ni au nouveau bâtiment de la Bibliothèque régionale, ni à la construction de logements ou surfaces commerciales, ni à accueillir l'Exposition internationale des jardins, mais rester tout simplement en l'état. La pétition en faveur d'un référendum contre l'aménagement du Tempelhofer Feld a duré jusqu'au 13 janvier 2014 et a recueilli 185 000 signatures. Le référendum a ensuite eu lieu le 25 mai 2014 : 64 % des voix étaient contre l'aménagement, 36 % pour. Le quorum nécessaire d'au moins 25 % était très largement atteint.

En 2011, la Ville de Leipzig lança un concours pour un monument à la Liberté et l'Unification. 38 projets furent soumis. Le choix du jury porta sur la proposition bariolée et ludique « Siebzigtausend » (70 000) conçue par M+M, Munich, et Annabau, Berlin – ce qui déclencha des réactions virulentes au sein de la population. Le projet devait se composer de cubes amovibles de toutes les couleurs. Or les personnes qui, à l'automne 1989, étaient descendues dans la rue, se sentirent ridiculisées. Et même le lieu prévu pour accueillir le monument – la place Wilhelm-Leuschner – ne trouva pas grâce aux yeux des habitants de Leipzig. Des critiques raillèrent le « néant central de Leipzig ». Les manifestations s'étaient en effet déroulées sur l'ensemble du boulevard circulaire, mais pas sur la place Leuschner.

Le litige à propos du monument à l'Unification remonta même jusqu'à la justice. Le projet « Siebzigtausend » n'ayant pas trouvé l'assentiment de la population, la Ville organisa une deuxième phase de concours – à la fin de laquelle les cubes n'étaient plus qu'en troisième position. M+M et Annabau se retournèrent contre la cour d'appel et le tribunal de grande instance de la Ville. Résultat : cette deuxième phase du concours devait avoir lieu une nouvelle fois. Mais il n'en fut rien, finalement, car le conseil municipal, et tous les partis représentés (SPD, CDU et Bündnis 90/Die Grünen) demandèrent que la procédure soit suspendue. L'ensemble du projet fut donc annulé, autrement dit éliminé, avant la pause estivale de 2014. Tous les partis et initiatives citoyennes se montrèrent ensuite publiquement favorables à un monument à l'Unification à Leipzig, mais, apparemment, pas selon les règles démocratiques pratiquées dans les concours en Allemagne et en Europe.

Berlin suivit ce même principe de révision des résultats des concours. En 2016, un projet déjà bien avancé de monument à la Liberté et à l'Unification à Berlin fut arrêté, sans que l'on ne sache trop par qui. La chorégraphe Sasha Waltz, qui avait remporté le concours avec l'architecte Johannes Milla, semble très tôt déjà avoir pressenti à quel point le projet serait compliqué et s'en était finalement retirée.

Aujourd'hui, où les médias ont transformé le monde, l'intercommunication joue un rôle autrement plus important qu'auparavant. Dans un monde globalisé, il est plus facile de communiquer des projets, expériences, concepts et approches innovantes. Même les résultats d'avant-projets peuvent être diffusés à une vitesse folle dès leur présentation par des blogueurs, ce qui peut augmenter aussitôt le nombre des adeptes ou des détracteurs, et influencer la suite des opérations.

Une tendance marquante chez les concepteurs d'espaces libres est qu'ils semblent parfois se faire obstacle à eux-mêmes quand il est question d'innover ou d'évoluer. Un certain automatisme s'observe dans les commissions et sessions de jury : le jury expert est presque contraint de retenir un projet qui permette tout. Les hommes politiques font confiance à leurs experts, dont la mission est, hélas, souvent d'écarter les travaux dont l'idée paraît « problématique », alors que ce sont souvent justement des projets plus audacieux. Les travaux sont jugés bien souvent sous l'angle de l'« expérience pratique », il est rare que l'innovation soit prise en considération. L'expérience et la familiarité influencent les critères de choix. Par chance, il arrive de temps à autre que des projets plus « courageux » soient admis à une « exécution à l'essai ». Pendant des années, les projets de la regrettée Zaha Hadid passèrent pour « difficile », alors que de nombreux promoteurs dans le monde entier sont prêts aujourd'hui à mettre ses visions en pratique.

Il est intéressant de noter que la position et la signification des architectes paysagistes, décrites dès 1997 par Stefan Bernard et Philipp Sattler dans leur publication Vor der Tür (Devant la porte) [1] restent valables jusqu'à aujourd'hui :

« L'image de l'architecture paysagiste au sein du public et la pratique du métier sont considérablement divergentes. L'architecture paysagiste est encore associée à des notions désuètes et romantiques comme le "jardin à l'anglaise", l'"écologie urbaine" ou la "floraison". [...] Les architectes paysagistes continuent d'être pris pour des "dessinateurs d'espaces verts" et d'être mis dans le même panier que les jardiniers paysagistes. Car il y a un problème de compréhension lié à la désignation du métier, dans la mesure où il est difficile de transmettre que l'architecture paysagiste est une discipline constructive dans et pour la ville. En tant que représentants d'une profession ayant peu d'effectifs, les architectes paysagistes ont du mal à donner une image de leur métier qui soit suffisamment porteuse et en même temps flexible pour être interprétée convenablement par chacun. »

Constanze A. Petrow écrit quant à elle, en mai 2004, dans la revue spécialisée Garten+Landschaft : [2]
« Si nous ne parvenons pas à faire passer l'architecture paysagiste comme un pan de l'architecture à proprement parler, nous resterons pour toujours des aménageurs d'espaces verts à l'échelon local. »
À ce propos, les questions soulevées lors du concours de 2015 pour le musée du XXe siècle au « Kulturforum » de Berlin sont particulièrement intéressantes, car elles portaient justement sur l'obligation d'intégrer une commission de travail avec des architectes paysagistes. Les architectes se demandent fréquemment pourquoi, lors d'un concours, ils devraient faire appel des paysagistes, et ces derniers n'interviennent d'ailleurs souvent que tout à la fin du projet architectural, histoire de mettre du vert dans les espaces vacants. Alors qu'il faudrait d'emblée élaborer une conception commune et interdisciplinaire.

L'exposition DEMO:POLIS – Das Recht auf öffentlichen Raum à l'Akademie der Künste (12 mars– 29 mai 2016) montrait des réalisations d'artistes et d'architectes. Les architectes paysagistes, dont c'est la mission depuis toujours de concevoir des espaces publics, n'y jouèrent hélas aucun rôle et en furent complètement exclus. Un seul architecte paysagiste (membre de l'Akademie der Künste) put présenter

1 Stefan Bernard/Philipp Sattler: Vor der Tür: Aktuelle Landschaftsarchitektur aus Berlin. 1997, p. 7 f., http://www.wasistlandschaft.de/was-ist-landschaftsarchitektur/aussenpraesenz.html
2 Constanze A. Petrow, Garten+Landschaft, mai 2004, p. 11

un projet personnel ainsi que le Brooklyn Bridge Park de Michael Van Valkenburh Associates). Ni le BDLA (Bund Deutscher Landschaftsarchitekten / Fédération des architectes paysagistes allemands) ni des revues spécialisées comme Garten+Landschaft ne firent cas de ces méthodes.

Finalement, ce sont les architectes paysagistes nous-mêmes et la fédération qui contribuent à cet état de fait. L'exposition en ligne du BDLA, 100 Jahre Landschaftsarchitektur – Gebaute Umwelt in Geschichte und Gegenwart, doit proposer une rétrospective des principaux projets réalisés au siècle dernier : l'Exposition universelle EXPO 2000 à Hanovre y est présentée, avec une contribution écrite du BDLA, comme une étape importante dans l'architecture paysagiste, mais les projets des auteurs et concepteurs des jardins de l'EXPO 2000, Dieter Kienast (†) et Kamel Louafi (tous deux non-membres du BDLA) n'ont pas été évoqués jusqu'ici, pour des raisons que l'on ignore.

Nous sommes là à l'opposé des architectes, qui n'auraient jamais songé à ne pas mentionner une contribution majeure sous prétexte d'une non-adhésion à une fédération. En architecture, il s'agit beau-coup plus de la chose en soi, tandis que les paysagistes passent souvent pour ceux qui doivent végéta-liser. Ils n'osent guère prendre position, ne veulent ni troubler ni menacer le rapport avec les architectes. Nous ne devons pas nous mesurer à ces derniers, ni chercher automatiquement la confrontation, mais bien souvent nous ne parvenons pas à faire comprendre que nous avons une contribution essentielle à apporter à l'urbanisme.

Si les fédérations et les journalistes spécialisés ne sont pas à même de définir clairement leur propre profession, c'est à nous architectes paysagistes, par exemple en exposant ou en publiant, d'en donner plus nettement les contours.

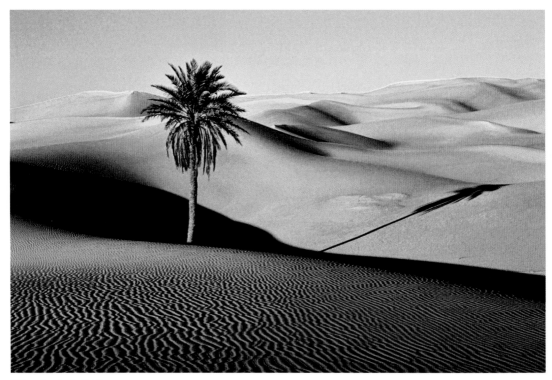

Dünenlandschaft Libyen

„Die Sahara ist lebendiger als eine Hauptstadt,
und die volkreichste Stadt wird leer, wenn die wesentlichen Pole
des Lebens ihre Kraft einbüßen.“
Antoine de Saint-Exupéry

“The Sahara may be more lively than a capital,
and the most crowded city is deserted if the essential poles
of life lose their magnetism.”
Antoine de Saint-Exupéry

» Le Sahara est plus vivant qu'une capitale
et la ville la plus grouillante se vide si les pôles essentiels
de la vie sont désaimantés. «
Antoine de Saint-Exupéry

URBANE NETZE

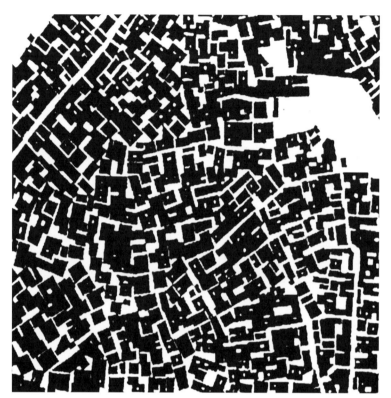

Algiers Stadtlabyrinth

Weltweit erleben Städte unter anderem durch ökonomische, demografische, klimatische und politische Prozesse (wie zum Beispiel den Strukturwandel, Rückbau, Verdichtung und Demokratie) fundamentale Veränderungen. Einerseits bieten diese Transformationsprozesse die Chance, die Freiraumgestaltung durch qualitätvolle Projekte und Interventionen voranzutreiben, andererseits soll mit der Gestaltung von öffentlichen Räumen das Augenmerk auf die Landschaftsarchitektur gerichtet werden, in welcher Ästhetik und Ökologie komplementär sein können: städtische Landschaftsgestaltung, Stadt und Landschaft, Landschaftskunst in der Stadt, städtische Identität und gartenkulturelle Höhepunkte, die das weiche und spielerische Element der Pflanzen und des Wassers in den steinernen Raum tragen, den Stadtraum auflockern und es zugleich wagen, klassische Instrumente der Profession zu nutzen, um Räume schön, attraktiv und in verschiedenster Hinsicht funktional zu gestalten. Mit natürlichen Elementen – Pflanzen aller Kategorien, Wasser, mineralischen Baustoffen – werden urbane Freiräume gebildet und gegebenenfalls auch ökologischen Belangen Rechnung getragen. Landschaftsgestaltung in der Stadt ist ein Kulturgut, welches den Bezug zwischen städtischen und landschaftlichen Lebensräumen verstärkt.

Heute, in einer medial veränderten Welt, in welcher der Gestaltungsanspruch eigentlich höher sein sollte, um Attraktivität zu erzielen, entstehen oft gesichtslose Plätze und öffentliche Räume, die nicht unbedingt zum Verweilen einladen. Dies liegt mit Sicherheit nicht an den Planern allein.
Die Gestaltung des öffentlichen Raums wird von den Bürgern, Politikern und Bürgerinitiativen im Gestaltungsprozess „okkupiert". Die Planer müssen dadurch noch robustere Entwürfe liefern und die Wünsche unterschiedlicher Gruppen in ihrer Planungsidee berücksichtigen, auch wenn diese unterschiedliche Sichtweisen und Bedürfnisse artikulieren – das ist die Kunst der integrativen Planung.
Die Frage, die wir uns stellen müssen, lautet: Wie demokratisch ist die Entwicklung der Aneignung der öffentlichen Räume? Ist die Ursprungsbedeutung des öffentlichen Raums noch gewährleistet, als ein Ort, an dem Menschen zusammentreffen und auch verweilen können, mit der Möglichkeit des Austauschs und der Kontaktaufnahme, aber auch des Rückzugs vom Treiben auf den Straßen, der Anlaufstelle und sozialer Knotenpunkt zugleich ist? Wir erleben mehr und mehr eine neue Form des demokratischen Verständnisses, mit der unbewussten Folge der Privatisierung des öffentlichen Raums.

Einige Beispiele:
Bei einem Sonntagsspaziergang 2014 auf dem ehemaligen Berliner Flughafengelände Tempelhofer Feld nahmen wir auf einem Sofa bei einem der Pionierprojekte platz. Prompt wurden wir gebeten, die sogenannten Räumlichkeiten, das heißt die Sitzsofaecke zu verlassen. Wir sprachen mit den Besitzern über das Motto „Tempelhof für alle" und ob das nicht eine Form der Privatisierung sei wie bei den Kleingärten. Eine Einsicht oder ein Bewusstsein zu dieser Thematik war kaum vorhanden.
An einer Wohnbebauung in Prenzlauer Berg wurde eine Baulücke von den Einwohnern besetzt und zur öffentlichen Fläche deklariert. An einem Sonntag habe ich mit Freunden die Fläche betreten und dort Platz genommen. Viele junge Familien mit Kindern grillten dort. Kurz danach kam ein junger Vater und bat mich, die Fläche zu verlassen, da diese für die Anwohner zur Verfügung stände. Ich bluffte und sagte, dass ich einer der Eigentümer sei. Er wurde blass und entfernte sich. Nach einigen Minuten ging ich zu der Gruppe. Nachdem ich ihnen meine Identität verraten hatte, waren sie sauer, aber es war ihnen auch peinlich, als ich das Thema der Privatisierung öffentlicher Flächen ansprach. Sie gaben zu, dass sie versucht hatten mich zu vertreiben, weil sie dachten, ich wäre ein Tourist. Sie wollten präventiv den Aufenthalt für andere Horden von Touristen unterbinden. Sie erkannten das Dilemma der Partizipation an der Privatisierung des öffentlichen Raums und wussten im Moment auch keine Antwort.

Urban Networks

Cities undergo fundamental change as a result of, among other things, economic, demographic, climatic and political processes (e.g., restructuring, demolition, densification and democracy). On the one hand, these transformation processes provide an opportunity to advance the design of open space by way of high-quality projects and interventions. On the other hand, through the design of public space attention will be directed at landscape architecture, where aesthetics and ecology can be complementary.

Landscape art in the city and highlights of garden culture, which use the soft and playful element of plants and water to break up urban space, also dare to use the profession's classical tools to design space in both a beautiful and in many respects functional way. Using natural elements – plants of all categories, water and mineral-based construction materials – urban open space is formed and environmental concerns are potentially addressed. Landscape architecture in the city is a cultural asset that strengthens the relationship between urban and natural habitats.

In today's medially changed world, in which our design standards should actually be higher in order to create more beauty, we often end up with faceless plazas and public space that does not necessarily invite people to spend time there. This is without doubt not only because of the planners involved. The design of open space is "occupied" by citizens, politicians and citizens' initiatives during the design process. And because of this, planners are required to deliver even more robust designs and to consider the wishes of different groups in their planning ideas, even if these articulate different perspectives and needs. This is indeed the art of integrative planning.

The question we needed to ask ourselves is, how democratic is the development of appropriating public space? Is the original meaning of public space still guaranteed, i.e. a place where people can meet and spend time, where human exchange and contact is possible, but also a place that offers us the chance to withdraw from the hustle and bustle of the street while remaining a focal point and social hub? We are increasingly seeing a new form of democratic understanding, which involves the unconscious privatisation of public space.

Here are a few examples:

During a Sunday stroll at the former Berlin Tempelhof Airfield in 2014, we took a seat on a sofa next to a pioneer project. We were quickly asked to vacate the "premises", i.e. the sofa. We talked to the owners about the park's motto "Tempelhof for Everyone" and asked if this wasn't similar to a form of privatisation found in allotment gardens. They had little comprehension or awareness of this issue.

In a residential area of Prenzlauer Berg, a vacant lot has been occupied by residents and declared a public area. One Sunday I entered this area with some friends and sat down. Many young families with children were barbecuing there. Shortly after arriving a young father approached us and asked us to leave, saying that this area was only for use by residents. I called his bluff and said I was one of the owners. He turned a bit pale and walked away. A few minutes after this I walked up to a group of people. They were angry but also embarrassed when I told them who I really was, and when I spoke about the issue of privatising public space. They admitted they were trying to get rid of me because they thought I was a tourist, and they wanted to prevent hordes of tourists from using the space. Although they recognised the dilemma of privatising public space, they saw no current solution to the problem.

Réseaux urbains

Les villes connaissent des transformations de fond, du fait notamment de processus économiques, démographiques, climatiques ou politiques (restructuration, démantèlement, densification, démocratie). D'un côté, ces processus de transformation offrent la possibilité de faire avancer l'aménagement d'espaces libres par des projets et interventions de qualité ; d'un autre côté, ces aménagements portent davantage d'attention à une architecture paysagiste dans laquelle l'esthétique et l'écologie seraient complémentaires. L'art paysager dans la ville et quelques joyaux culturels en termes de jardin, qui jouent avec les éléments comme les plantes et l'eau pour alléger l'espace urbain, savent exploiter les outils classiques de la profession afin de façonner l'environnement de façon attractive et, à maints égards, fonctionnelle. Avec des éléments naturels – végétaux de tout type, eau, matières minérales –, des espaces urbains sont ainsi créés qui tiennent compte également des aspects écologiques. L'aménagement paysagiste en ville constitue un bien culturel qui renforce le rapport entre les environnements urbains et campagnards.

Aujourd'hui, dans un monde que les médias transforment sans cesse, et dans lequel on devrait créer et aménager davantage dans un but d'attractivité, des places et espaces publics sans âme voient le jour qui n'incitent pas vraiment à s'arrêter. Ce n'est certainement pas la seule faute des planificateurs.
La configuration de l'espace public est « investie » par les citoyens, les politiques et les initiatives citoyennes dès la phase de planification. Les planificateurs doivent donc fournir des projets encore plus « costauds » et tenir compte des desiderata de toutes les communautés, même si ces projets s'articulent autour de visions et besoins différents – c'est là l'art d'une « planification intégrative ».
La question que nous devons nous poser est la suivante : jusqu'où va la démocratie dans le processus d'appropriation des espaces publics ? Est-ce que la signification première de l'espace public est encore garantie en tant que lieu où les individus peuvent se retrouver et s'arrêter, tout en ayant la possibilité d'échanger avec d'autres, d'établir un contact, mais aussi de se retirer de l'agitation des rues – des lieux qui aient une fonction centrifuge et sociale à la fois ? Nous assistons de plus en plus à une refonte des principes de la démocratie qui, inconsciemment, induit une privatisation de l'espace public.

Quelques exemples :
Lors d'une promenade dominicale en 2014 sur le terrain de l'ancien aéroport berlinois de Tempelhof, nous avons pris place sur un canapé posé là dans le cadre d'un projet pionnier. Aussitôt, nous avons été priés de quitter les « lieux », autrement dit le coin canapé. En faisant valoir aux propriétaires le slogan « Tempelhof für alle » (Tempelhof pour tous), nous nous demandions si ce n'était pas là une forme de privatisation, comme les jardins ouvriers. Mais les enjeux de ce problème ne semblaient pas présents dans la conscience et les esprits.
Lors d'un chantier de construction à Prenzlauerberg, une brèche a été occupée par les habitants et déclarée espace public. Un dimanche, avec des amis, je pénètre dans cet espace et m'y installe. Plusieurs familles avec enfants y sont en train de faire un barbecue. Un jeune père vient alors à ma rencontre et me prie de partir, cette place étant réservée aux riverains. En bluffant, je lui dis que je suis un des propriétaires : il pâlit aussitôt et s'éloigne. Quelques minutes plus tard, je vais vers le groupe. Les gens réunis sont à la fois agacés, mais aussi gênés quand je leur révèle mon identité et aborde le thème de la privatisation des espaces publics. Ils avouent avoir essayé de me chasser car ils croyaient que j'étais un touriste et voulaient éviter d'autres hordes de touristes. Tout en reconnaissant le dilemme de la participation et de la privatisation de l'espace public, ils ne trouvèrent, dans un premier temps, rien à dire.

Essay: Stadtleben – Begegnung am Winterfeldtplatz, Berlin

Der Platz ist kahl, an den Rändern befinden sich Shisha-Cafés, indische Restaurants, das „Habibi", die Slumberland-Kneipe mit Sand auf dem „Karibik"-Boden, der „Italiener" an der Ecke und ein Café. Zweimal pro Woche wird der Platz zum Markt.

Paul wohnt in der Winterfeldtstraße. Er besucht häufig den Platz und am Wochenende geht er gerne auf den Markt. An diesem Samstag hilft Jasmin, die Psychologie studiert, ihrem Vater am Gemüsestand. Paul kauft bei Jasmin Gemüse ein und beim Plaudern fragt er, ob alles aus Brandenburg stammt. Sie antwortet ihm: „Das Gemüse kommt aus Fläming. Mein Papa und ich sind aus der Goltzstraße um die Ecke." Paul erwidert: „Und ich aus der Winterfeldtstraße, in der Nähe der Martin-Luther-Straße. Ich war am Rückert-Gymnasium und Du?" „Am Rheingau-Gymnasium in Friedenau, jetzt bin ich an der FU in Dahlem", antwortet sie mit einem Lächeln. Um die Konversation fortzuführen, fragt Paul, ob die Geschäfte gut laufen. Sie sagt: „Ich habe keinen Überblick, die Kasse ist Vaters Sache." Der Vater bemerkt mit einem Grinsen: „Junger Mann, wenn Du es auf die Kasse oder meine schöne Tochter abgesehen hast, ..." Paul antwortet: „Nein, ... nein, ... ich mein ... ja" und verabschiedet sich verlegen mit leicht errötetem Kopf. Jasmins Vater meint schmunzelnd: „Das muss ich Mama erzählen." Jasmin ist auch ein wenig rot geworden.

Am nächsten Tag geht Paul früh morgens mit einem riesigen Schmetterling im Bauch auf den Platz. Der Winterfeldtplatz erlebt sein Reinigungsritual mit viel Wasser. Dort springen nicht die Möwen hin und her wie am Meer, sondern Spatzen.

Es ist, als ob Paul versucht, dem gestrigen Moment mit Jasmin nachzuspüren. Aus heiterem Himmel kommt in dieser frühen Stunde Jasmin in ihrem Jogginganzug auf ihn zu. Er bleibt wie versteinert stehen. Sie fragt: „Was machst Du denn hier so früh am Sonntag?" Er antwortet: „Ich dachte, ich könnte unsere Begegnung noch intensiver spüren, bevor sie alles wegwischen." Sie umarmt ihn.

Essay: Urban Life – Encounter at the Winterfeldtplatz, Berlin

The plaza is empty. It is surrounded by shisha cafés, Indian restaurants, the kebab shop Habibi, the bar Slumberland, with sand on its Caribbean floor, the Italian restaurant on the corner and a café. The plaza comes alive twice a week, on market day.

Paul lives in the Winterfeldstraße. He spends a good deal of time on the plaza and at the week-end he likes to go to the market. This Saturday Jasmin, who is studying psychology, is helping her father at his greengrocer's stall. Paul buys some vegetables from Jasmin, and after chatting he asks if everything comes from Brandenburg. She replies „The vegetables are from the Fläming but my father and I live around the corner in the Goltzstraße". Then Paul says „And I live in the Winterfeldstraße, near Martin Luther Straße. I went to the Rückert School. What about you?" „I went to the Rheingau School in Friedenau, but now I'm studying at the FU in Dahlem," she answers with a smile.

In order to keep the conversation going, Paul asks if business is good. She says „I don't really know, my father is responsible for the money side of things." Her father hears this and smiles „Young man, if you have designs on my money or my beautiful daughter…" Paul says, „No,… no,… I mean…yes," and says goodbye as he blushes. Jasmin's father smiles and says „I'll have to tell your mother about this!" Jasmin blushes a little as well.

Early the next day Paul has butterflies in his stomach as he walks across the Plaza. Winterfeld-platz is undergoing its cleansing ritual and lots of water is being used. But instead of seagulls flying back and forth, there are many sparrows. It seems like Paul is trying to relive the experi-ence he had with Jasmin yesterday. And out of the blue, at this early hour, he sees Jasmin run-ning towards him in her jogging suit. He stands there as if petrified. She asks, „What are you doing here so early on a Sunday?" He answers, „I wanted to think about our meeting yes-terday a little more intensively before it's all washed away." She walks up to him and gives him hug.

Essai : Vie urbaine – rencontre à la place de Winterfeldt, Berlin

La place est vide ; elle est bordée de bar à chichas, de restaurants indiens, le « Habibi », le bistrot « Slumberland » avec du sable sur le sol des « Caraïbes », l'Italien du coin et un café. Deux fois par semaine, la place se transforme en marché.

Paul habite dans la Winterfeldtstrasse. Il est souvent sur cette place et se rend volontiers au marché le week-end. Ce samedi-là, Jasmin, étudiante en psychologie, aide son père sur le stand de fruits et légumes. Paul fait ses courses et demande à Jasmin si tous les légumes viennent du Brandenburg. Elle répond : « Ils viennent de Fläming. Et mon père et moi, de la Goltzstrasse, juste de l'autre côté. » Paul à son tour : « Et moi de la Winterfeldtstraße, pas loin de la Martin-Luther-Straße. J'étais au lycée Rückert, et toi ? » « Au lycée Rheingau à Friedenau, et maintenant j'étudie à la fac à Dahlem », répond-elle avec un sourire.

Pour poursuivre la conversation, Paul lui demande si les affaires vont bien.

Jasmin : « Je n'ai pas de vue d'ensemble, c'est mon père qui tient la caisse… » Le père note alors en rigolant : « Jeune homme, tu lorgnes sur la caisse ou sur ma jolie fille ?!… » Paul : « Non, non… euh, je veux dire… », et il prend congé, embarrassé, le visage un peu rouge. Le père de Jasmin dit en s'amusant : « Alors ça, il faut que je le raconte à Maman. » Jasmin rougit à son tour.

Le jour d'après, tôt le matin, Paul se dirige vers la place, avec une drôle de sensation dans le ventre. La Winterfeldtplatz est en plein nettoyage, il y a de l'eau partout. Ce ne sont pas les mouettes qui volent dans tous les sens, comme à la mer, mais les moineaux.

Paul essaie de revivre l'échange de la veille avec Jasmin… Soudain, comme par miracle, Jasmin fait irruption à cette heure matinale, en tenue de jogging. Paul est pétrifié. Elle lui demande : « Que fais-tu donc si tôt ici, un dimanche matin ? » Et lui de répondre : « J'espérais pouvoir retenir quelque chose de notre rencontre d'hier, avant que tout ne soit nettoyé. »

Elle s'approche et enlace ses bras autour de lui.

URBANITÄT

Stadtplätze gestern und heute

Piazza del Campo, Sienna, Italien. Federzeichnung, um 1578

Die Funktionen und der Raum des Platzes verdeutlichen die menschliche Dimension, sie schaffen einen Ort, an dem Menschen zusammentreffen und auch verweilen. Dieser Ort erhöht den menschlichen Austausch und Kontakt, er bietet Rückzug vom Treiben auf den Straßen. Der Platz wird zur Anlaufstelle, zum Treffpunkt.

Ein Platz verdeutlicht die architektonisch-städtebauliche Dimension und vermittelt ein vitales Landschaftsbild im Stadtgefüge. Ein Platz ist ein städtischer, öffentlicher Raum, den sich Bewohner und Besucher aneignen. Eines der wichtigsten Elemente, die die europäische Stadtlandschaft charakterisiert, ist das Vermächtnis der kompakten Stadt. Die Dichte bestimmt die urbanen Orte Europas. Wie attraktiv sind darin die Plätze!

Die Attraktivität der Plätze ist nicht immer gleich, einige Orte sind belebt, voller Atmosphäre und andere mehr oder weniger leer. Unabhängig von ihrer Attraktivität sind Plätze allemal für alle zugänglich, Orte des Zusammentreffens, des Marktes und der Feste. Der klassische Stadtplatz bietet unbezahlten Aufenthalt neben Caféterrassen. Hier ist es möglich, auf einer Bank zu sitzen oder am Rand eines Brunnens, um die Atmosphäre zu genießen. Plätze sind Orte, an denen sich Menschen treffen und austauschen können. Sie bieten einen Unterschlupf, um sich vor dem tobenden Verkehr zu schützen und sich von der Spannung der überfüllten Straßen zu erholen. Wie Gärten und Parks sind Plätze ein Ausdruck der Kultur und als solcher auch eine Visitenkarte. Eines der typischen Merkmale der europäischen Stadtplätze ist ihre Öffentlichkeit. Diese fördert das kultivierte Verhalten der Bewohner zueinander. In dieser Hinsicht trägt die Begegnung im öffentlichen Raum gesellschaftlichen, das heißt politischen Charakter: Die Funktion der europäischen Plätze als Ort demokratischen Austauschs ist an die Entstehung der Polis (Stadt) gekoppelt. Sie gehört historisch zur Herausbildung der Identität der Stadt und ihrer Bürger. Im Laufe der Jahrhunderte wurde diese Tradition des Platzes als Ort der Demokratie verbunden mit der Kontemplation, dem Aufenthalt und der Repräsentation von dienenden gestalterischen Merkmalen wie Brunnen, Gehölzen, Schmuckpflanzungen und Skulpturen im Gesamtensemble.

In einer Zeit zunehmender Kommerzialisierung und damit Teilprivatisierung der Innenstädte und ihrer Geschäftsstraßen ist die Bereitstellung öffentlicher Plätze nach wie vor von Belang – in der Moderne weniger zum Zweck herrschaftlicher Repräsentation als für den allgemeinen Aufenthalt und die Begegnung im Freien. Hierzu braucht es atmosphärische Orte. Die Tradition der raumbildenden Prinzipien lässt sich dabei für moderne Gestaltungen werkzeugartig einsetzen. Raumwirkung, Proportionen, Sitzmöglichkeiten, Licht- und Schattenverteilung, Nutzbarkeit von Belägen, Veränderung innerhalb der Jahreszeiten und Pflegekonzepte kombiniert mit einer Zugänglichkeit für alle, einer Einbindung in den räumlichen, kulturellen und sozialen Kontext und einer Anpassung an moderne gesellschaftliche Strömungen können klassische Anlagen modern machen. Manchmal haben minimale Interventionen, wie die Erlaubnis, Rasenflächen zu betreten, eine starke Wirkung in der Veränderung der Atmosphäre eines Ortes. Freianlagen bieten Raum und Rahmen für die Präsentation der Stadtgesellschaft.

Die Wahrnehmung und Bedeutung des öffentlichen Raums und seiner Plätze ist geografisch, städtebaulich und gesellschaftlich bedingt. Auch wenn die Lebendigkeit einer Stadt im Süden aufgrund der klimatischen Bedingungen anders zu erleben ist als im Norden, wird immer aus der städtebaulichen Entwicklung, aus der Konfiguration der Bebauung und der Freiflächen die kontextuelle Vorgabe für die Bedeutung und Verortung und somit für die Hierarchisierung solcher Freiräume gegeben. Die Plätze, Piazzettas, Marktplätze, Versammlungsplätze im Sinne der Agora aus dem antiken Griechenland, sind heute unter anderem Symbole der Lebensart, sie sind öffentlich zugänglich, sie sind Orte der sozialen und politischen Versammlung, sie sind Orte des kostenlosen Aufenthalts. Dorfplatz, Marktplatz, Festplatz, Kirchplatz, Schlossplatz, Theatervorplatz, Bahnhofsvorplatz sind einige Bezeichnungen für Plätze in der europäischen Stadtentwicklung, die einer konkreten Nutzung unterliegen.

Viktoria-Luise-Platz, Berlin, Entwurfszeichnung von Fritz Encke, 1899

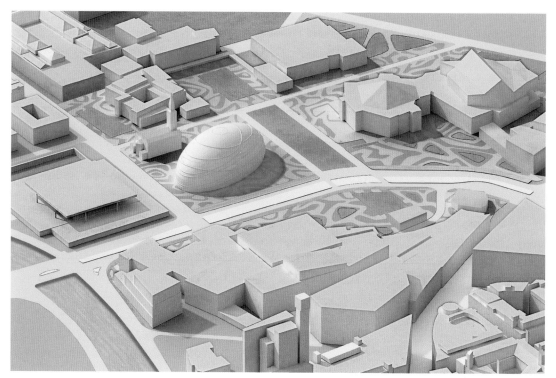

Wettbewerbsbeitrag Museum des 21. Jahrhunderts am Kulturforum, Berlin
Kamel Louafi, 2015

Die Identifikation mit der eigenen Stadt, dem eigenen Viertel oder Kiez, das Bedürfnis an Kommunikation und Austausch, am Mitgestalten ist in allen Schichten der Bevölkerung stetig gewachsen. Das Engagement in Bürgerinitiativen, Foren und sozialen Netzen wird immer professioneller. Wobei in diesen Organisationen und Bürgerinitiativen unterschiedliche Ansichten und Auffassungen zur Nutzung des urbanen Raums herrschen. Wo primär Repräsentation und Kontemplation gelten, müssen die Vertreter des Im-Rasen-Liegens oder von Aktivitäten im Grünen stark kämpfen, um sich Gehör zu verschaffen und sich eventuell mit Kompromissen zufrieden geben. Die Entwicklung und Etablierung der Fachsparte „Moderation und Mediation" in der Architektur und Landschaftsarchitektur ist nicht ausschließlich das Ergebnis einer Auseinandersetzung zwischen Gestaltern und Nutzern, sondern vor allem auch zwischen Nutzern und Anrainern.

Die Geschichte des Städtebaus zeigt, dass der Wohnraum (unabhängig von klimatischen Regionen) vom Platz nicht ausreichend war, um einen durchgängigen Aufenthalt der Menschen zu gewährleisten. Der Außenraum bildete daher oft das fehlende dritte Zimmer.

Urbanity: Urban Plazas Yesterday and Today

The functions and space of plazas highlight the human dimension, they create a place where people meet and spend time. These places increase human exchange and contact, and offer people a place where they can withdraw from the hustle and bustle of the street. Plazas are both a destination and a place to meet others.

Plazas emphasise the architectural-urban planning dimension and convey a vital landscape image within the urban fabric. They are urban, public spaces that residents and visitors alike claim for themselves. One of the most important elements that characterises European urban landscapes is the legacy of the compact city. Density governs Europe's urban areas, which makes plazas all the more attractive.

This attractiveness is not always the same, however; some are lively and full of atmosphere while others are more or less empty. Regardless of their appeal, plazas are accessible to everyone, they are places for meeting others, for markets and festivals. The classic urban plaza provides space for an unpaid stay adjacent to café terraces. Here it is possible to sit on a bench or the edge of a fountain in order to simply enjoy the atmosphere. Plazas are places where people can meet and exchange ideas and information. They offer people a shelter, where they can protect themselves from busy traffic and recover from the stress of crowded streets. Just like gardens and parks, plazas are an expression of culture, and as such, are also calling cards. One of the typical characteristics of European urban plazas is their public character. This promotes the cultivated behaviour of residents as they interact. In this regard, meetings in public open areas have a social or political character: The function of European plazas as places of democratic exchange is coupled to the emergence of the Polis (city). Historically, plazas have helped to establish the identity of a city and its citizens. Over the centuries this tradition has been associated with design elements such as fountains, trees, decorative planting beds and sculptures, which together create a place for contemplation and lingering, and which may also have a representative function.

In a time of increasing commercialisation and thus the partial privatisation of inner cities and their shopping streets, the provision of public space continues to be relevant – in modern times less for the purposes of stately representation than for those as places to spend time in and meet other people outside of flats and offices. This requires the presence of places that have atmosphere, however. To this end, the tradition of space-defining principles can be used as tools for the creation of modern design. Spatial effects, proportions, seating, the distribution of light and shadows, the use of paving materials, seasonal variations and maintenance concepts

combined with access for everyone, integration in the spatial, cultural and social context and adaptation to modern social trends can all be used to make classical structures modern. Sometimes minimal interventions such as permission to walk on the grass can be hugely successful in changing the atmosphere of a place. Open space provides space and a setting for the presentation of urban society.

The perception and significance of public space and of plazas is dependent on local geography, urban development and society. Even if the vitality of cities in the south is experienced differently than it is in the north due to climatic conditions, the urban development resulting from the configuration of buildings and open space will always serve as the contextual guideline for the importance and location, and thus for the hierarchy, of the open space. The plazas and piazettas as synonyms for marketplaces and gathering areas, as was the agora in ancient Greece, are now, among other things, symbols of a way of life; they are publicly accessible, places of social and political assembly and places that people can use free of charge. Village squares, marketplaces, fairgrounds, church squares and forecourts for palaces, theatres and railway stations are some of the names given to plazas in European urban development that are subject to a specific use.

The identification with one's city, district or neighbourhood, and the need for communication and exchange and for helping to shape these areas has steadily grown within all levels of society. The activities of citizens' initiatives, forums and social networks is becoming more professional, although in these organisations and initiatives there are different views and opinions as to the use of urban space. Where representation and contemplation are of primary importance, representatives of those who wish to lie in the grass or have active open areas have to fight hard to be heard and may have to settle for compromise. The development and establishment of the field of 'moderation and mediation' in architecture and landscape architecture is not only the result of disagreements between designers and users, but mainly those between users and neighbouring residents.

The history of urban design shows that indoor living areas (regardless of climatic regions) were not enough to guarantee the continuous presence of people in cities. Outside space has often been the missing 'third room'.

Urbanité : Les places dans la ville, hier et aujourd'hui

Les fonctions et l'espace d'une place mettent la dimension humaine en avant. Ainsi se crée un lieu où des individus se rencontrent et s'arrêtent un moment. Ce lieu permet l'échange et le contact, il invite à se retirer de l'agitation des rues. La place devient lieu de convergence, c'est un point de rencontre.
Une place illustre la dimension architecturale et urbaine, elle communique l'image vitale d'un paysage dans la structure de la ville. Une place est un espace urbain et public que s'approprient les habitants et les passants. Un des éléments les plus importants qui caractérise le paysage urbain européen est l'héritage de la ville compacte. C'est la densité qui détermine les lieux urbanisés en Europe. Quelle est l'attractivité des places dans tout cela ?
L'attractivité des places n'est pas toujours la même. Certains lieux sont animés, pleins d'ambiance, d'autres sont plus ou moins vides. Indépendamment de leur attractivité, les places sont accessibles à tout le monde, elles sont un lieu de rencontre, de marchés et de fêtes. La place urbaine classique permet qu'on y séjourne gratuitement, à côté des terrasses de cafés. Il est possible de s'y asseoir sur un banc ou sur le bord d'une fontaine pour savourer l'ambiance. Les places sont le lieu où l'on peut se retrouver et échanger. Elles offrent un point de refuge à ceux qui veulent échapper au bruit de la circulation ou aux tensions des rues bondées. Comme les jardins et les parcs, les places sont l'expression

d'une culture et donc une « carte de visite ». Un des aspects importants des places en Europe est leur caractère public, qui encourage un rapport civilisé des habitants entre eux. En ce sens, la rencontre dans l'espace public a un caractère social, autrement dit politique : la fonction des places en Europe comme lieu de synergie démocratique est liée à l'émergence de la polis (ville). Elle contribue historiquement à façonner l'identité de la ville et de ses citoyens. Au cours des siècles, cette tradition a été associée à des caractéristiques formelles et créatives servant à la contemplation, au séjour et à la représentation : fontaines, bois, plantations ornementales, sculptures de plein air.

À une époque de commercialisation croissante et donc de privatisation partielle des centres-villes et des rues commerçantes, la mise à disposition de places publiques reste toujours d'actualité – moins, en nos temps modernes, à des fins de représentation que pour séjourner et se retrouver en extérieur. Il faut pour ce faire des lieux dégageant une ambiance. La tradition des principes configurant l'espace peut être employée ici comme un outil de création moderne. Effet d'espace, proportions, possibilités de s'asseoir, répartition des ombres et des éclairages, utilisation des revêtements, changements au fil des saisons et concepts d'entretien, le tout combiné avec une accessibilité à tous, une intégration dans le contexte spatial, culturel et social, ainsi que l'adaptation aux courants sociétaux contemporains peuvent rendre modernes des emplacements classiques. Parfois, des interventions minimes, telles que l'autorisation de marcher sur le gazon, peuvent avoir un impact fort sur la transformation de l'ambiance d'un lieu. Les espaces de plein air offrent un cadre à la présentation de la société urbaine.
La perception et la signification de l'espace public et des places sont conditionnées par des éléments géographiques, urbanistiques et sociaux. Même si, du fait des conditions climatiques, l'aménagement d'une ville du Sud se vit autrement qu'au Nord, c'est toujours le développement de la cité, l'urbanisation et les zones non-construites qui déterminent les directives contextuelles pour la signification, le positionnement et, partant, la hiérarchisation de ces zones-là. Les places ou placettes, comme synonymes de places de marché ou places de rassemblement, comme l'« agora » de la Grèce antique, sont aujourd'hui autant de symboles d'un mode de vie ; elles sont accessibles à tous, elles sont le lieu de convergences sociales et politiques, lieu de séjour gratuit. Place du village, place du marché, place des fêtes, place de l'église, place du château, place du théâtre, parvis de la gare – ce ne sont que quelques-unes des façons de désigner, dans le développement urbain en Europe, les places ayant une fonction concrète.

L'identification avec sa ville ou son quartier, le besoin de communiquer, d'échanger et de participer, n'a cessé de croître dans toutes les couches de la population. L'engagement dans les actions citoyennes, les forums et réseaux sociaux gagnent toujours plus en professionnalisme, même si, parmi ces différents mouvements et organisations, les opinions et conceptions sur l'utilisation de l'espace urbain divergent. Là où la représentation et la contemplation sont au premier plan, les adeptes de détente et de verdure devront se battre pour se faire entendre et accepter les compromis. Le développement et l'établissement de la rubrique « modération et médiation » dans l'architecture et l'architecture paysagère n'est pas le résultat d'une confrontation seulement entre planificateurs et utilisateurs, mais surtout aussi entre utilisateurs et mitoyens.

L'histoire de l'urbanisme montre que l'habitat (indépendamment des régions climatiques) n'a pas suffi à garantir un lieu durable de séjour aux individus. L'espace extérieur est souvent la troisième pièce qui manque.

PLACES PUBLIQUES

Der französische Landschaftsarchitekt Michel Corajoud († 2014) definiert den öffentlichen Raum

„als Einheit von offenen Orten, zugänglich von allen Bürgern ohne Unterscheidung der Rasse, der Klasse oder des Geschlechts, der geprägt wird durch eine große soziale Durchmischung. Es sind gleichzeitig multifunktionelle Orte, die vielfältige Nutzungen ermöglichen: Man begibt sich dorthin, um Besorgungen zu machen, spazieren zu gehen oder sich einfach von Punkt A nach Punkt B zu bewegen."

In Anbetracht der Nutzungskonflikte befürwortet er, dass diese Nutzungen durch das Prinzip der Harmonie geregelt werden.

French landscape architect Michel Corajoud († 2014) defines open space "as an assembly of open places, accessible to all citizens without distinction of race, class or gender, and characterised by great social mixing. These places are multifunctional and allow for a variety of uses: One goes there to run errands, to go for a walk or to simply move from point A to point B."
Given that there are conflicts of use, he acknowledges that these uses need to be regulated according to the principle of harmony.

Le paysagiste Francais Michel Corajoud († 2014) souligne pertinemment que l'espace public, « c'est l'ensemble des lieux ouverts, accessibles à tous les citoyens sans distinction de race, de classe ou de sexe, et qui se caractérisent ainsi par une grande mixité sociale. Ce sont également, comme il le souligne, des lieux polyfonctionnels qui permettent des usages croisés : on s'y rend pour faire des courses, pour se promener, ou pour simplement se déplacer d'un point A à un point B. »
Mais, étant donné les conflits d'usage, il préconise que ces usages soient régis par le principe de l'harmonie.

Auszeit mitten im Trubel

„König Ernst August hätte sicher gestaunt und vielleicht die Stirn gerunzelt. Jahrelang hatte sich der Monarch den Plänen von Baumeister Laves widersetzt, in der Stadtmitte ein Opernhaus zu bauen, genau an der nach seinem Vater benannten Flaniermeile, der Georgstraße. Auf der geschleiften Stadt-mauer war ein Boulevard errichtet worden, auf dem die Bürger zum Sehen und Gesehen werden ent-lang schreiten konnten. Ernst-August selbst amüsierte sich lieber im Gartentheater zu Herrenhausen inmitten der prächtigen barocken Gartenanlage. Und in der Stadt hatte er schließlich das Schlossopern-haus am Leineschloss." [...] „Man weiß, dass der Widerstand letzten Endes zwecklos war: Baumeister Georg Ludwig Friedrich Laves, ohne den Hannover nicht Hannover wäre, durfte 1852 die Eröffnung des von ihm entworfenen neuen Hoftheaters erleben." [...] „Aber nun das: Der in Algerien geborene Garten-architekt Kamel Louafi" [...] „schlägt eine Brücke von der Herrenhäuser Gartenkunst zum Operndreieck am Rathenauplatz. In barocker Symmetrie säumen Eiben und Buchsbäume die breite Sichtachse, die den Blick auf das 1994 von Michelangelo Pistoletto gestaltete Mahnmal für die im Nationalsozialismus ermordeten Juden Hannovers lenkt. Die geometrischen Formen der Hecken und Wege sind ganz dem großen Vorbild Herrenhausen verpflichtet und könnten gut aus einem der kleinen Sondergärten des Großen Gartens stammen. Seit die Windmühlenstraße nicht mehr befahren werden darf und damit den Opernplatz nicht mehr vom Rathenauplatz trennt, hat die Stadt mit dem dadurch entstandenen Opern-dreieck eine neue durchgehende Grünfläche gewonnen. Kamel Louafi hat es nicht nur geschafft, die Georgstraße, den Opernplatz und das Bankenviertel mit seinen historischen Bauten optisch zu verbin-den, sondern er hat einen Park geschaffen, in dem sich Flaneure, Opernbesucher und Touristen begeg-nen. In ruhiger, entspannter Atmosphäre schlendert man über die gepflegten Kieswege und die Achse aus Sandstein und nimmt eine kleine Auszeit von der umliegenden Geschäftigkeit." [...] „Dank des Rathenauplatzes hat man ein Stück Herrenhausen mitten in die Stadt geholt. Und wer weiß, vielleicht hätte das ja sogar Ernst August gefallen." ³

An Oasis in the Middle of the City

"King Ernst August would certainly have been amazed and may have even scowled a bit. For years the monarch had opposed architect Laves' plans to build an opera house in the centre of the city, in the middle of the promenade named after his father, Georgstraße. A boulevard was built where the wall around the city had once stood, and it had become a place where local citi-zens turned out to see and be seen. And anyway, Ernst August preferred to amuse himself in the Gartentheater (hedge theatre) in Herrenhausen, located in the middle of the magnificent baroque gardens. In the city he already had the Schlossopernhaus am Leineschloss." [...] "It's common knowledge that, in the end, his opposition was pointless: Architect Georg Ludwig Friedrich Laves, without whom Hannover would not be what it is today, was able to experience the opening of his new royal theatre in 1852." [...] "And now this: The Algerian-born landscape architect Kamel Louafi" [...] "has built a bridge between Herrenhausen garden art and the Opern-dreieck at Rathenauplatz. Yews and boxwood fill up the broad axis in baroque symmetry, which directs the view to Michelangelo Pistoletto's memorial to the National Socialist persecution of

3 *Gartenregion Hannover: Grüne Orte.* 2009, S. 188,
www.hannover.de/content/download/65907/1776872/file/Besondere-Orte.pdf

the Jews in Hannover. The geometric shapes of the hedges and walkways are directly related to the Herren-hausen Gardens and could actually stem from one of the smaller thematic gardens located there. Since Windmühlenstraße is no longer open to vehicular traffic and the Opernplatz is therefore no longer separated from Rathenauplatz, the city has gained a new uninterrupted park in the form of the Operndreieck. Kamel Louafi not only managed to visually connect Georg-straße, the Opernplatz, and the city's financial district, with all its historic buildings, he also created a park where people out for a stroll, visitors to the opera, and tourists can all congregate. Visitors can leisurely stroll along the peaceful and well-maintained gravel walkways and the sand-stone-paved axis and take a short break from the surrounding hustle and bustle." [...] "Thanks to the Rathenauplatz, a piece of Herrenhausen has been brought into the city centre. And who knows, in the end maybe even Ernst August would even have been pleased about this." [3]

Pause au milieu de l'agitation

«Durant des années, le roi Ernst August a tenté d'empêcher l'architecte Laves de réaliser la maison de l'opéra dans le centre ville, le long de la promenade de la rue George qui porte le nom de son père. La construction du boulevard supplanta le tracé des fortifications permettant aux citoyens le libre court aux flâneries et panades publiques. Le roi quant à lui, préférait plutôt se divertir dans les jardins du théâtre Herrenhausen au milieu des magnifiques promenades baroques, et en ville il avait le château de l'opéra, le Leineschloss.» [...] « Sans l'architecte Georg Ludwig Friedrich Laves, Hanovre ne serait pas ce qu'elle serait aujourd'hui, et l'ouverture du nouvel Opéra royal s'inaugura en sa présence en 1852.» [...] «Mais maintenant ceci Kamel Louafi propose un lien entre les jardins artistiques baroques de Herrenhäuser et la place de l'opéra. Il souligne la perspective par la géométrie d'un parterre végétal axé vers le mémorial juif, conçu par Michelangelo Pistoletto.Le dessin des haies est façonné par la taille d'ifs européens (Taxus Baccata),et les sentiers sont inspirés des grands modèles utilisés dans les jardins baroques de Herrenhausen. A la suite de réaménagements urbains, la ville a alors pu obtenir de nouveaux espaces verts dans tout le triangle de l'opéra. Kamel Louafi a réussi non seulement à connecter visuellement la rue George, la place de l'Opéra et le vieux quartier financier avec ses bâtiments chargés d'Histoire, mais il a aussi conçu un lieu de détente, de légèreté, un parc empli d'une force tranquille destiné au repos. » [...] «Les jardins de la nouvelle place de l'opéra auront ramenés quelques intrigues baroques Herrenhausen dans la ville, en clin d'oeil à Ernst August a qui ils auraient certainement plût.» [3]

3 *Gartenregion Hannover: Grüne Orte.* 2009, p. 188,
www.hannover.de/content/download/65907/1776872/file/Besondere-Orte.pdf

Essay: Wiedersehen am Opernplatz, Hannover

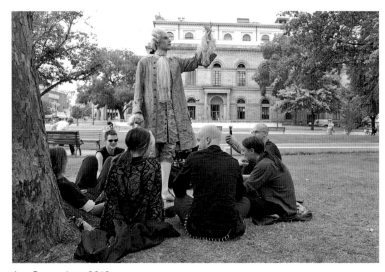

Am Opernplatz, 2012

Janine wohnt in Linden. Seit sie 16 Jahre alt ist, ist sie in der Gothic-Szene. Bei schönem Wetter geht sie zum üblichen Treff auf der Rasenfläche am Opernplatz. Janine und ihre Freunde haben viel Respekt vor dem Mahnmal der deportierten Juden in der Platzmitte. Ihre Versammlungen finden an der Börsenstraße auf dem Rasenrand statt. Die Georgstraße ist für sie zu spießig.

Janine hatte keinen Freund, bis sie auf einem Gothic-Festival in Hildesheim den gleichaltrigen Jo aus Bemerode kennenlernte. Er sagte zu allem „krass", und wenn Janine etwas gesagt oder gemacht hatte, sagte er: „Voll krass". Ihre Hände berührten sich zärtlich in der Abendsonne auf der Wiese und beide spürten dieses Kribbeln im Bauch. Sie hatte ihn zu einem Treffen am Opernplatz eingeladen. „Voll ... voll krass. Ja, ich bin da am Wochenende ..." Zwei Wochenenden ist er nicht erschienen. Janine war traurig und melancholisch zugleich. Am Samstag darauf ist sie träge und lustlos zum Opernplatz hingefahren. Sie lag mit ihren Kumpeln auf dem Rasen.

Sie beobachtete das Treiben auf dem Platz. Die Kinder rannten zwischen den Hecken mit ausgestreckten Armen umher, sie lächelte und dachte: Das sind die Tänzer der „Arabesques" (der tanzenden Heckenformen). Sie erkannte viele Gesichter, die auf den Bänken saßen und plauderten. Am Mahnmal standen zwei Schulklassen, neben ihnen wurde der Liegerasen immer voller, sie beobachtete die Vögel auf den Birkenbäumen. Amüsiert schaute sie Richtung Börsenstraße. Bankangestellte saßen auf der Stufenanlage und machten ihre Pause. Sie drehte sich und blickte auf die Oper und die Heckenbänder. Sie blickte zwischen die gerade geschnittenen Hecken und folgte dem Gang der Menschen hinter den Hecken bis zum Platz.

„Hey, Jo!", schrie Achim, „es wurde aber auch Zeit!" Janine sprang auf und sah, dass Jos Arm komplett eingegipst war. Er gab ihr einen Kuss und setzte sich neben sie. Achim hatte angefangen, die gotische Schrift auf dem Gips laut zu lesen: Janiiiiiiiine! Janine und Jo sind leicht rot geworden. Achim sagte: „Schon krass!"

Essay: A Reunion at the Opernplatz, Hanover

Janine lives in Linden. She's been in the Gothic scene since she was 16 years old. When the weather is nice she usually meets her friends on the lawn at the Opernplatz. They have a lot of respect for the memorial for the deported Jews located at the centre of the plaza. Their gather-

ings are often at the edge of the lawn along the street called An der Börse. They don't really like the stuffy atmosphere at Georgstraße. Janine didn't have a boyfriend until she met Jo from Bemerode, who's the same age, at the Gothic Festival in Hildesheim. He said "awesome" the whole time, and whenever Janine said or did anything, he said "really awesome". Their hands touched each other gently as the sun set over the meadow and both of them had butterflies in their stomachs. She invited him to one of the gatherings at the Opernplatz. "Really... really awesome! I'll definitely be there at the weekend ..." But then he didn't show up the following two weekends. Janine felt sad and melancholy at the same time. The following Saturday she went the Opernplatz, but is pretty sluggish and listless. She lay on the grass with her friends.

She watched all the activity on the plaza, and the children running between the hedges with outstretched arms. She smiled and thought, "They're like the dancers of the Arabesques (dancing shaped hedges)". She recognised many of the faces of the people who were sitting on the benches chatting with one another. Two school classes were looking at the memorial. The lawn was getting fuller and fuller, but she concentrated on the birds sitting in the birch trees instead.

Amused, she looked towards An der Börse. Bank employees were sitting on the steps, taking a break. She turned around and looked at the opera building and the rows of hedges. Looking down these neatly pruned rows, she could see people walk along them on their way to the plaza. "Hey Jo!" screamed Achim. "It's about time you got here!" Janine jumped up and saw that Jo's whole arm was in a cast. He gave her a kiss and sat down next to her. Achim loudly read the Gothic writing on the cast, "Janiiiiiiiine". Janine and Joe both blushed a little and Achim said "Pretty awesome!!"

Essai : Se revoir à la Place de l'Opéra de Hanovre

Janine habite à Linden. Depuis l'âge de 16 ans, elle fréquente la scène gothique. Par beau temps, elle rejoint ses copains au point de ralliement sur la pelouse, près de Opernplatz. Ils ont beaucoup de respect pour le monument aux Juifs déportés qui se trouve au milieu de la place. Leurs rencontres ont lieu en bordure de la Börsenstrasse. La Georgstrasse, c'est pour les petits bourgeois.

Janine n'avait pas d'ami jusqu'au jour où elle a rencontré Jo, de Bemerode, à un festival gothique à Hildesheim. Jo a le même âge qu'elle, pour lui tout est « trop cool ». Chaque fois que Janine disait ou faisait quelque chose, il disait que c'était « carrément trop cool ». Leurs mains se sont tendrement effleurées dans le soleil du soir, sur la pelouse, et tous deux ont ressenti un petit frisson dans le ventre. Alors elle l'a invité avec ses copains de Opernplatz. « C'est carrément trop trop cool. Ce week-end, j'y serai ... »

Deux week-ends sont passés sans qu'il apparaisse. Janine est triste, mélancolique. Le samedi d'après, elle se rend jusqu'à Opernplatz, sans entrain. Elle s'allonge sur l'herbe avec ses copains. Ils regardent le va-et-vient sur la place. Les enfants courent entre les haies, les bras tendus. Elle sourit en pensant : ce sont les danseurs des « Arabesques » (des haies dansantes). Elle reconnaît plusieurs visages de gens qui sont assis sur les bancs et papotent. Près du monument, deux groupes de scolaires. À côté de sa bande, de plus en plus de monde s'installe. Ils regardent les oiseaux dans les bouleaux.

Elle jette un œil amusé en direction de la rue, près de la Bourse. Des employés de banque sont assis sur les marches d'escalier et prennent leur pause. Elle se retourne, voit l'opéra et les rangées de haies. En regardant à travers les haies fraîchement taillées, elle peut suivre les gens qui marchent jusqu'à la place.

« Hé, Jo !, crie Achim, il était temps ! »

Janine se lève d'un bond et voit que tout le bras de Jo est dans le plâtre ... Il lui fait un baiser et s'assoit à côté d'elle. Achim commence à déchiffrer l'écriture gothique sur le plâtre et lit à voix haute : Janiiiiiiiine ! Janine et Jo rougissent légèrement... Et Achim de dire : « Trop trop cool !! »

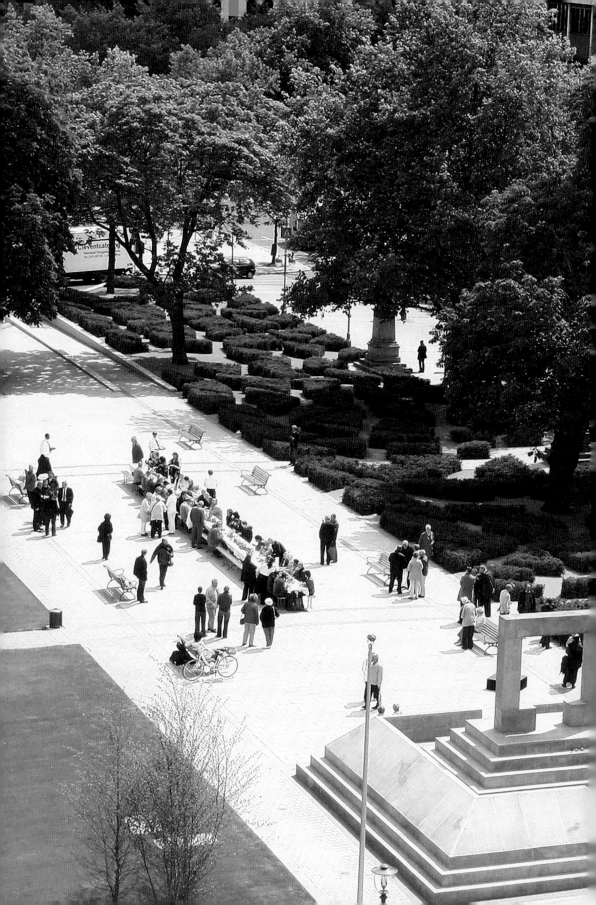

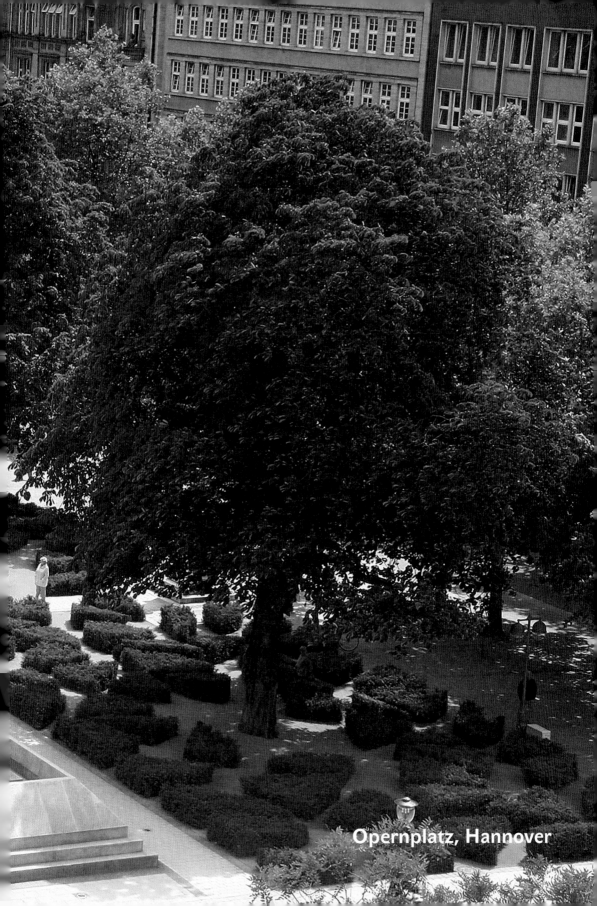

Opernplatz, Hannover

Essay: Stadtbilder am Königsplatz, Kassel

Am Königsplatz, 2004

Die Besucher der documenta machen gerne Halt am Königsplatz. Sie sind neugierig: Wie sieht der Platz nach dem Abriss der documenta-Treppe aus?

Die Terrasse des italienischen Restaurants ist der ideale Ort, um das Treiben auf dem Platz zu beobachten. Selik, Architekt aus Istanbul, besucht jedes Mal die documenta und verbindet damit einen Besuch bei seiner Schwester, die in Kassel wohnt. Er beobachtet die Rituale der Stadtbewohner sowie den Königsplatz als Bühne für die Stadtbewohner und Besucher. Ältere Damen und Herren sitzen auf den Holzbänken, plauschen miteinander und lachen. Junge Eltern, deren Kinder mit den Strahlen der Wasserspeier spielen, sitzen auf der Caféterrasse. Frauen sitzen auf den Bänken und scheinen sich viel zu erzählen zu haben. Jungs kurven auf Fahrrädern zwischen den Wasserspeiern hin und her. Im Café mit Blick auf den Platz sitzen gut gekleidete ältere Damen und Herren mit Hut und Zigarettenhalter, um bei einem Kaffee das Treiben zu beobachten und zu kommentieren. Es ist ein Platz des Dialogs, des Austauschs, ein Platz des Spiels und der Beobachtung.

Selik beobachtet das Neben- und Miteinander aller Generationen, vom Flaneur bis zum Fahrradfahrer. Er selbst sitzt am Rand des öffentlichen Raums unter den Platanen auf einer Restaurantterrasse und stellt fest, dass die öffentlichen Bänke voll sind und wie wichtig es ist, neben der Privatisierung von Flächen auch Plätze für einen frei zugänglichen, kostenlosen Aufenthalt zu ermöglichen.

Essay: Urban Scenes at the Königsplatz, Kassel

Visitors to the documenta often like to stop at the Königsplatz as well. They are generally curious: What is the plaza like now that the documenta stairway is gone?

The terrace at the Italian restaurant is the ideal place to watch what's going on at the plaza. Selik, an architect from Istanbul, always goes to the documenta and also visits his sister, who lives on Jägerstraße in Kassel. He watches the city's residents as they do their daily activities and also looks at the Königplatz as a stage for both locals and visitors. Older men and women sit on the wooden benches, chat with each other and laugh. Young families, whose families play with the jets of water spouting from the water features, sit at the coffee terrace. Women sit on various benches and appear to have a multitude of things to tell each other. Young boys on bicycles cruise back and forth between the jets. Well-dressed older men and women with hats

and cigarette holders sit at the adjacent café observing the goings-on, perpetually commenting on what they see. It is a plaza full of dialogue, of exchange; a place for playing and observing. Selik watches the juxtaposition and coexistence of all these various generations, from the flâneur to the bicyclist. He sits outside at a restaurant on the edge of this public space, under the plane trees. He realises that the public benches are all occupied, and thinks about how important it is to offer space that can be used free of charge, in addition to the private open space of the terraces and cafés.

Essai : Scenes urbaines à Königsplatz, Kassel

Les visiteurs de la documenta s'arrêtent volontiers sur la Königsplatz. Ils sont curieux : une fois démonté l'escalier de la documenta, qu'est devenue la place ?

La terrasse du restaurant italien est le lieu idéal pour contempler le va-et-vient sur la place. Selik, architecte d'Istanbul, se rend à chaque documenta et en profite pour aller voir sa sœur qui habite Jägerstraße, à Kassel.

Il observe les rituels de la population et la façon dont la Königsplatz sert de scène à tout le monde, habitants et visiteurs. Des dames et des messieurs âgés sont assis sur les bancs en bois, bavardent, rigolent. Des jeunes familles, dont les enfants jouent avec les jets d'eau, sont installées à la terrasse du café. Des femmes assises sur les bancs semblent avoir beaucoup de choses à se dire. Des garçons slaloment avec leurs vélos entre les jets. Au café, où l'on a vue sur la place, des personnes d'un certain âge, bien vêtues, avec chapeau et porte-cigarettes, regardent toute cette animation en buvant leur café et ponctuant leurs échanges de quelques commentaires. C'est une place de dialogue, d'échange, une place qui incite au jeu et à la contemplation.

Selik regarde comment les générations se mêlent et se côtoient, du flâneur au cycliste. Lui-même est assis sur le bord, dans l'espace public, sous les platanes, à la terrasse d'un restaurant ; il constate alors que tous les bancs publics sont occupés et combien il est important, au-delà de toute privatisation, de permettre aux gens de se poser gratuitement.

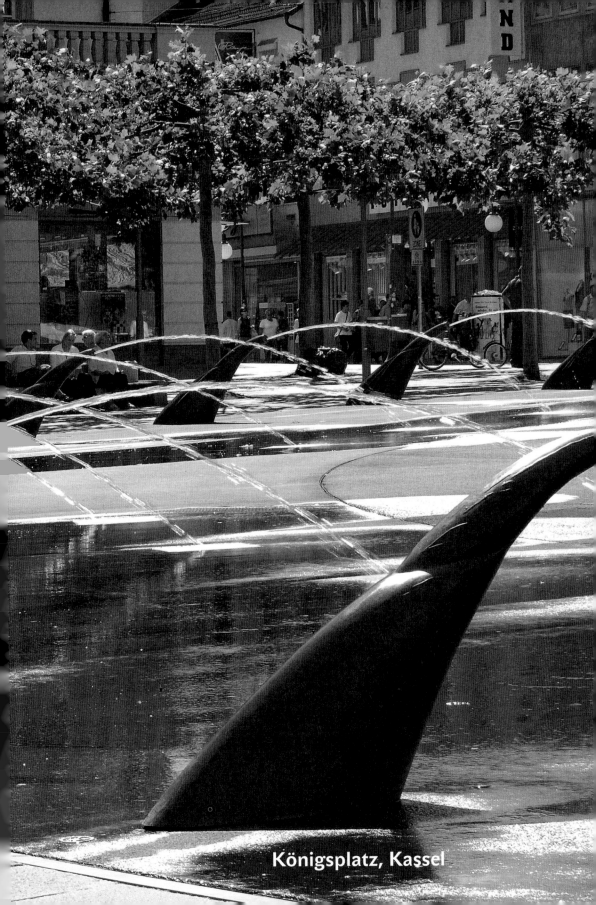

Königsplatz, Kassel

Essay: Stadtleben am Place des Martyrs, Algier

Am frühen Morgen um fünf Uhr wird der Platz mit viel Wasser von den Arbeitern der Kommune gereinigt, die Möwen springen auf dem Platz hin und her. Die ersten, die sich am Kiosk versammeln, sind die Hafenarbeiter. Sie trinken einen Espresso und plaudern miteinander. Im Laufe des Vormittags füllen sich die Sitzbänke langsam mit Frauen mit ihren Einkäufen vom Markt und Reisenden, die auf ihre Weiterreise warten. Die Platzbesucher wandern mit dem Schatten.

Nach der langen Siesta am späten Nachmittag wird der Platz von den Einwohnern der angrenzenden Viertel bevölkert: Rentner, Frauen, Kinder, die am Platz spielen sowie eine Gruppe jugendlicher Mädchen und Jungs. Die Mädchen mit und ohne Kopfverhüllung sitzen an der einen Ecke, die Jungs an der anderen: Sie machen auf sich aufmerksam, kommentieren sehr laut, was auf dem Platz und rundherum geschieht.

Djamel hatte gerade angefangen, Architektur zu studieren. Der Besuch des Place des Martyrs mit seinen Kumpeln war ein Ritual aus früherer Kinderzeit, als sie dort zusammen Ball spielten. Djamel bemerkte ein neues Gesicht in der Mädchengruppe. Er schaute das Mädchen intensiv an, die dies auch bemerkte. Das übliche Ritual des Blickaustauschs wurde durchgeführt, bis jeder ein Lächeln auf den Lippen hatte. Djamila spürte genauso wie Djamel die Schmetterlinge im Bauch. Die Kumpel von Djamel und die Freundinnen von Djamila hatten dies längst beobachtet und immer wieder mit Kichern kommentiert. Die beiden freuten sich jeden Nachmittag über ihr Wiedersehen am Platz und mussten die üblichen Kommentare ihrer Freundinnen und Freunde ertragen. Djamel sprach sie dann an der Bushaltestelle zur Uni an: „Bist Du zu Besuch?" „Nein", antwortete sie, „ich habe immer hier oben in der Kasbah gewohnt." Er: „Ich auch, aber ich habe Dich vorher nie gesehen." Sie: „Ich habe bis vor kurzem den Tschador getragen." Er: „Was für ein Glück, dass Du den nicht mehr trägst." Die Abendsonne und der Gesang von Moh „zina ja zina" verstärkten das Kribbeln im Bauch.

20 Jahre danach sitzen Djamila und Djamel am Platz. Sie sind nach Frankreich emigriert und sind nun hier mit ihren Kindern zu Besuch. Die Sonne geht unter. Er nimmt ihre Hand und gemeinsam beobachten sie den Sonnenuntergang, die Rentner am Kiosk, die spielenden Kinder am Platz, eine Gruppe kichernder Mädchen und eine Gruppe lauter Jungs. Einer der Jungs singt mit der Gitarre „zina ja zina". Djamila lehnt sich an Djamels Schulter und sagt: „Wie schön, wie früher." Er sagt: „Ja, ja, die Platanen sind auch älter geworden."

Essay: Urban Life at the Place des Martyrs, Algiers

At 5 am in the morning public workers use plenty of water to clean the plaza, which causes the seagulls there to take flight and circle back and forth. The first people to gather at the kiosk are the dock workers. They drink espresso and chat with each other. As the morning progresses, the benches fill with women on their way back from the market as well as tourists taking a short break from their travels. Visitors to the plaza move often in order to keep in the shade. After the long siesta in the late afternoon many residents from the surrounding area come to the plaza: pensioners, women, children, who play loudly there, and groups of young men and women. The young women, some of whom wear head scarves, sit at the far end, while the young men try to draw attention to themselves and talk loudly about the various things they see at the plaza and in the streets.

Djamel has just started studying architecture. Visiting the Place des Martyrs with his friends is a ritual he has been doing since his early childhood, when they used to play various ballgames. But now he sees a new face in the group of young women and checks it out intensively, which the woman in turn notices. The usual ritual of making eye contact is repeated until both of them have a smile on their faces. Both Djamila and Djamel feel the butterflies in their stomachs. Their friends also see what is going on and repeatedly laugh or giggle as they comment on the situa-

tion. The two young people look forward to seeing each other every afternoon but have to endure the typical comments their friends make. Djamel eventually talks to Djamila while waiting to take a bus to the university. "Are you just visiting here?" he asks. "No," she answers, "I've always lived here, up in the casbah". "I've never noticed you before," he says. "Until recently I always wore a chador," she replies. "How lucky I am that you no longer wear it," he says with a smile. The evening sun and Moh's song 'zina ja zina' make the butterflies move a little faster.

Twenty years later Djamila and Djamel are sitting on a bench at the plaza. They have both emigrated to France and are now visiting with their children. The sun is sinking lower in the sky. He takes her hand and together they observe the sunset, the pensioners at the kiosk, the children playing, a group of girls laughing and a bunch of boys being loud. One of the boys plays a guitar and sings 'zina ja zina'. She leans her head on his shoulder and says "How nice, just like it used to be." "Yes it is," he replies, "except that the plane trees have grown."

Essai : Vie urbaine à la Place des Martyrs, Alger

Tôt le matin, vers 5 heures, la place est nettoyée à grande eau par la main-d'œuvre de la commune. Les mouettes sautillent dans tous les sens. Les premiers à se retrouver au kiosque sont les ouvriers du port. Ils boivent un petit café, échangent quelques mots. Les bancs se remplissent tout au long de la matinée, des femmes qui ont fait leurs emplettes au marché ou des voyageurs qui attendent de poursuivre leur voyage. Les passants migre vers l'ombre

Après la longue sieste, en fin d'après-midi, la place se peuple d'habitants venus des quartiers avoisinants : retraités, femmes, enfants qui jouent sur la place, bandes de filles et de garçons. Les jeunes filles, certaines la tête couverte d'autres non, sont à l'autre bout ; les jeunes essaient d'attirer l'attention sur eux et commentent d'une voix forte tout ce qui se passe sur la place et alentours.

Djamel venait juste de commencer ses études d'architecture. Se rendre Place des Martyrs avec ses copains était un rituel depuis qu'il était tout petit. Là, tous ensemble, ils jouaient au ballon.

Djamel remarqua un nouveau visage parmi les jeunes filles et le regarda avec insistance, ce que la jeune fille finit par relever aussi. Selon l'usage traditionnel, les regards s'échangent jusqu'à ce que chacun esquisse un sourire. Djamila, tout comme Djamel, fut prise d'un certain frisson. Les copains de Djamel et les amies de Djamila avaient tout observé depuis le début et n'ont pas manqué de faire des petits commentaires en ricanant.

Tous deux se réjouissaient de se revoir chaque après-midi sur la place, même s'il fallait endurer les commentaires habituels de leurs copains et copines.

À l'arrêt du bus, en direction de la fac, Djamel lui adressa la parole : « Tu es de passage ? » Elle répondit : « Non, j'ai toujours habité là-haut, à la Kasbah. ». Lui : « Moi aussi, mais je ne t'avais jamais vue avant. » Elle : « Il n'y a pas longtemps encore, je portais le voile. ». Lui : « Quelle chance que tu ne le portes plus. » Le soleil vespéral et le chant de Moh « Zina ya Zina » renforcèrent la sensation de douce incertitude.

20 ans plus tard, Djamila et Djamel sont assis sur la place. Jadis, ils ont émigré en France et sont là en visite avec leurs enfants. Le soleil se couche. Il prend sa main et tous les deux contemplent le crépuscule, les retraités près du kiosque, les enfants qui jouent, une bande de filles qui gloussent et de garçons qui piaillent. Un des garçons joue à la guitare en chantant « Zina ya Zina ». Djamila pose sa tête sur l'épaule de Djamel et dit : « Comme c'est beau, c'est comme avant. » Et lui : « Oui, et les platanes ont eux aussi vieilli. »

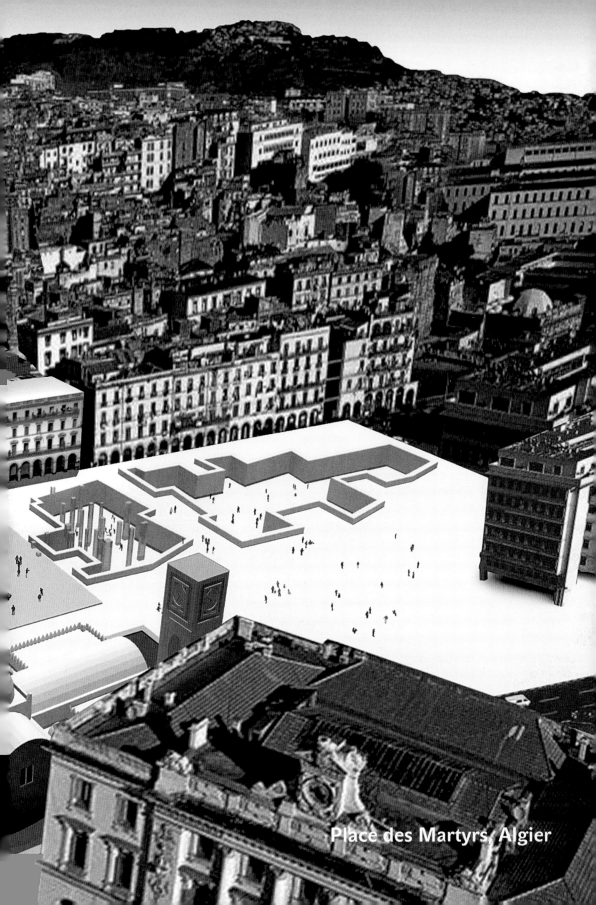

Place des Martyrs, Algier

ZWEI ORTE

Hannover – *Stadt des Wassers und der Parks*

Rathausplatz am Maschsee

Esch-sur-Alzette – *Stadt der Eisenerze*

Brillplatz

Am Beispiel des Trammplatzes vor dem Rathaus Hannover sowie dem Platz der fünf Kontinente (Brill-platz) in Esch-sur-Alzette dokumentieren wir nicht nur die Hintergründe und die Realisierung einer Platzgestaltung, sondern wir beziehen auch Position zur Diskussion um das Verhältnis von Landschafts-architektur, Landschaftskunst und Kunst im öffentlichen Raum.

Denn ein wesentlicher Aspekt zum Verständnis der Gestaltung dieser unterschiedlichen europäischen öffentlichen Plätze ist, dass sie – wenn auch mit einem modernen Konzept – Bezüge zu einer Tradition der Garten- und Landschaftskunst aufweisen, in der Parks, Landschaften, Gärten nicht als Panorama für andere Kunstobjekte definiert werden, sondern als Gesamtwerk. Dabei kann die Gestaltung der Außenräume zu einer Gartenkunst führen, die von kultureller Bedeutung für jede Gesellschaft ist. Die Plätze sollen sowohl als attraktive Stadtplätze für die benachteiligte internationale Bürgerschaft als auch zur Repräsentation dienen. Sie sind aber zugleich eine Hommage an „Landschaft" und die Inter-nationalität des Brill-Viertels sowie an das Projekt „Stadt als Garten" in Hannover.

In der Landschaftsgestaltung werden mit vegetativen und mineralischen Materialien Räume geschaf-fen. Diese können als Hintergründe gestaltet werden, die ihr Umfeld vorteilhaft in Szene setzen und Funktionalität garantieren; ihre Gestaltung kann aber genauso einen eigenständigen Charakter zeigen. Durch die Gebundenheit an natürliche und kulturelle Gegebenheiten lassen sich Freiräume jedoch kaum unabhängig von ihrem Umfeld, vom Kontext entwickeln. Unsere Arbeiten sind jeweils städtebau-lich, von der räumlichen Komposition sowie von der regionalen Geschichte geprägt. Sie lassen sich nicht aus ihrem Kontext herauslösen. Alle Bestandteile einer Freianlage werden über den Entwurf zuei-nander und zu dem Ort, an dem sie entstehen, in Bezug gesetzt. Das Gesamte bildet den Raum und die Abfolgen von Impressionen. Dies gilt auch für die darin befindlichen Kunstobjekte. Bestehende Kunstwerke werden in eine neue Geometrie integriert und neue Kunstwerke im Kontext der Anlage oft selbst hinzugefügt. Garten und Landschaft werden in diesem Fall nicht als Panorama für dominante Werke anderer gestaltet, sondern sind als eigenständiges Werk zu verstehen, mit klarem Gestaltungs-anspruch, kultureller Bedeutung und als Ausdruck eines Zeitgeistes.

TWO LOCATIONS
Hanover – City of Water and Parks, Town Hall Square at Maschsee
Esch-sur-Alzette – City of Steel, Brillplatz

Using the examples of the Trammplatz in Hanover and the Platz der Fünf Kontinente (Plaza of the Five Continents) in Esch-sur-Alzette, we want to not only document the projects' backgrounds and construction but to also take a clear position with regard to the relationship between landscape architecture, landscape art and art in public space. In order to understand the design of these two different public European plazas it is important to understand that they – albeit using a modern concept – evince references of a tradition of garden and landscape art in which parks, landscapes and gardens are not defined merely as a panorama for other artworks but instead as a complete work. Their design with mineral and vegetative materials leads to garden art that can be of cultural significance for every society. The plazas should function both as attractive urban plazas for disadvantaged international citizens and as representative space. They are a tribute to "landscape" and to the internationality of the Brill district and to the "City as Garden" project in Hanover. In designing the landscape, vegetative and mineral materials are used to create space. This can be designed as a background that provides a positive setting for its surroundings and guaranties functionality, or the design of the space can also have its own independent character. Due to their relationships with the natural and cultural circumstances of its environment, however, open space can rarely be developed independently of its surroundings or context.

Both of our projects are influenced by the cities in which they are located, as well as by the spatial composition and regional history. They cannot be detached from their particular contexts. Through design, all the components of an open space are put into relation to one another and to the place where they are created; indeed it is this entirety that creates the space and the sequence of impressions. This also applies to the artworks contained within the design. Existing works of art are integrated into a new geometry while new works are often added within the context of the system itself. As such, garden and landscape are not designed as a background for the dominant works of others, but should instead be understood as an independent product, with their own clear design standard, cultural significance and expression of a particular zeitgeist.

DEUX LIEUX
Hanovre – ville de l'eau et des parcs, place de la Mairie au Maschsee
Esch-sur-Alzette – ville du fer, place de Brill

La Trammplatz à Hanovre et la place des Cinq continents (place de Brill) à Esch-sur-Alzette sont non seulement deux exemples qui illustrent le processus de conception et de réalisation, mais sont aussi des prises de position dans le débat sur les liens entre architecture du paysage, art du paysage et art dans l'espace public.

Car pour comprendre l'aménagement de ces deux différentes places publiques européennes, il est important de bien voir que celui-ci – même s'il suit un précepte contemporain – fait le lien avec la tradition de l'art des jardins et des paysages selon lequel les parcs, les paysages et les jardins ne réduisent pas à de simples coulisses pour d'autres objets d'art, mais forment avec eux une œuvre complète. L'aménagement, avec ses matériaux minéraux et végétaux, aboutit à un art paysager susceptible d'être culturellement pertinent pour toute société. Les places doivent jouer un double rôle : être des lieux urbains intéressants pour les citoyens immigrés défavorisés tout en assurant leur fonction représentative. Elles sont aussi un hommage au « paysage », un clin d'œil au caractère international du quartier de Brill ou au projet « la ville comme jardin » de Hanovre.

Les matériaux végétaux et minéraux servent dans l'aménagement du paysage à créer des espaces. Ils peuvent être en retrait pour mettre leur environnement en valeur et en faciliter l'ergonomie ou revêtir un caractère propre. Mais par les liens qu'ils entretiennent aux contraintes naturelles et culturelles de leur milieu, les espaces ne sauraient voir le jour hors de leur contexte. Nos travaux s'entendent comme des constructions urbaines tant marquées par la composition spatiale que l'histoire régionale. Ils ne sauraient être extraits de leur contexte. Dans la phase de projet, nous cherchons à lier tous les éléments entre eux ainsi qu'au lieu de leur implantation ; c'est l'ensemble qui forme l'espace et les suites d'impressions. Cette remarque vaut aussi pour les objets d'art qui s'y trouvent intégrés. Les œuvres d'art déjà présentes sont insérées dans une nouvelle géométrie et de nouvelles œuvres s'intégrant dans le contexte s'y ajoutent. Jardin et paysage ne sont pas aménagés pour servir de coulisse à des œuvres dominantes ; il faut bien plus y voir une œuvre indépendante répondant à ses propres contraintes, ayant sa propre portée culturelle et constituant une expression de l'esprit du temps.

ART IN CONTEXT

TRANSFORMATI

DEUTUN

PERSPEKTIV
WECHSEL

DISPOSITION U

RÄUMLIC

GEOMETRIE

KONSTRUKTION

DISPOSITION

INTERVENTIONEN

ORIENTIERUNGS-
PUNKTE

S PROZESS

HNITT VON PFLANZEN IM RAUM

FARBEN

BLICKFÄNGE

MENTE

KUNST IM KONTEXT

Klanginstallation auf der EXPO 2000, Kamel Louafi

Vogelskulptur Albatros im Bocage-Park Bremen, Kamel Louafi

Freiräume können schön und voller Poesie sein. Manchmal vermögen sie, die Perspektive von der alltäglichen Bezogenheit auf das Poetische, das Spielerische, auf Ideen oder das Transzendentale zu lenken, Raum dafür zu bieten.

Besondere Orte und das Besondere im Ort, ansprechende Atmosphären und Raumerfahrungen sind Gegenstand ständigen Bestrebens, ein Ziel, um das man sich in der Gestaltung bemühen kann.

In diese Orte lassen sich bildnerische Werke anderer sinnfällig integrieren; Skulpturen in Parks, Gärten und Plätzen haben eine lange Tradition. Genauso gut können aber – über das Arrangement hinausgehend – unter Verwendung gestalterischer Prinzipien und Techniken durch Modellieren, Schneiden, Bildgestaltung, Inhalte eigene Setzungen im Raum erfolgen.

Aufgrund der Funktions- und Nutzerbezogenheit von Landschaftsarchitektur und -kunst wirkt diese meist eher affirmativ; die in Kunst gegebenenfalls transportierten gesellschaftskritischen Aussagen, feine Ironie oder Provokation sind in der Freiraumgestaltung zwar denkbar, aber nicht das treibende Moment. Dieses ist das stimmige Gesamtensemble des zu gestaltenden Lebens- und Bewegungsraums, für den gestalterische Aussagen zu treffen sind. Es geht um Transformationen im Raum als Ergebnis eines kreativen Prozesses, inspiriert durch natürliche Phänomene. Hierbei erfolgt die Auseinandersetzung mit Themen wie Zeit und Raum, Vergänglichkeit, Wachstum, Natur/Kultur, Pflanzen, Farbe, Raumwirkung, Wahrnehmung, aber auch zum Beispiel mit geschichtlichen Spuren, Ideen und sozialer Relevanz. Assoziieren lassen sich auch Wandel, Umformen, Verändern, Prozess, Material, Licht, Beobachtung, Pause, Witterung, Tiere, Lebendigkeit, Wind, Wasser, Töne, Düfte, Geschmack, Aufenthalt, Draußen-Sein, Begegnung, Spiel, Aneignung, Funktionslosigkeit, Nutzen, Verbindungen …

Keines dieser Werke entsteht und existiert kontextlos, quasi frei in Raum und Zeit oder losgelöst von gesellschaftlicher Prägung. Die räumliche und natürliche Gebundenheit der Freiräume und der an sie gestellten Aufgaben machen den Kontext zu einem Wesenszug ihrer Gestaltung. Er ist Material in und mit dem gearbeitet wird und das mit Interventionen transformiert wird – gerne zu etwas Schönem.

In diesem Prozess vermag ein Kunstwerk zu entstehen. Ob denn ein solches Werk als Kunstwerk erfahren wird, entscheidet sich letztlich in der Wahrnehmung der Betrachter.

Dörte Eggert-Heerdegen

Die Erosion und die Dünenformationen sind neben der Vegetationsentwicklung die wichtigsten gestalterisch oder bildhauerisch anmutenden Arbeiten der Natur. Sie führen zu natürlich geformten Produkten von oft unvergleichlicher Schönheit, in der Betrachtung nicht funktional, entstanden in einem transformativen Prozess. Diese Transformationen sind Leitmotiv und Inspiration für unsere Installationen, Raumgestaltungen, Bauten und Skulpturen. Unsere künstlerischen Absichten sind bereits im Konzept Bestandteil der Parks, Plätze und Gärten. Die entwickelten Objekte, Räume, bildhauerischen Arbeiten sind komplementär innerhalb des Entwurfsgerüsts der Freiräume. Sie sind Teil des Gesamtensembles und unserer Interpretation der Geschichte, des Ortes, der Vision, sie sind Teil der Landschaft.

Art in Context

Open space can be beautiful and full of poetry. Sometimes it may be able to draw one's attention from an everyday perspective to the poetic, the playful, to ideas or the transcendental; for this it provides space..

Special places and the specialness of a place, appealing atmospheres and impressions of space are the subjects of an ongoing desire that one strives for in design.

The artistic Works of others can be integrated into these places in a sensible manner; sculptures in parks, gardens and squares have a long tradition. Through the use of creative principles and techniques such as grading, cutting, layout and content it is, however, also possible to go beyond mere arrangement and carry out one's own spatial interventions.

Due to the functionality and user-focus of landscape architecture and art, they often appear in an affirmative fashion; the socially critical statements, subtle irony or provocation sometimes transported in art are conceivable in open space design, but are not the driving forces.

Instead, design statements need to be made for the coherent ensemble of space for living and transition. It involves transformations in space that are the result of a creative process, inspired by natural phenomena. This also involves addressing the issues of time and space, transience, growth, nature/culture, plants, colour, spatial effect and perception, as well as considering, for example, historical traces, ideas and social relevance. Other factors may also be transition, transforming, change, process, material, light, observation, pause, weather, animals, vitality, wind, water, sounds, smells, tastes, being outside, encounters, games, adoption and acceptance, lack of function, benefits, connections ... None of these projects is created or exists without a context, i.e. is simply a part of space and time, or is free of societal influence. The spatial and natural integration of an open space and the tasks placed upon it make its context a major feature of its design. This is the material in and with which a space is developed, and which is transformed through intervention – hopefully into something beautiful.

This process may indeed lead to the creation of a work of art. But whether such a project is considered to be art is, in the end, really a question of the viewer's perception.

Dörte Eggert-Heerdegen

In addition to the development of vegetation, erosion and the dune formation are important sculpturally or design-related works of nature. They lead to naturally formed products that are often of incomparable beauty, appear to be non-functional, and are the result of transformative processes. These transformations serve as inspiration for our installations, spatial designs, structures, and sculptures. Right from the initial concept, our artistic intentions are elements of parks, plazas, and gardens. The objects, spaces, and sculptural works we develop are complementary within the open space design framework. They are part of the overall ensemble and represent our interpretation of history, the site, and the vision. They are part of the landscape.

L'art en contexte

Les friches peuvent être belles et pleines de poésie. Elles permettent parfois de détacher le regard du quotidien pour le déplacer vers un espace poétique et ludique, ouvert aux idées et à la transcendance. Les lieux particuliers et ce qu'il y a de particulier en un lieu, les ambiances et approches de l'espace font l'objet d'un effort constant – un but que l'aménagement doit chercher à atteindre.

Dans ces lieux, les œuvres d'art peuvent s'intégrer et avoir valeur de symbole : les sculptures dans les parcs et les jardins, ou sur les places, relèvent d'une longue tradition. Mais elles peuvent tout aussi bien être – au-delà de l'arrangement – le fruit de principes et techniques de création, comme le modelage, le façonnage ou la coupe, et, par leur teneur, mettre des accents dans l'espace.

Compte tenu de leur fonction et de leur caractère convivial, l'art des jardins et l'architecture paysagiste ont généralement quelque chose d'affirmatif ; les messages sociocritiques, dont l'art est souvent le vecteur, l'ironie délicate ou la provocation sont certes concevables dans l'aménagement des friches, mais n'en sont pas l'élément moteur. Celui-ci doit être l'harmonie d'ensemble de l'espace de vie et de mouvement à aménager, et pour lequel il convient de trouver des énoncés créatifs. Il s'agit de transformations de l'espace comme résultat d'un processus de création, inspiré par des phénomènes naturels. Et il faut se confronter ici à des thèmes comme temps et espace, fugacité, croissance, nature/culture, plantes, couleur, volumes, perception, tout en tenant compte aussi par exemple des traces historiques, des idées ou de l'impact social. On peut aussi y associer toutes les notions suivantes : transition, changement, processus, matériau, lumière, observation, pause, intempéries, animaux, animation, vent, eau, sons, odeurs, goût, séjour, être à l'extérieur, rencontre, jeu, appropriation, absence de fonctionnalité, utilisation, liens…

Aucune de ces œuvres naît et existe hors contexte, hors temps et espace, hors empreinte sociétale. Les friches s'inscrivent dans l'espace et la nature, et la mission qui leur incombe font du contexte un trait essentiel de leur aménagement. C'est le matériau dans et avec lequel il faut travailler, et que les interventions transforment – pour en faire éventuellement quelque chose de beau.

Ce processus peut donner naissance à une œuvre d'art. Mais c'est en fin de compte la perception de l'individu qui dit si l'ouvrage est vraiment œuvre d'art.

Dörte Eggert-Heerdegen

L'érosion, la formation des cordons dunaires, ainsi que la croissance végétale sont des créations de la nature semblables à des oeuvres d'art ou des sculptures. Ces phénomènes engendrent des formes naturelles d'une beauté souvent incomparable, qui résultent d'une métamorphose et paraissent ne pas avoir de fonction. Ces transformations sont l'inspiration qui guide nos installations, nos aménagements, nos constructions et nos sculptures. Dès la phase conceptuelle, notre intention artistique est partie constituante des parcs, des places et des jardins. Les objets, les espaces, les sculptures que nous développons sont complémentaires de la trame élaborée pour l'aménagement des espaces libres. Ces éléments sont partie intrinsèque d'un tout et de notre interprétation de l'histoire, du lieu, du dessein ; ils sont une des composantes du paysage.

DER ORT
Hannover, *Stadt als Garten*

Einige wenige Bilder sind exemplarisch für das Landschaftsbild Hannovers in der Vorstellung vieler Menschen: die Leine, der Maschsee, die Eilenriede und die Herrenhäuser Gärten, das Welfenschloss, die Nana von Niki-de-Saint-Phalle. Sie alle zeugen von der Bedeutung, die Garten und Landschaft in Hannover seit Langem haben. Die Stadt und ihr Umland gehören zu den am stärksten von Grünflächen geprägten Gegenden Deutschlands. Das Merkmal der „Stadt der Gärten" wird weiter entfaltet durch die Stadtentwicklungsprojekte „Die Stadt als Garten", „Gartenregion Hannover" und „Hannover schafft Platz", mit denen anlässlich der EXPO 2000 und daran anschließend zahlreiche Freianlagen realisiert oder verändert wurden – darunter die Allmende am Kronsberg und die Gärten der Weltausstellung.

„In seiner langen Geschichte hat sich der Garten in vielen Menschenkulturen als eine bestens geeignete Metapher bewährt, um die beiden skizzierten menschlichen Grundhaltungen der Natur gegenüber, die Distanz und die Zuwendung, harmonisch zusammenzuführen. Das Faszinierende am Garten ist seine Mischung von Vorstellung und Wirklichkeit. Er vermag Defizite zwischen Ideal und Wirklichkeit zu kompensieren, denen wir täglich in unserer Lebensumwelt ausgesetzt sind. Der Garten repräsentiert eine Natur, die vom Menschen nach seinen Vorstellungen, aber ohne Missachtung beeinflusst worden ist." [4] *Kaspar Klaffke*

THE LOCATION
Hanover, the City as a Garden

Most people think of a few well-known images when they think of the typical landscape in and around Hanover: the Leine River, the Maschsee (a large artificial lake in the centre of the city), the Eilenriede (a forest and park), the Herrenhausen Gardens, the Welfenschloss, and Niki de Saint Phalle's Nanas. They all testify to the importance that gardens and the landscape have had in Hanover over the centuries. The city and its surrounding landscape are among the greenest areas in all of Germany. The attribute 'The City of Gardens' has been reinforced through the urban development projects The City as Garden, the Garden Region Hanover, and Hanover Creates Space, with which, on the occasion of the Expo 2000 and afterwards, numerous open space projects were built or improved upon, including the Allmende am Kronsberg and the gardens at the World Exposition.

"In its long history, the garden in many human cultures has proven to be a highly appropriate metaphor for harmoniously bringing together the two basic human attitudes towards nature, i.e. distance and devotion. The fascinating thing about the garden is its mixture of imagination and reality. It is able to compensate for the deficits between an ideal world and the reality we face in our everyday environment. The garden represents a type of nature that is influenced, without contempt, by humans according to their ideas." *Kaspar Klaffke*
(For original source see German text [4])

4 Kaspar Klaffke: Gartendenken. In: *10 Jahre EXPO-Projekt „Stadt als Garten"*. Hannover 2010, S. 7

LE LIEU
Hanovre, la ville comme jardin

Quelques rares images symbolisent le paysage de Hanovre dans l'esprit des gens : la rivière Leine, le lac de Maschsee, les plaines humides d'Eilenriede et les jardins de Herrenhausen, le château des Welfes et les Nanas de Niki de Saint Phalle. Ces emblèmes témoignent de l'importance constante des jardins et du paysage dans la ville de Hanovre. La ville et sa périphérie font partie des régions les plus vertes d'Allemagne. Ce caractère de « ville des jardins » sera confirmé dans les projets d'urbanisme tels que « La ville – jardin », « Hanovre, région de jardins » et « Hanovre fait de la place », conçus dans le cadre de l'EXPO 2000. De nombreux espaces verts tels que l'Allmende (les communs) à Kronsberg et les jardins de l'exposition universelle ont également vu le jour ou ont été modifiés à cette occasion.

« Au cours de sa longue histoire, le jardin s'est révélé dans de nombreuses cultures comme une métaphore particulièrement bien appropriée pour conjuguer harmonieusement les deux attitudes instinctives de l'homme face à la nature : distance et attirance.
Ce qui fascine dans le jardin, c'est le mélange d'imaginaire et de réalité. Il est capable de compenser les failles entre idéal et réel auxquelles nous sommes quotidiennement confrontées dans notre environnement. Le jardin représente une nature que l'homme a façonnée de ses visions mais sans la mépriser ». Kaspar Klaffke
(Original référence voir texte allemand [4])

Stefan Schostok
Oberbürgermeister, Hannover

„Jedermann ist erlaubt sich [hier] eine veränderung zu machen."

Stellen wir uns einen Vogelflug über Hannover vor. Erstaunliche Wechsel grafischer Formen bietet Hannover aus dieser Perspektive.

Im Nordwesten folgt auf das mäandernde Band der Leine das große Rechteck des Barockgartens. Gefüllt mit strengen Linien und verspielten Ornamenten, dem Hell und Dunkel von Vegetation und Wegen, Licht und Schatten zwischen hohen Bäumen und kunstvollen Rabatten, glitzernden Wasserflächen und sprudelnden Fontänen. Im Süden fällt der Blick auf die elegante, sommerlich leicht anmutende Fassade des Schlosses. Aus bodennaher Sicht der Besucher treten nicht nur Blumen und Skulpturen in den Blick, auch die Tafel, die seit der zweiten Hälfte des 18. Jahrhunderts die Ordnung des Ortes erläutert: „Jedermann ist erlaubt sich im königlichen garten eine veränderung zu machen."

Schnurgerade durchzieht im Anschluss die Linie der Herrenhäuser Allee eine nahezu englische Parklandschaft, um nach gut drei Kilometern auf ein weiteres Viereck zu stoßen – den Trammplatz. Auch hier Ornamente im Spiel von Hell und Dunkel, umfriedetes Grün, sprühendes Wasser. Gelegen an der Nordseite einer sehr viel üppigeren Fassade, nicht eines Schlosses, sondern des Rathauses der Stadt. Übrigens wiederum in enger Nachbarschaft eines Landschaftsparks. Bodennah zeigen sich die Details des Platzes, sein gepflastertes Blumenmuster, sein sanft gewellter Boden, Schrägen und Treppen, die animieren, näher zu treten. Denn wenn es auch nicht geschrieben steht: „Jedermann ist erlaubt sich [hier] eine veränderung zu machen."

Zwei Orte also aus der Vogelperspektive, die sich ähneln und doch anders sind. Sie stammen aus ganz verschiedenen Zeiten, unterschiedliches Material ist verwendet, die zugehörigen Gebäude dienen ganz unterschiedlichen Zwecken. Was sie verbindet: ihr Flair; das Wohlgefühl, das sie in ihren Besucherinnen und Besuchern hervorrufen; die Begeisterung beim Betrachten.

Der Trammplatz bringt etwas von der Atmosphäre des Großen Barockgartens in die Innenstadt. Eine Aura, die hier vor dem Rathaus seit Jahren abwesend war, wenn es sie denn jemals gab: mit dem gewissen Etwas, das einen gern hier sein lässt; das einlädt, hier eine „veränderung zu machen". Eine „veränderung machen" – was für ein schöner Ausdruck, um zu umschreiben, was vielleicht die Qualität aller öffentlichen Räume bestimmen sollte, was ihre Existenz notwendig und das Streben nach guter Gestaltung unabdingbar macht. Eine „Veränderung" meint hier, durchatmen können, sich erholen, entspannen, neue Perspektiven gewinnen, gestärkt in den Alltag zurückkehren.

Möglich ist das auf dem Trammplatz seit dem Frühjahr 2015 – seit seiner eigenen Veränderung nach dem Entwurf von Kamel Louafi. Ursprünglich als akkurate Rasenfläche angelegt, repräsentativ auf die neue Rathausfassade und ihre imponierenden Proportionen ausgerichtet, war der Platz deutlich in die Jahre gekommen. In den 1970er-Jahren in strenger Geometrie durch Pflasterstreifen und quadratische Baumscheiben gegliedert, durch mächtige Hochbeete vom Friedrichswall und damit von der Innenstadt abgeschottet, wirkte er abweisend, fast wie ein ungeliebter ehemaliger Exerzierplatz.

Dabei wurde er durchaus begeistert genutzt: swingend zu Himmelfahrt, jubelnd beim Pokalgewinn der 96-Fußballer, ebenso nach Lena Meyer-Landruts Triumph im Eurovision Song Contest, international und musikalisch zu Geburtstagsparaden der englischen Queen, bei Festen der Kulturen oder Tagen der offenen Tür. Dass die danach jeweils wiederkehrende Leere und Tristesse der Vergangenheit angehören sollte, war sogar schon vor der Neueröffnung des Platzes zu sehen: Die letzten Elemente des Bauzauns standen noch, als die ersten Gäste bereits Treppenstufen und Beetmauern für Pausen in der Sonne nutzten.

Inzwischen ist dies ein gewohntes Bild. Und auch als Feier- und Versammlungsort hat der Platz seine Bewährungsproben bestanden.

Das hannoversche Rathaus ist ein offenes Haus. Bei aller spätwilhelminisch wirkenden Imposanz steht es Gästen und Einwohnerinnen und Einwohnern immer offen, für Besuche, für städtische Feiern und private Fotos, und – natürlich – für Kontakte zu Politik und Verwaltung.

Der neue Trammplatz mit seiner Offenheit zur Stadt, seinem Flair und seiner Gestalt passt bestens dazu. Er könnte eine Visitenkarte der Stadt werden. Das Motto kennen wir schon aus den Gärten: „Jedermann ist erlaubt sich [hier] eine veränderung zu machen."

Stefan Schostok, Mayor, Hanover
"Everyone is allowed to make a change [here]."

Just imagine what a bird sees while flying over Hannover. The city provides an amazing variety of graphic forms when seen from this perspective.

To the northwest, near the meandering River Leine, lies the large, rectangularly shaped baroque Herrenhausen Gardens. Sparkling water bodies and bubbling fountains are located between the garden's numerous straight lines and playful ornaments, its dark vegetation and lightly coloured paths, and its light and shadows between high trees and ornate borders. From the southern part of the garden, the view is of the elegant, airy façade of the castle. The ground-level view visitors have is not only of flowers and sculptures, but also of the information panels that have explained the garden's rules since the second half of the 18th century: "Everyone is allowed to make a change in the royal garden …".

Directly abutting the east side of the garden is Herrenhäuser Allee, which, in a perfectly straight line, crosses parkland designed in an English style. Moving along this line, an additional square is reached after nearly three kilometres. Visitors here will also find ornaments in an interplay of light and dark, clearly defined vegetative areas and sparkling water. All of this is located on the north side of a much more lavish façade, which is not that of a castle but rather that of the New City Hall. This is, incidentally, also located adjacent to a landscape park. Close to the ground, the details of the square become obvious; a paved floral pattern whose gently undulating surface, ramps and stairs invite us to have a closer look. And, even if it is not written, "Everyone is allowed to make a change here (as well)".

Two places seen from a bird's-eye view; both of which are similar and yet very different from one another. They are products of very different times, the material used to build them was also very different and the buildings associated with them serve very different purposes. And yet, they do have several things in common: Their flair, the feeling of well-being they evoke in visitors and the enthusiasm that is obvious in those who have the opportunity to look at them a bit more closely.

Trammplatz successfully brings some of the atmosphere of the large baroque garden into the city's centre. There is now an aura directly in front of City Hall that had been missing for years, if it had ever existed at all: There is a certain something here, a positive atmosphere that also invites people to make a "change".

Making a "change" – what an appropriate way to describe that which should perhaps determine the quality of all public space, that makes its existence necessary and the pursuit of good

design essential. In this context, "change" means being able to breathe and relax, to gain new perspectives in order to return to everyday life with renewed strength and energy. This has been possible at the Trammplatz since the spring of 2015 – since the plaza was transformed according to the plans of Kamel Louafi.

Originally built as a meticulously maintained lawn that served as a counterpart to the City Hall's façade and its imposing proportions, the plaza had gotten a bit "long in the tooth". In the 1970s new paving strips and square tree grates gave the plaza a strict geometry, and large planting beds separated it from the Friedrichswall and thus from the city centre. This made the plaza somewhat forbidding and unapproachable, and it felt almost like an unloved old parade ground. And yet it was still used with great enthusiasm: Listening to jazz on Assumption Day, jubilation after a Hannover 96 cup victory or Lena-Meyer Landrut's victory at the Eurovision Song Contest, internationally and musically during birthday parades for the English Queen and at the Festivals of Culture or Open House days.

There was a desire to make the recurring emptiness and dreariness after these events a thing of the past, and this was evident even before the plaza reopened: parts of the fence around the construction site were still standing when the first curious guests began to use the new stairs and planting bed walls as places to enjoy their coffee and lunch breaks in the sun.

This is now a common sight. And the plaza has also passed the acid test as a place for celebrations and large crowds.

Hannover's City Hall is open to everyone. Despite its imposing late-Wilhelminian style, it is always open to guests and residents for visits, for the city's celebrations as well as for private photos and, of course, in order to maintain contact with politicians and administrators.

With its openness to the city, it's flair and its design, the new Trammplatz is perfectly suited to this role, and may even become one of the city's landmarks. And because of the city's famous gardens we already know what the the motto will be: "Everyone is allowed to make a change [here]".

Stefan Schostok, Maire de Hanovre
« Que chacun puisse envisager [ici] un changement à sa guise. »

Imaginons Hanovre vu du ciel – ce qui frappe dans cette perspective aérienne, c'est l'alternance des formes graphiques.

Au nord-ouest, après les méandres de la Leine, apparaît le vaste rectangle du parc baroque avec ses lignes rigoureuses et ses ornements ludiques, le clair-obscur de la végétation et des allées, l'ombre et la lumière parmi les grands arbres et les parterres savamment fleuris, le scintillement des plans d'eau et le gargouillement des fontaines. Au sud, le regard se dirige vers l'élégante façade à l'allure légère et estivale du château. Vu d'en bas, à hauteur de visiteurs, ce ne sont pas seulement les fleurs et les sculptures qui captent le regard, mais également l'écriteau qui depuis la deuxième moitié du xviiie siècle indique le règlement : « Que chacun puisse envisager un changement à sa guise dans les jardins royaux… »

Le tracé rectiligne de la Herrenhäuser Allee traverse un paysage rappelant les parcs à l'anglaise et débouche, après quelque trois kilomètres, sur un autre grand carré : la Trammplatz. Ici aussi, des ornements dans un jeu de clair-obscur, une pelouse encadrée, des jets d'eau – côté nord d'une façade beaucoup plus luxuriante, non pas d'un château mais de la mairie de la ville, elle aussi d'ailleurs située à proximité d'un jardin paysager. Au sol se révèlent les détails de la place, son pavage avec motif floral, la légère ondulation, les déclivités et les marches qui invitent à s'approcher. Car, même si n'est marqué : « Que chacun puisse envisager [ici] un changement à sa guise… »

Deux endroits qui, vus d'en haut, se ressemblent malgré toutes leurs différences d'époque, de matériaux employés et de fonctions.

Ce qui les unit, c'est le caractère qu'ils dégagent, leur ambiance, le bien-être et l'enthousiasme qu'ils suscitent chez le visiteur.

La Trammplatz traduit quelque peu l'atmosphère du grand jardin baroque au centre-ville, une aura, qui ici, devant la mairie, a cruellement manqué pendant de longues années, si jamais elle a existé d'ailleurs – une ambiance invitant les gens à se retrouver, à eux-mêmes apporter leur « changement ».

Envisager un « changement » – quelle belle expression pour décrire ce qui devrait peut-être déterminer la qualité de tous les espaces publics, les rendre en quelque sorte indispensables, ce qui suppose un aménagement réussi.

Le « changement » signifie ici de pouvoir respirer profondément, se recréer, se détendre, de trouver de nouvelles perspectives, s'en retourner revigoré aux tâches du quotidien.

Depuis le printemps 2015, depuis la transformation d'après les plans de Kamel Louafi, c'est désormais possible sur la Trammplatz.

Conçue comme un carré régulier de gazon, orientée de manière représentative vers la nouvelle façade de la mairie et ses proportions imposantes, la place avait mal vieilli. Avec sa géométrie rigoureuse des années 1970, structurée par des bandes pavées et des tronçons d'arbres carrés, bordée par d'énormes plates-bandes surélevées l'isolant ainsi complètement du rempart du Friedrichswall et donc du centre-ville, cette place était inhospitalière, presque comme une vilaine place d'armes.

Et pourtant elle a connu ses moments de joie : le swing à l'occasion de l'Ascension, les cris enthousiastes lors de la coupe de football remportée par l'équipe du 96, mais aussi le triomphe de Lena Meyer-Landrut au Concours d'Eurovision de la chanson, l'ambiance internationale toute en musique à l'occasion des parades officielles pour l'anniversaire de la Reine d'Angleterre, les fêtes des cultures et de journées portes ouvertes.

Le vide et la tristesse qui ont suivi appartiennent désormais au passé, ce qui que l'on pouvait constater avant même l'inauguration de la nouvelle place : les derniers pans de grillage étaient encore là que les premiers visiteurs arrivaient déjà pour profiter du soleil sur les marches et les murets des plates-bandes. Entre-temps, l'image est devenue un classique. Et même en tant que lieu de fête et de rassemblement, la place a fait ses preuves.

La mairie de Hanovre affiche l'ouverture. Malgré son aspect imposant de l'époque wilhelminienne, elle accueille tous les visiteurs et citoyens : pour une visite, lors des cérémonies festives de la municipalité, pour des photos privées, et évidemment aussi pour effectuer des démarches politiques et administratives.

La nouvelle Trammplatz, ouverte sur la ville, par son caractère et son aspect particulier, s'y associe à merveille. Elle pourrait devenir la carte de visite de la ville. Avec cette fameuse devise qui rappelle évidemment celle des jardins : « Que chacun puisse envisager [ici] un changement à sa guise… »

TRAMMPLATZ
am Maschpark, Hannover

Der Trammplatz ist ein Rathausvorplatz. Er wurde als Versammlungs- und Veranstaltungsplatz zwischen dem Neuen Rathaus Hannover und dem Friedrichswall angelegt. Der Platz entstand bis 1913 im Zuge der Errichtung des Neuen Rathauses. Er war zunächst als Schmuckplatz konzipiert, der ehrenhofartig vom Neuen Rathaus, dem Museum August Kestner und dem Bauamt eingefasst war. Die Rasenflächen auf dem Platz waren gegliedert durch Großbäume, des Weiteren gab es einen breiten Mittelweg, Treppen und Terrassenmauern. Die geplante Verlängerung der Platzachse über die Friedrichstraße hinweg als direkter Zugang zur Innenstadt wurde nie realisiert. Erst 1917 wurde der Rathausvorplatz nach Heinrich Tramm (1891–1918 Stadtdirektor von Hannover) benannt. Im Rahmen der Ummantelung des Museums mit einer Glas-Beton-Rasterfassade wurde der Trammplatz 1960/61 als architektonischer Platz nach Entwürfen von E. Laage und A. Schmidt-Lorenz neu gestaltet. Der Platz wurde um rund einen Meter abgesenkt, mit Beeten und Wasserbecken asymmetriert und durch ein Hochbeet vom Cityring getrennt ausgeführt. Die Verknüpfung mit der Innenstadt wurde nun durch eine Unterführung hergestellt. Die Rasenflächen wurden durch orthogonal gegliederte Plattenflächen ersetzt.

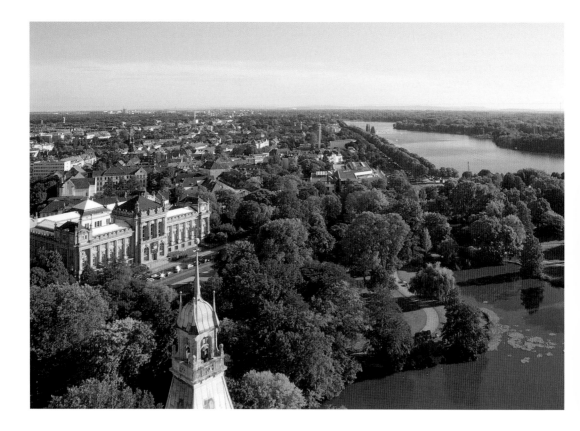

Trammplatz at Maschpark, Hanover

The Trammplatz is a plaza directly in front of the city hall. It was designed as a space for gatherings and events between Hanover's New City Hall and the thoroughfare Friedrichswall. The plaza was built in 1913 at the same time the city hall was constructed, and was initially a decorative plaza in the shape of a courtyard bordered by the New City Hall, the August Kestner Museum and a building used by the municipal building authorities. The plaza's lawn was dominated by large trees and there was also a broad central path, steps and terrace walls. The planned extension of the plaza's axis across Friedrichstraße as a direct entrance into the old part of the city never got beyond the planning stage. In 1917 the plaza was named after Heinrich Tramm, who was the municipal director of the city from 1891 to 1918. The plaza was redesigned according to a rigorous architectural design by E. Laage and A. Schmidt-Lorenz in 1960/61 in the course of the sheathing of the August Kestner museum with a grid-like glass and concrete façade. The plaza's surface was lowered approximately one metre, filled asymmetrically with planting beds and water basins and separated from the adjacent ring road by a raised planting bed. The lawn was replaced by orthogonal patterns of pavers and a connection to the inner city was provided by a tunnel.

Trammplatz à Maschpark, Hanovre

La Trammplatz est une esplanade de mairie. Elle a été conçue comme place de réunion et de manifestations entre le Neues Rathaus de Hanovre et le Friedrichswall. La place a vu le jour en 1913 lors de la construction du Neues Rathaus. Elle fut d'abord conçue comme place ornementale, sorte de cour d'honneur prise entre le Neues Rathaus, le Musée August Kestner et l'Office d'urbanisme. Les pelouses de la place étaient structurées par de grands arbres ; il y avait aussi un large chemin central, des escaliers et des murs de terrassement. Le prolongement initialement prévu de l'axe de la place au-delà de la Friedrichstrasse permettant un accès direct au centre-ville n'a jamais été réalisé. En 1917 seulement, l'esplanade de la mairie reçut le nom de Heinrich Tramm (maire de Hanovre de 1891 à 1918). Dans le cadre de travaux consistant à recouvrir le musée d'une façade en verre et béton, la Trammplatz fut réaménagée en 1960–1961 d'après les plans d'E. Laage et A. Schmidt-Lorenz. La place fut abaissée d'environ un mètre, agencée de manière asymétrique avec des plates-bandes et des jets d'eau et séparée du boulevard par des plates-bandes surélevées. La place se vit reliée au centre-ville par un simple tunnel. Les pelouses furent remplacées par des plaques de béton orthogonales.

Uwe Bodemann, Stadtbaurat, Hannover

Trammplatz, Hannover

Mehr als zehn Jahre nach der EXPO 2000 beschloss der Rat der Landeshauptstadt im Jahr 2011 ein Konzept, um die Innenstadt weiterzuentwickeln. Der Planungsprozess mit dem Titel Hannover City 2020+ wurde durch die Initiative Nationale Stadtentwicklung des damaligen Bundesministeriums für Bau und Stadtentwicklung gefördert und die interessierte Öffentlichkeit wurde in den Prozess stark einbezogen. Er startete im Jahr 2008 und wurde gegen Ende des Jahres 2010 abgeschlossen. Inhaltlich stehen seitdem für die Hannoversche Innenstadtentwicklung stadträumliche Präzisierungen, Verstärkungen der Wohnnutzung und Aufwertungen der öffentlichen Räume im Vordergrund.

Mittels eines mehrstufigen städtebaulichen Wettbewerbsverfahrens wurden unter diesen Gesichtspunkten für einige exemplarisch ausgewählte Bereiche der Innenstadt Entwicklungsperspektiven aufgezeigt. Einer dieser wichtigen Interventionsbereiche ist die südliche Altstadt mit dem Köbelinger Markt, dem Friedrichswall und der Umgebung des Neuen Rathauses. Durch Abriss eines Behördengebäudes wird sich am Köbelinger Markt in den nächsten Jahren die Gelegenheit ergeben, öffentliche Räume neu zu gliedern und in attraktiver Lage ein neues, gemischt genutztes Wohnquartier zu entwickeln, dabei bleibt der Köbelinger Markt erhalten. Auch wird durch die geplante Umnutzung eines alten Volkshochschulgebäudes und die Umgestaltung eines Hotels eine neue städtebauliche Verknüpfung über den Friedrichswall zwischen der südlichen Altstadt, dem Neuen Rathaus und dem südlich anschließendem Maschpark möglich. In diesem Zusammenhang wurde vorgeschlagen, den stadtseitigen Vorplatz des Neuen Rathauses, den Trammplatz, neu zu gestalten.

Ursprünglich war der Trammplatz ein gärtnerisch gestalteter grüner Schmuckplatz, der vor rund 100 Jahren mit Errichtung des Neuen Rathauses entstand. Seine Fläche entsprach früher exakt der Grundfläche des Neuen Rathauses und bot damit die stadträumlich angemessene Vorfläche vor dessen beeindruckender Kulisse. Die Gestaltung des Platzes war symmetrisch konzipiert und dem Zeitgeschmack gehorchend ausgestattet mit steinernen Schmuckbalustraden und Kandelabern, versehen mit terrassierten Rasenflächen, Formgehölzen, Schmuckpflanzungen und großen Bäumen. Ausgehend von der Haupttreppe des Rathauses schreitend, passierte man den leicht abgesenkten Platz und gelangte über einen zentralen Weg zur Promenade, welche parallel geführt zur damaligen Friedrichstraße verlief. Über eine Treppe ging es schließlich wieder zur Friedrichstraße hoch.

Durch Zerstörungen im Krieg und die Neukonzeption des Cityrings nach 1945 wurde der Platz substanziell verändert und seine ursprüngliche Ausdehnung durch den sechsspurigen Ausbau des Friedrichswalls beschnitten. Aus dem gärtnerischen Schmuckplatz der Entstehungszeit wurde in der Nachkriegszeit ein steinerner Platz. Zur Querung des Straßenraumes wurde ein Fußgängertunnel angelegt. Wuchtige Pflanztröge grenzten den Platz vom Friedrichswall ab. Kurz vor der Umgestaltung im Winter 2014/15 war sein baulicher Erhaltungszustand eines Rathausvorplatzes nicht mehr würdig.

Uwe Bodemann, Head of Building and Planning, Hanover
Hanover's Trammplatz

In 2011, more than 10 years after Expo 2000, Hanover's City Council chose a concept for the development of the city centre. The Hannover City 2020+ planning process was funded by the National Urban Development Initiative, which in turn was supported by the German Federal Ministry for Transport, Building and Urban Development. Interested members of the general public were actively involved in the process, which started in 2008 and ended in 2010. The focus of the initiative was to clarify Hannover's inner-city development objectives, reinforce residential use and improve public space.

A multi-stage urban design competition procedure was used to examine development prospects for several specific areas of the downtown area. One of these important areas of intervention was the southern part of the old city, including the Köblinger Market, the Friedrichswall and the area surrounding the New City Hall. Through the demolition of a building belonging to the public authorities, it became possible to reorganise the open space in the area surrounding the Köblinger Market and develop a mixed-use residential area in an attractive location. In doing so, it was decided that the market area would be preserved. The planned conversion of an old community college building and redesign of a hotel will also create a new urban connection via the Friedrichswall between southern areas of the old city, the New City Hall and the Maschpark further to the south. In this context, a proposal was introduced to redesign the Trammplatz, the urban plaza directly adjacent to the New City Hall.

The Trammplatz was originally a decorative ornamental plaza built at the same time the New City Hall was constructed a little more than 100 years ago. The plaza's size once corresponded exactly to the size of the New City Hall, thus providing an adequate urban forecourt in front of this impressive backdrop. The symmetrical design of the plaza was typical of the tastes of the day, with ornamental stone balustrades and candelabras, terraced lawns, topiaries, ornamental beds and large trees. Starting at the City Hall's main staircase, one walked across the slightly sunken plaza, reaching a central path to a promenade that ran parallel to Friedrichstraße as it existed at that time. A final staircase then led up to Friedrichstraße, which was higher than the plaza.

Due to destruction during World War II and the redesign of the city's ring road after 1945, the plaza was substantially changed and its original size reduced due to the six-lane expansion of the Friedrichswall. After the war an austere paved plaza replaced the original ornamental design. A tunnel was built for pedestrians, who had to then cross underneath the street in order to reach the other side. Massive planting troughs separated the plaza from the new Friedrichswall. Until the redesign of the plaza in the winter of 2014–2015, it was completely inadequate as the City Hall's public forecourt.

Uwe Bodemann, Directeur à l'urbanisme de Hanovre
La Trammplatz de Hanovre

En 2011, plus de dix ans après l'EXPO 2000, le conseil de la capitale du Land a voté un plan de réaménagement du centre-ville. La phase consultative intitulée « HannoverCity 2020+ » était portée par l'Initiative Nationale Stadtentwicklung (Initiative Nationale pour le Développement Urbain) du ministère fédéral la Construction et du Développement urbain, et le public intéressé y était largement associé. Cette étape a débuté en 2008 et s'est achevée fin 2010. Depuis, pour développer le centre-ville de Hanovre, le réaménagement de l'espace urbain a été placé en première ligne, tout particulièrement la promotion de l'habitat et la requalification des espaces publics.

Un concours à plusieurs volets organisé autour de la construction urbaine, et ciblé sur certains espaces emblématiques du centre-ville, a révélé le potentiel d'un développement futur. Un de ces quartiers visés est le sud de la vieille ville, avec notamment le Köbelinger Markt, le rempart Friedrichswall et les alentours du Neues Rathaus (nouvelle mairie). La destruction d'un bâtiment administratif permettra dans les prochaines années de réaménager les espaces publics à côté du Köbelinger Markt et, tout en le conservant, de créer dans cette partie agréable de la ville un nouveau quartier résidentiel à vocation multiple.

Le projet d'une réaffectation de l'ancienne Volkshochschule (Université populaire) et le réaménagement d'un hôtel vont créer, via le Friedrichswall, une nouvelle passerelle urbaine entre le sud de la vieille ville, le Neues Rathaus et le Maschpark au sud. C'est dans ce contexte que s'inscrit le projet de réaménagement de la Trammplatz, le parvis du Neues Rathaus côté ville.

À l'origine, la Trammplatz était une place d'agrément plantée, créée au moment de la construction du Neues Rathaus, il y a cent ans. D'un point de vue urbanistique, la surface, à l'origine identique à celle du Neues Rathaus, répondait parfaitement aux dimensions de cette scène impressionnante. La place, toute en symétrie et aménagée en fonction des critères à la mode de l'époque, avec des balustrades ornées en pierre et des réverbères, garnie de pelouses en terrasse, de bois sculptées, de plantes ornementales et de grands arbres. À partir des marches principales de la mairie, on passe sur la place légèrement abaissée, arrivant ainsi par l'allée centrale à la promenade, qui était alors parallèle à la Friedrichstraße. Par des escaliers, on retrouvait enfin la Friedrichstraße.

Avec la destruction pendant la guerre et la reconfiguration du Citiring (périphérique) après 1945, la place a subi des transformations d'envergure, son étendue initiale se trouvant ainsi circonscrite par l'élargissement à six voies du Friedrichswall. Ainsi la jolie place d'agrément d'origine est devenue une place toute en pierre. Pour traverser la chaussée, un passage piéton souterrain avait été construit. D'imposants bacs à fleurs séparaient la place elle-même du Friedrichswall. Peu avant sa requalification à l'hiver 2014–2015, son état de délabrement n'était plus digne du parvis d'une mairie municipale.

Stadtplanungsamt – Thomas Göbel-Groß
1. Prolog

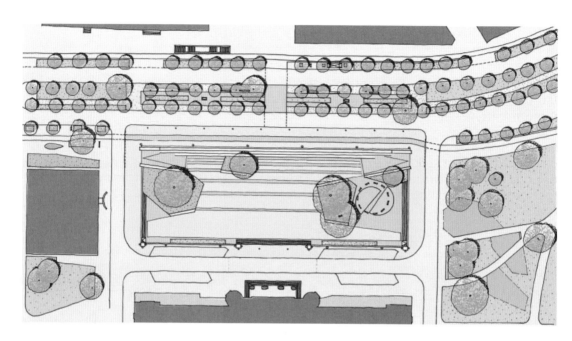

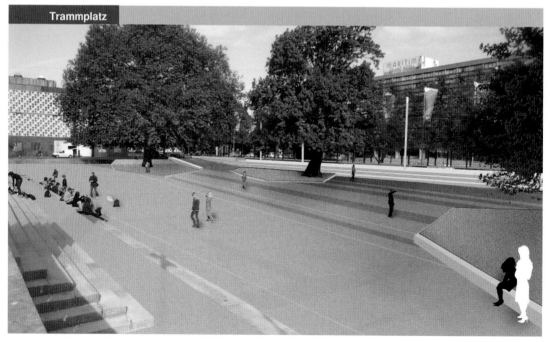

Vorentwurf: Stadtplanungsamt

1. Prolog

Innerhalb des Stadtplanungsamtes Hannover wurde ein Vorentwurf zur Umgestaltung des Tramm-platzes und seiner Umgebung von Thomas Göbel-Groß erarbeitet. Die wesentlichen Gestaltungsmerk-male dieses Vorentwurfs sind die Erhöhung des Platzes um 30 Zentimeter, die Entfernung des Tunnels, eine großzügige Landschaftstreppe am Friedrichswall, Plattenbänder und geometrische orthogonale Baumeinfassungen sowie die Beibehaltung der Geometrie der Ost-West- sowie der Rathaustreppe. Die Busspur am Friedrichswall soll entsiegelt und mit einem Rasenteppich und Bäumen versehen wer-den.

Preliminary Design: Urban Planning Department

1st Prologue

A preliminary design for the redesign of the Trammplatz and its environs was developed by Thomas Göbel-Groß at Hanover's Urban Planning Department. The major elements of this pre-liminary design were the raising of the plaza by about 30 cm, the removal of the tunnel, a gener-ous stairway at the Friedrichswall, bands of slabs and geometric orthogonal edging around the trees, as well as the preservation of the original geometry of the east-west and city hall steps. The paving of the bus lane at the Friedrichswall was to be removed and replaced with grass and trees.

Le projet de l'Office de planification urbaine

1er Prologue

L'Office de planification urbaine et Thomas Göbel-Groß ont élaboré un premier plan pour le réaménage-ment de la Trammplatz. Les spécifications essentielles en sont le rehaussement de la place de 30 cm, l'élimination du tunnel, des gradins le long du Friedrichswall, des plates-bandes, des tours d'arbres aux formes géométriques et angulaires, la conservation de l'orientation est-ouest ainsi que l'escalier de la mairie. La voie de bus le long du Friedrichswall devait être remplacée par un tapis de gazon bordé d'arbres.

Kamel Louafi
2. Prolog

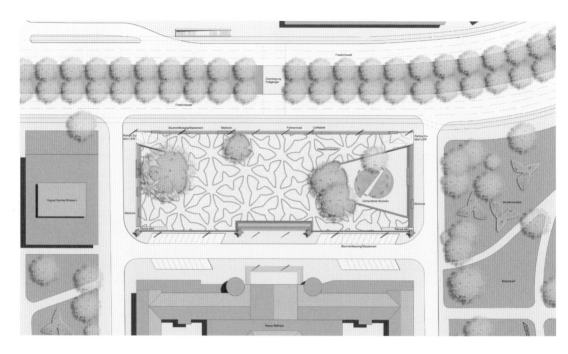

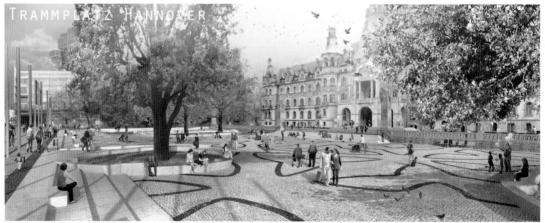

TRAMMPLATZ HANNOVER

Platzdesign: Platzidee
2. Prolog

Die Umgestaltung und das Design des Trammplatzes sollte aufgrund der erforderlichen Repräsentation mit einer unverwechselbaren Gestaltungsidee besetzt werden, die zugleich gegenüber dem Rathaus bestehen kann. Das Rathausgebäude, ein wilhelminischer Prachtbau im eklektizistischen Stil 1913 realisiert, ist heute eines der Wahrzeichen von Hannover. Viele Menschen halten es bis heute für ein Schloss. Das Neue Rathaus ist in den zehn Hektar großen Maschpark am Südrand der Innenstadt eingebettet, außerhalb des historischen Stadtkerns von Hannover. Die Südseite des Gebäudes ist dem Maschteich zugewandt und dient eher der Repräsentation. Diese zwei Elemente – der Prachtbau und der Park – definieren unser Leitmotiv. Mit der wilhelminischen Architektur kann die Gestaltung des Platzes kaum konkurrieren. Jedoch haben wir uns entschieden, den Trammplatz mit einer zeitgenössischen Interpretation von grünen Gestaltungselementen aus der Natur, mit einer floralen Signatur als Fortsetzung des Maschparks zu besetzen. Ziel des Gestaltungsvorschlags war es, ein adäquates, unverwechselbares Platzdesign zu entwickeln, unter Berücksichtigung aller bisherigen Planungen, welche die Erhöhung des Platzes um 30 Zentimeter, die Entfernung des Fußgängertunnels, eine Landschaftstreppe am Friedrichswall und die Beibehaltung der Geometrie der Ost-West- sowie der Rathaustreppe vorsehen.

Plaza Design: Plaza Idea
2nd Prologue

The redesign of the Trammplatz needed to be a unique concept due the plaza's function as a representative space, and it also had to be able to stand on its own with regard to the city hall. The city hall, a magnificent, eclectic Wilhelmine building designed in 1913, has become one of the city's most important landmarks. To many visitors it even appears to be a castle. The New City Hall is embedded in the 10-hectare Maschpark on the southern edge of the inner city, but is not part of the city's historic old centre. The south side of the building faces the Maschteich pond and has a mainly representational function. These two elements – the magnificent building and the park – have defined our leitmotif. The design of the plaza can hardly compete with the building's Wilhelmine architecture, and yet we decided that the Trammplatz should be a modern interpretation of green design elements, of nature, with a floral signature as a continuation of the Maschpark. The goal of the concept was to develop an appropriate and unique plaza design while taking into account the previous ideas of raising the plaza about 30 cm, removing the tunnel, a stairway at the Friedrichswall and preservation of the original geometry of the east-west and city hall steps.

Le projet: Idée de la place
2e Prologue

En raison de ses fonctions représentatives, le réaménagement et la conception de la Trammplatz devaient s'inscrire dans une idée unique compatible avec le bâtiment de la mairie. Cet édifice de l'époque wilhelminienne au style éclectique, érigé en 1913, est aujourd'hui le symbole de Hanovre. De nombreuses personnes croient encore aujourd'hui qu'il s'agit d'un château. Le Neues Rathaus est intégré dans le Maschpark, un parc de 10 hectares situé en bordure sud du centre-ville, en dehors du centre historique de Hanovre. La façade sud du bâtiment est tournée vers le Maschteich et remplit des fonctions représentatives. Ces deux éléments, le splendide édifice et le parc, seront notre leitmotiv. La nouvelle place réaménagée ne saurait concurrencer l'architecture wilhelminienne. Nous avons donc décidé de donner à la Trammplatz une interprétation contemporaine avec des éléments verts naturels et une signature florale en prolongement du Maschpark. L'objectif de cette proposition de réaménagement était de développer un concept adéquat et unique prenant en considération tous les projets précédents et prévoyant un rehaussement de la place de 30 cm, l'élimination du tunnel piéton, la mise en place de gradins, la conservation de l'orientation est-ouest ainsi que de l'escalier de la mairie.

STEINSKULPTUREN
auf dem Trammplatz vor dem Rathaus am Maschsee

STONE SCULPTURES
on the Town Hall Square Trammplatz at Maschsee

SCULPTURES DE PIERRES
à la place de la Mairie Trammplatz au Maschsee

ENTSTEHUNG DER IDEE
Die Kleeform als Pflasterornament und Steinskulptur

Das Stadtwappen Hannover und der Klee

Wie entsteht eine Gestaltungsidee für einen so exponierten Platz, vor einem Prachtbau, für einen Veranstaltungsort mit Repräsentationscharakter?

Aus einer „Lektüre" des Orts ergaben sich eine Fülle an Gestaltungsorientierungen: Der steinerne Trammplatz mit seinen Baumsolitären erscheint als Unterbrechung der Park-Umarmung des Rathauses durch den Maschpark. Die zum Park zugewandte Rathausseite fungiert als Repräsentationsseite, der Trammplatz selbst reflektiert keine eigene Identität. Ziel der Gestaltungsidee war es, den Maschpark durch gestalterische Elemente auf den Trammplatz fortzuführen, die Solitärbäume in die Platzgestaltung zu integrieren, den Platzcharakter zu betonen und somit unterschiedliche Veranstaltungen zu ermöglichen.

Ein Pflanzenmotiv innerhalb des hannoverschen Stadtwappens – der Klee – erschien uns als geeignetes Leitmotiv für die Entwicklung der Vorentwurfsidee. Das Thema Pflanzen/Klee sowie die geometrische Form als Leitthema für die Umsetzung der gestalterischen Idee des stilisierten Pflasterornaments verdeutlichen in erster Linie die Verbindung mit dem Maschparkensemble. Um die Bestandsbäume bilden Steinskulpturen aus Granitblöcken in Form eines abstrakten Kleeblatts eine dynamisch amorphe Bewegung als Sitzmöglichkeit. Die Baumeinfassungen deuten in ihrer Form und Bewegung eine bildhauerische Skulptur als Monolith an. So erhält der Platz komplementär zur Landschaftstreppe aus dem ersten Vorentwurf eine zeitgemäße Interpretation und betont durch den künstlerischen Ansatz mit der Silhouette des Klees die traditionelle Verbundenheit der Landeshauptstadt Hannover als „Stadt der Gärten" mit der Kulturlandschaft.

The Birth of the Idea:
The Cloverleaf as a Paving Feature and Stone Sculpture

How is a design concept developed for such an exposed and extroverted plaza, directly adjacent to an amazing building, a commonly used event space that has both a very urban and representative character?

"Reading" the site gave us a wealth of ideas with regard to the orientation and design of the plaza: The paved Trammplatz with its individual trees appeared to be an interruption of the Maschpark as it embraced the city hall. The side of the city hall facing the park functioned as a representative area while the Trammplatz didn't appear to have its own identity. Our design objective was therefore to extend Maschpark onto the Trammplatz through the use of design elements, to integrate the individual trees into the plaza's design, to emphasise the character of the site as a plaza, thus allowing for a variety of events to take place there. Hanover's coat of arms contains a cloverleaf, which we thought was well-suited to the design idea we were developing. The theme of plants/clover, as well as its geometric shape as a main part of our idea of a stylised paving ornament, makes it obvious that there is a direct link to Maschpark. Stone sculptures made of granite blocks placed around the existing trees in the shape of an abstract cloverleaf create a dynamically amorphous movement that also provides a place to sit. The shape and movement of the edging around the trees gives it the appearance of a sculptural monolith. The plaza has thus been given an element that is complementary to the stairs built as a part of the initial design, but which is nonetheless a contemporary interpretation. And through its artistic use of the silhouette of a cloverleaf, the design emphasises the traditional association the state capital Hanover, the "City of Gardens", has with the cultural landscape surrounding it.

Naissance de l'idée :
La feuille de trèfle comme motif pour le pavement et les sculptures de pierre

Comment un concept d'aménagement voit-il le jour pour une place aussi exposée, située devant un somptueux édifice, lieu de manifestation assumant à la fois le rôle d'une place publique et de représentation ?

Une « lecture » du lieu a livré une série d'idées : la Trammplatz en pierre avec ses arbres isolés semble interrompre la verdure du Maschpark qui embrasse la mairie. La façade de la mairie donnant sur le parc remplit une fonction représentative, la Tammplatz n'a en soi aucune identité propre. Le but de l'aménagement était, à l'aide d'éléments ornementaux, de prolonger le Maschpark sur la Trammplatz, d'intégrer les arbres isolés dans l'aménagement de la place, de souligner le caractère de place publique du lieu et d'en faire ainsi un espace apte à accueillir différentes manifestations. Un motif végétal présent dans les armoiries de la ville de Hanovre – le trèfle – nous a paru un bon leitmotiv lors du développement du concept. Le thème des plantes et du trèfle ainsi que sa forme géométrique qui a trouvé un réemploi dans l'agencement stylisé des pavés, traduit avant tout le lien avec le Marschpark. Autour des anciens arbres, des sculptures en forme d'une feuille de trèfle abstraite servent dans un dynamisme amorphe de bancs. Les tours des arbres rappellent par leur forme et leurs lignes une sculpture monolithique. Ajoutés aux gradins du premier projet, ils donnent à la place son caractère contemporain. Avec la forme du trèfle, on souligne également le lien traditionnel de Hanovre – ville de jardins –, aux parcs ornementaux.

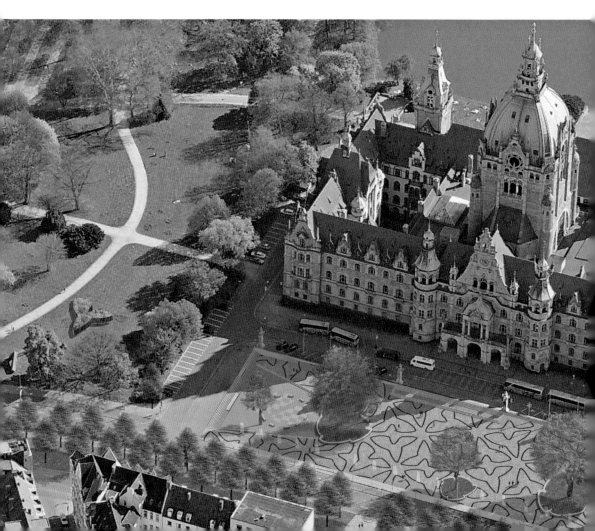

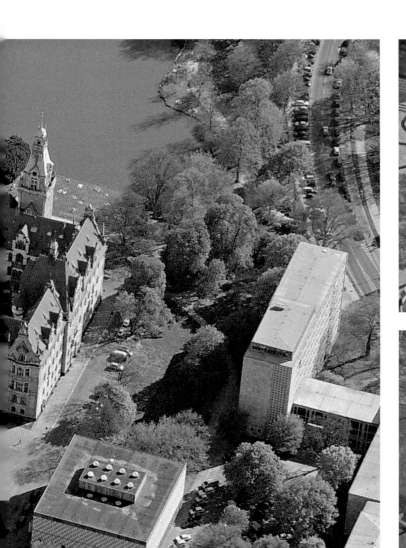
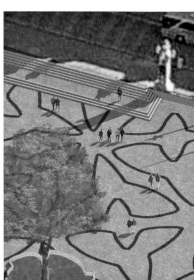

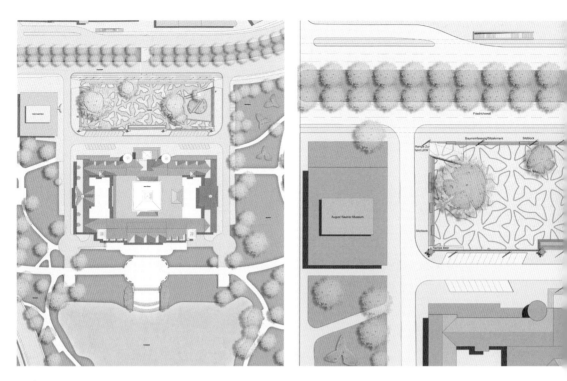

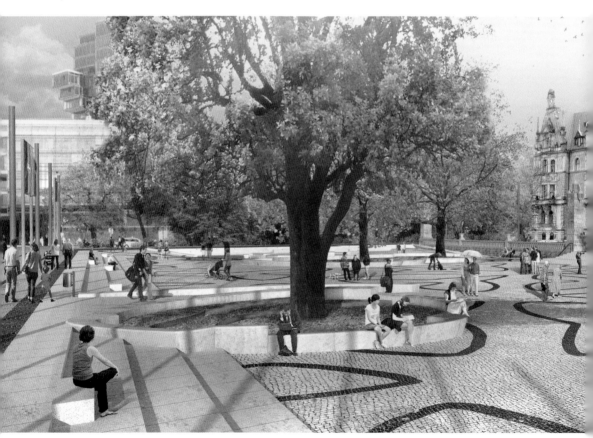

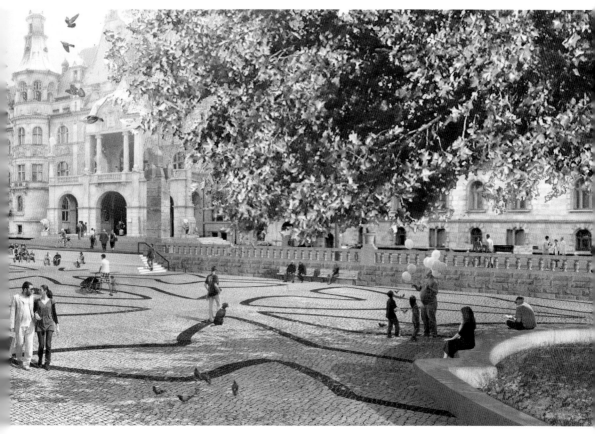

Essay: Stadtleben – Elfi am Trammplatz

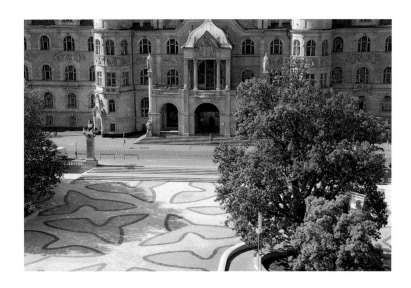

Elfi ist Rentnerin, 85 Jahre alt und hat 45 Jahre lang als Chefsekretärin im Obergeschoss des Rathauses mit Blick auf den Trammplatz gearbeitet. Sie hat den Trammplatz wie keine andere erlebt. Bei schönem Wetter hat sie gerne einen kleinen Spaziergang im angrenzenden Maschpark hinter dem Rathaus unternommen.

An diesem sonnigen Tag im Frühjahr ist sie auf dem Weg zur Ratskeller-Kantine, um sich auf einen kleinen Plausch mit ehemaligen Kollegen zum Mittagessen zu treffen. Heute sieht sie die neue Umgestaltung des Platzes zum ersten Mal. Sie hatte das Geschehen in der Presse verfolgt. Jetzt steht sie am August-Kestner-Museum und schaut auf den Platz. „Elfi!", ruft Georg, auch ein Rentner der Stadtverwaltung. „Na, was sagst Du zur neuen Kleidung des Platzes?" Sie lächelt und sagt: „Immerhin sind die Bäume noch gut erhalten, die sind ja älter als wir. Sie sehen schön aus und werden respektvoll umarmt von den Steinskulpturen." Georg sagt: „Auf dem Platz sind jetzt viel mehr Menschen als früher." „Georg", sagt Elfi, „lass uns den Platz von Nahem begutachten." Sie setzen sich kurz auf die Baumeinfassung, dann auf die Holzbänke, laufen zu allen Seiten und prüfen und begutachten mit dem Fuß die glatte, ebenflächig gesägte Pflasterfläche für Kinderwägen und Rollatoren. Anschließend gehen sie in die Kantine und treffen dort ehemalige Kollegen, plaudern und essen gemeinsam. Nach dem Essen sagt Elfi: „Lasst uns zum ‚Blütenplatz' gehen, solange die Sonne noch scheint." Georg sagt zu den anderen: „Das Pflaster und die Baumeinfassungen sollen die Blätter einer Pflanze darstellen …" Elfi sagt laut: „Ein Klee, der Klee, mein Lieber, aus unserem Stadtwappen."

Essay: Urban Life – Elfi at the Trammplatz

Elfi is a pensioner, and 85 years old. For 45 years she worked as an executive secretary on the top floor of city hall, where she had a view of the Trammplatz. She experienced this plaza in a way that no one else has. When the weather was nice she often went for a short walk in nearby Maschpark, just behind city hall.

On this sunny spring day in 2015 she is on her was to the canteen in the Ratskeller, where she will have lunch and a chat with some of her old colleagues. While walking she sees the new design of the plaza for the first time. She had followed its progress in the newspaper, and now she stands at the August Kestner Museum and looks out over it.

"Elfi!" cries Georg, who is also retired from the city administration. "Well, what do you think of the plaza's new clothes?" She smiles and says "At least they've taken good care of the trees, they're older than we are! They look beautiful and are being respectfully embraced by the stone sculptures". Georg says "Seems like a lot more people are using the plaza than before". "Georg," says Elfi, "Lets take a closer look at everything". They sit for short while on the sculptural benches surrounding the trees, move on to the wooden benches, then walk all around the plaza before closely examining the cut stone slabs for the rollators with their feet. Finally they head to the canteen to meet their colleagues for lunch and a good chat. After the meal Elfi says "Lets go sit at the 'flower' plaza and enjoy the sun while we can…". Georg adds "The paving pattern and the concrete benches surrounding the trees are supposed to symbolise a plant's leaves." And then in a loud voice Elfi says "A clover leaf! A clover leaf is my favourite part of the city's coat of arms."

Essai : Vie urbaine – Elfi à Trammplatz

Elfi est retraitée, elle a 85 ans. Pendant 45 ans, elle a travaillé comme secrétaire de direction à l'étage supérieur de la mairie, avec vue sur la Trammplatz. Cette place, elle la connaît mieux que quiconque. Quand il faisait beau, elle aimait bien faire une petite balade dans le Maschpark attenant, derrière la mairie.

En cette belle journée du printemps 2015, elle est en route pour le Ratskeller où elle va déjeuner et échanger avec d'anciens collègues. Aujourd'hui, pour la première fois, elle voit la place réaménagée. Elle avait suivi le projet dans la presse. La voilà près du musée August Kestner à contempler la place.

« Elfi ! », appelle Georg, lui aussi retraité de l'administration municipale, « que dis-tu de la place et de ses nouveaux atours ? » Elle sourit et dit : « Au moins, les arbres sont encore bien conservés. Ils sont plus vieux que nous. Ils sont beaux et dignes, avec les formes en pierre tout autour. » Georg répond : « Sur la place, il y a maintenant beaucoup plus de monde qu'avant. » Et Elfi de poursuivre : « Georg, allons donc la voir de plus près. » Ils s'assoient brièvement sur le muret autour d'un arbre, puis sur un des bancs en bois, ils marchent dans tous les sens, examinent du pied et commentent les plaques fendues pour les caddies. Puis ils finissent par se rendre à leur cantine où ils retrouvent leurs anciens collègues et déjeunent tous ensemble en bavardant. À la fin du repas, Elfi propose : « Allons faire un saut sur la "place aux fleurs" tant que le soleil brille encore… » Georg dit aux autres : « Les pavés et les murets autour des arbres forment les feuilles d'une plante… » Et Elfi d'ajouter : « C'est un trèfle, mon cher, le trèfle des armoiries de la ville. »

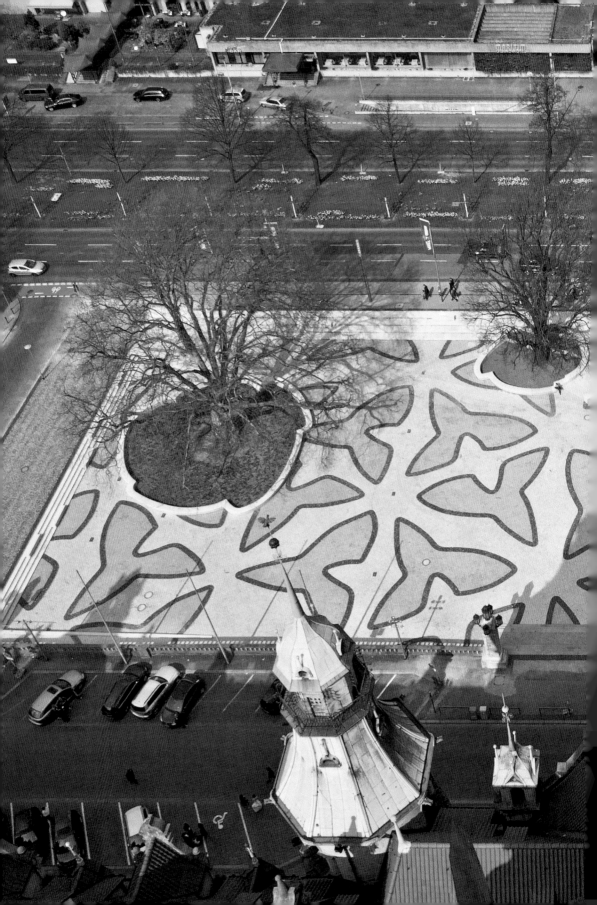

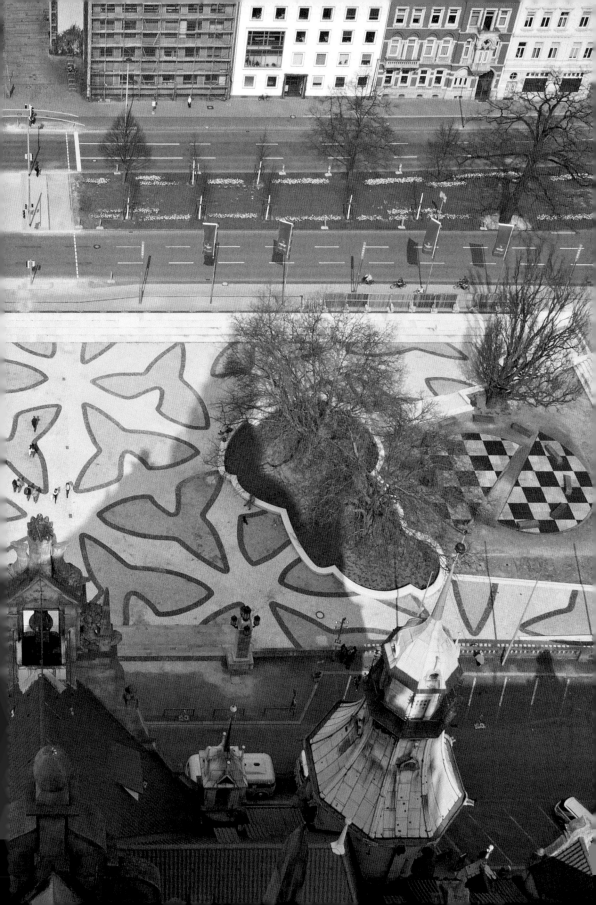

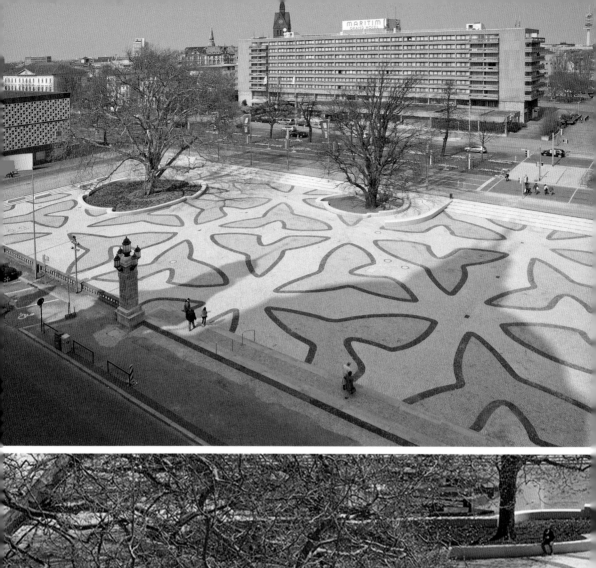
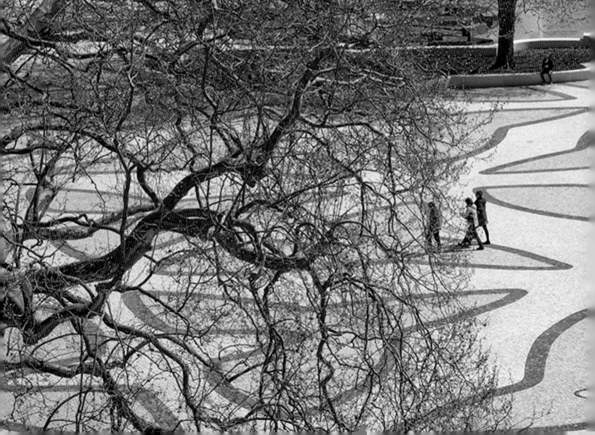

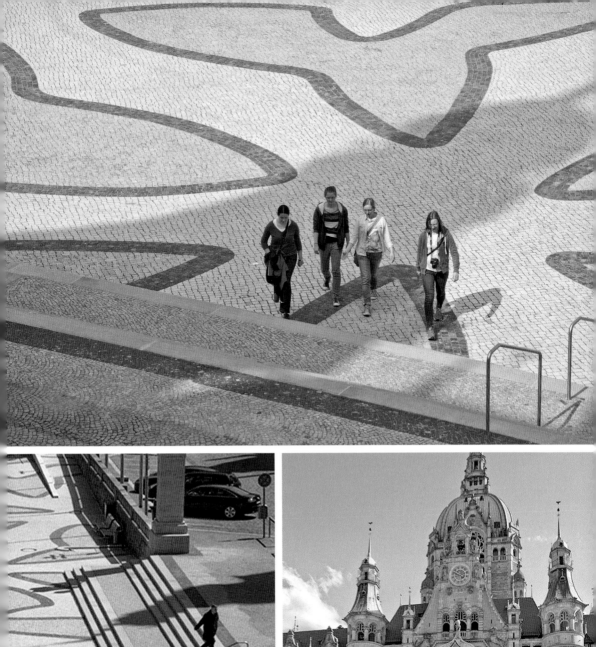
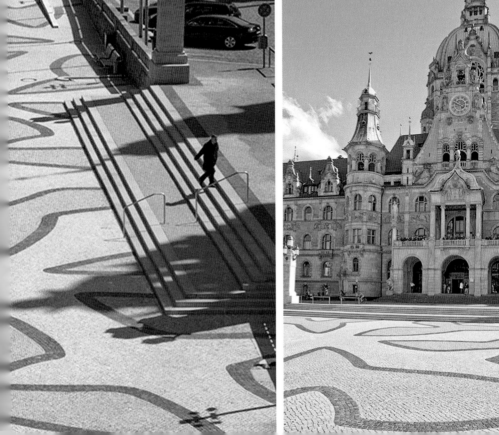

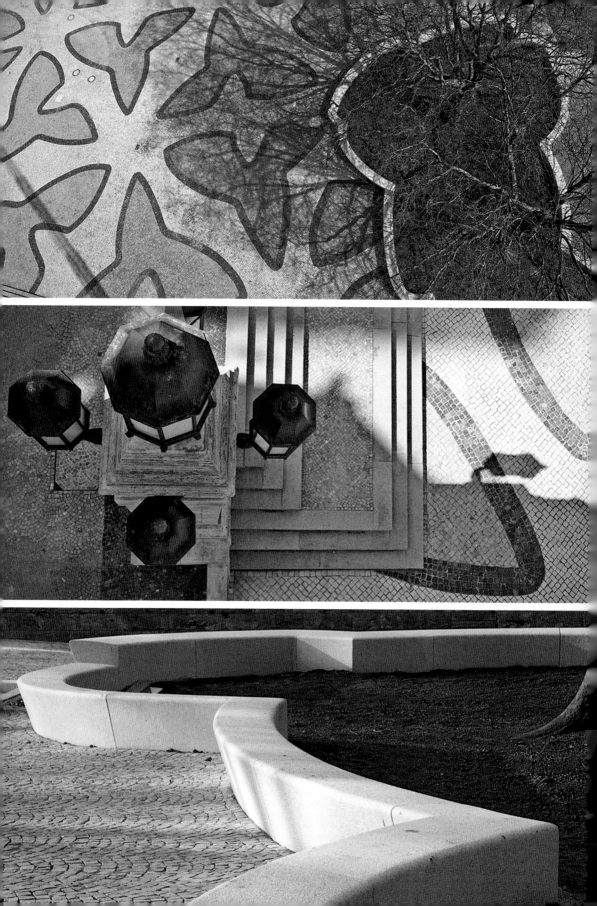

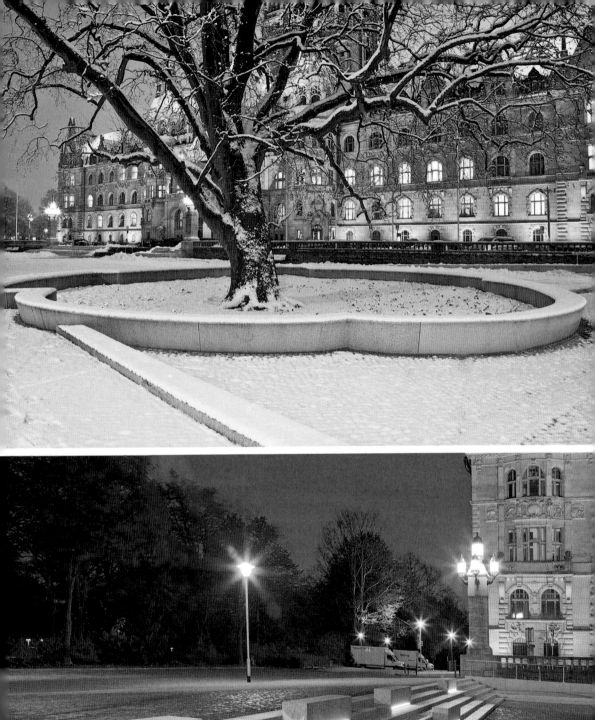
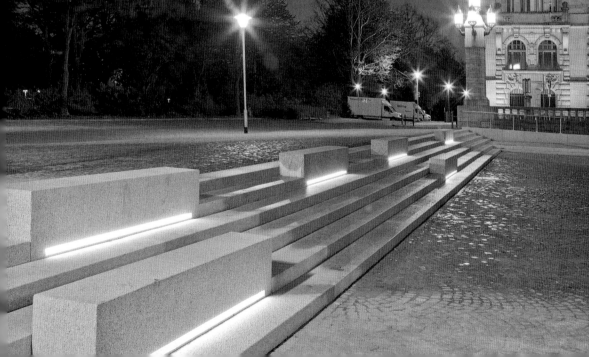

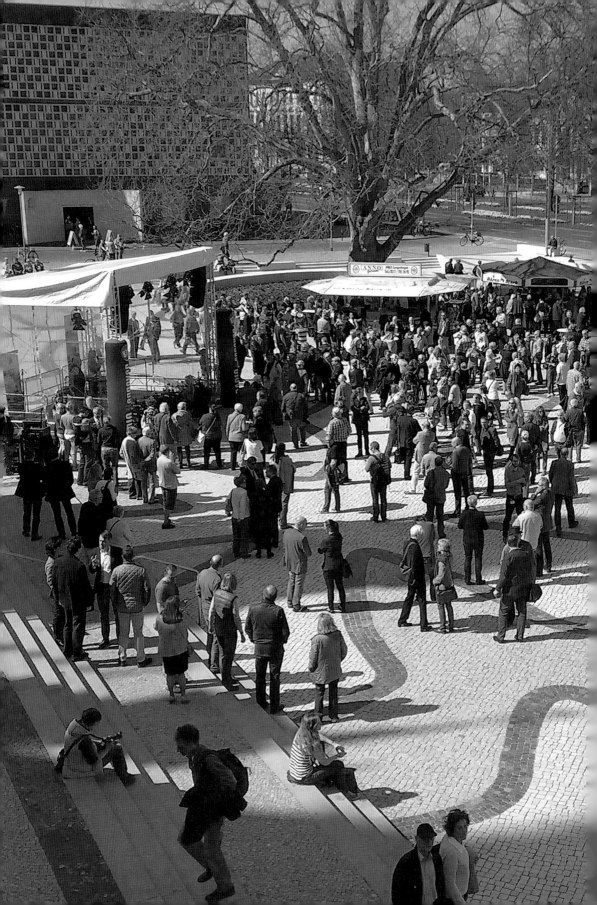

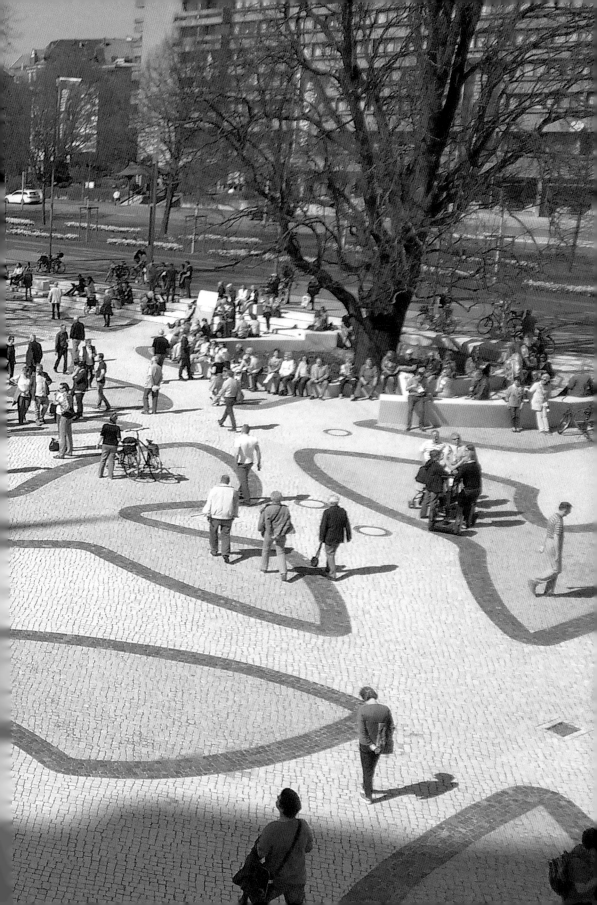

DER ORT

Esch-zur-Alzette, *Stadt der Eisenerze*

Hochöfen und rote Erde prägten lange Zeit Esch-sur-Alzette und seine Umgebung. Die zweitgrößte Stadt des Großherzogtums Luxemburg liegt unmittelbar an der Grenze zu Frankreich im flacheren Landesteil. Mit dem Fund von Eisenerzen begann im 19. Jahrhundert der Aufstieg von Esch zu einer Stahlstadt, die viele Immigranten anzog. Die Eisenerzgewinnung und Stahlproduktion bestimmten bis zur Stahlkrise in der zweiten Hälfte des 20. Jahrhunderts das Stadt- und Landschaftsbild. Nach der Schließung vieler Bergwerke und Hütten begann dann die Umstrukturierung der Region mit Betonung von Dienstleistungen, Kultur, Bildung und Wissenschaften. Mitte der 1980er-Jahre begann man mit der Instandsetzung des Stadtkerns und die Abwanderungstendenzen stoppten. Beim Umbau und bei der Sanierung von Esch-sur-Alzette spielten stadt- und landschaftsplanerische Festsetzungen und die Umgestaltung des öffentlichen Raumes eine wesentliche Rolle, insbesondere Stadtplätze und Straßenräume wurden transformiert. Transformation und Modernisierung waren Ziel der Stadt Esch. Das ehemalige Zechengelände am Rande der Stadt wurde umgebaut zum Gelände der Universität de Belval; die Luxemburger Fakultäten wurden hier angesiedelt. Esch-sur-Alzette unterliegt einem gravierenden Strukturwandel.

Esch-sur-Alzette erfuhr seit den 1870er-Jahren mit der Industrialisierung eine rasante städtebauliche Entwicklung vom Dorf zur Kleinstadt mit ca. 30.000 Einwohnern, die viele Immigranten anzog. Mit der luxemburgischen Stahlkrise 1975–1984 endete jedoch die Stahlproduktion in Esch-sur-Alzette.

Der öffentliche Raum prägt das städtische Antlitz, er ist mitentscheidend für die Aufenthaltsqualität und damit dafür, ob Menschen in der Stadt bleiben oder gar hinzuziehen. Was aber macht funktionierende öffentliche Räume aus, was macht Stadtplätze attraktiv? Und welche Impulse braucht die Stadt Esch?

THE LOCATION
Esch-sur-Alzette, City of Steel

For a long time Esch-sur-Alzette and its environs were dominated by blast ovens and red earth. The Grand Duchy of Luxembourg's second largest city is situated in a relatively flat part of the country close to the French border. The discovery of iron ore led to the city's transformation into a steel city in the 19th century, which in turn attracted many immigrants. Iron ore mining and steel production then defined the the image of the city and its landscape until the steel industry crisis during the second half of the 20th century. Restructuring of the region began after the closure of many mines and steel factories, with an emphasis put on services, culture, education and science. In the mid-1980s restoration efforts began in the city centre and the continuous exodus of inhabitants from the city ended. During the rebuilding and renovation of Esch-sur-Alzette urban and landscape planning strategies and the redesign of public space has

played a key role, and many urban plazas and streets have been transformed. Transformation and modernisation were the city's objectives. The former mining area on the city's periphery has been converted into the University of Luxembourg's Belval campus, where various faculties from around Luxembourg have been relocated. Esch-sur-Alzette is experiencing a major structural change.

The transition of Esch-sur-Alzette from a village to a city of 30,000 inhabitants began in the 1870s as industrialisation brought about rapid urban development. The production of steel in the city, however, ended as a result of the steel industry's crisis between 1975 and 1984.
Public open space greatly influences the image a city has; it plays a crucial role in the quality of life and thus in the decisions people make about whether to stay or even move there from somewhere else. But what does functioning public open space actually consist of, and what makes urban plazas and squares attractive? And what kind of impetus does Esch need?

LE LIEU
Esch-sur-Alzette, ville du fer

Hauts-fourneaux et terre rouge ont longtemps marqué Esch-sur-Alzette et ses environs. La deuxième ville du Grand-Duché du Luxembourg est directement située sur la frontière avec la France dans une région de plaine. La découverte de minerai de fer au XIXe siècle a été le moteur de la croissance d'Esch-sur-Alzette qui attira de nombreux immigrés. La ville et le paysage étaient profondément marqués par l'industrie minière et sidérurgique jusqu'à la crise de l'acier dans le second moitié du XXe siècle. Après la fermeture de nombreuses mines et de hauts-fourneaux, la région commença sa mue en mettant l'accent sur les services, la culture, l'éducation et la recherche. Vers la moitié des années 1980, on commença à assainir le centre-ville et la tendance à la dépopulation cessa. Lors de la reconstruction d'Esch-sur-Alzette, les considérations de planification d'ensemble de la ville et du paysage ainsi que la transformation de l'espace public jouèrent un rôle essentiel, en particulier pour les places publiques et des rues. Car il fallait transformer et moderniser Esch-sur-Alzette. L'ancien terrain d'exploitation minière à la lisière de la ville fut transformé en campus de l'université de Belval et on y installa les facultés du Luxembourg. Esch-sur-Alzette vit un profond changement structurel.

À partir des années 1870, Esch-sur-Alzette connut une croissance rapide, passant de l'état de village à celui de petite ville comptant environ 30 000 habitants et attirant de nombreux immigrants. Mais avec la crise sidérurgique que connut le Luxembourg dans les années 1975–1984, la production d'acier cessa à Esch-sur-Alzette.

L'espace public marque le visage urbain. Il est déterminant pour la qualité de vie et donc décisif si l'on cherche à maintenir la population ou même à attirer de nouveaux habitants. Mais qu'est-ce qui caractérise les espaces publics qui fonctionnent bien, qu'est-ce qui rend une ville intéressante ? Et de quelles impulsions a besoin Esch ?

Vera Spautz
Bürgermeisterin, Esch-sur-Alzette

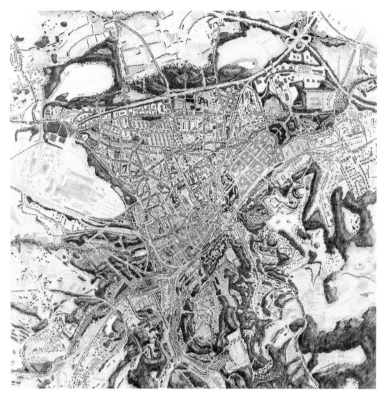

Landschaftsplan der Stadt Esch, 1989 – Müller, Knippschild, Wehberg
Landschaftsarchitekten, Berlin

Der Brillplatz bietet Raum zum „Kennenlernen des Anderen"

Der öffentliche Raum lässt sich nicht auf eine geometrische Größe reduzieren, er ist vielmehr Treffpunkt, Raum für Begegnungen und Kommunikation, Ort der Interaktion, für Konflikte und Interessenaustausch, ein Ort des Lernens wie auch ein Ort für Integration oder Ausschluss – somit ist ein öffentlicher Raum immer auch Sozialraum. Er besitzt eine gesamtgesellschaftliche Funktion für die Stadt. Als „Agora" dient er der Bildung sowie dem Austausch politischer Ideen und Aktionen. Er kann so zum Objekt der politischen Willensbildung werden. Die Initiative, die sich für die Gestaltung des Brillplatzes und gegen den geplanten Entwurf (Heller-Entwurf) im Jahre 2007 zusammenschloss, zeugt von der Lebendigkeit eines solchen öffentlichen Dialogs.

Dass der Platz, im Volksmund als Brillplatz bekannt, besonders den Funktionen der Begegnung, des Austauschs und der Interaktion dienen soll, scheint Kamel Louafi wohl verstanden zu haben. In diesem sehr urbanen Stadtteil, gekennzeichnet durch eine kulturelle und soziale Vielfalt mit einer hohen Bevölkerungsdichte, hat Kamel Louafi mit seiner Fünf-Kontinente-Skulptur das Thema des „Kennenlernens des Anderen" hervorragend symbolisiert.

Es lässt sich ohne Weiteres bezeugen, dass die Gestaltung des Brillplatzes hervorragend gelungen ist und durch die Verbindung von Kunst und Funktionalität ein schöner Platz entstanden ist. Doch ein öffentlicher Platz kann nur dann alle seine zugesprochenen Funktionen erfüllen, wenn sich Nutzer den Platz aneignen, ihn praktisch in Besitz nehmen und in die alltäglichen Lebensvorgänge einbeziehen. Raum ist ein soziales Konstrukt, das nur durch seine Benutzung lebt.

Der Raum ist dann öffentlich, wenn er für jedermann, ohne Einschränkung, zugänglich ist und somit von vielen verschiedenen Gruppen benutzt werden kann. Der Brillplatz ist kein zweckgebundener öffentlicher Raum wie etwa Friedhöfe, Sportanlagen oder Schrebergärten, sondern ein Platz, auf dem sich die Vielfalt von Lebensäußerungen – wie sie in Esch/Alzette allgemein und im Stadtteil Brill besonders zu finden ist – öffentlich ausbilden kann.

Somit kann jeder sich individuell oder als Teil einer Gruppierung den Brillplatz zur vertrauten Umgebung machen und sich mit ihm identifizieren, in Ritualen der Tagesroutine, durch regelmäßige Besuche oder Gewohnheiten. Die Aneignung von Raum kann aber auch ganz anders verlaufen, kann durch Verdrängung und Umnutzung entstehen, wie zum Beispiel beim Spielen von Kindern oder durch den Aufenthalt von Jugendlichen.

Daneben prägt der öffentliche Raum in entscheidendem Maße das Bild eines Ortes, eines Stadtviertels und sogar vielleicht einer ganzen (Klein-)Stadt. Er erscheint als wichtiger Standortfaktor für die Wohnwahl sowie für Investoren. In seiner Funktion als Aushängeschild sollte der öffentliche Raum attraktiv sein, Identität stiften, integrierend sein und Raum bieten für verschiedene Nutzungen. Auch dies ist Kamel Louafi gelungen.

Bleibt abzuwarten, welche Funktion und Bedeutung der urbane öffentliche Raum zukünftig in Nutzung und Gestaltung angesichts des gesellschaftlichen Wandels spielen wird.

Vera Spautz, Mayor, Esch-sur-Alzette

Brillplatz is a place where you can "get to know other people"

Public space cannot be reduced to a particular geometric size, but is rather a place for meeting people and communicating, a place for interaction and conflict, for exchanging ideas and interests, a place for learning as well as one of integration or exclusion. And thus, public space is always social space. It has in overall social function within a city. As an agora, it provides space for education and serves the exchange of political ideas and actions. It can therefore become an object of public policy development. The initiatives formed both in order to design Brillplatz and to oppose the planned design (Heller design) in 2007 testify to the vitality of such public dialogue.

The idea that this plaza, which is popularly known as Brillplatz, is especially important as a place for meeting others, as a place of exchange and interaction, appears to have been clearly understood by Kamel Louafi. In this very urban, densely populated part of the city, which is characterised by cultural and social diversity, Kamel Louafi developed the perfect symbol, i.e. the Five Continents sculpture, with regard to "getting to know other people".

It is easy to see that the design of Brillplatz is an outstanding success and that a wonderful plaza has been created in conjunction with art and functionality. And yet a public space can only be said to fulfil its ascribed functions if users accept it and make it their own, make it a part of their daily activities. Space is a social construct that lives only through its use. Space becomes public if is accessible for everyone, without any restrictions, and can thus be used by many different groups. Brillplatz is not an earmarked public space such as a cemetery, sport facility or allotment garden, but rather a space in which all of life's great diversity, which is especially common to Esch/Alzette in general and the Brill neighbourhood in particular, can be publicly expressed.

Individually or as part of a group, everyone can therefore make Brillplatz a part of their familiar environs and identify with it, whether as part of a ritual or a daily routine, through regular visits or habits. Making a space one's own can, however, occur in very different ways as well, for instance through crowding out others or changing its use, for example through children's play or as a place for adolescents to "hang out".

Public space can also play a crucial role in shaping the image of an area, a neighbourhood or even perhaps that of an entire town or city. It appears to be an important factor when considering where to live or invest money. In its function as an advertisement, public space should be attractive, provide a sense of identity, be inclusive and offer space for a variety of uses. Kamel Louafi's design successfully does this as well.

It remains to be seen what functions urban open space will have in the future, and what significance it will play with regards to use and design, especially during times of great social change.

Vera Spautz, Maire d'Esch-sur-Alzette
La place du Brill, un espace où « rencontrer autrui »

L'espace public ne peut être réduit à sa dimension géométrique, il est d'abord un espace de rencontre et de communication, un lieu d'interaction où se partagent les centres d'intérêt, un lieu d'apprentissage et d'intégration – voire d'exclusion. Un espace public est donc toujours un espace social. Il revêt pour la ville une fonction sociétale globale. En tant qu'« agora », il sert à l'éducation, à l'échange des idées et des actions politiques. Il peut même devenir objet de démagogie politique. L'initiative qui s'est constituée en faveur de l'aménagement de la place du Brill, et contre le projet d'abord envisagé (projet Heller) en 2007, témoigne de la vivacité du dialogue public.

Manifestement, Kamel Louafi a bien compris que cette place, communément appelée place du Brill, a vocation justement à favoriser la rencontre, l'échange et l'interaction. Dans cette partie très urbanisée de la ville, que caractérise la pluralité culturelle et sociale avec une forte densité de population, Kamel Louafi a su trouver un symbole idéal sur le thème de la rencontre avec autrui, à savoir une sculpture des cinq continents.

On constate aussitôt que l'aménagement de la place du Brill est parfaitement réussi, et que l'association ente art et fonctionnalité a permis de créer un bel endroit. Une place publique ne remplit cependant toutes les fonctions qui lui reviennent que si les gens se l'approprient, la prennent pour ainsi dire en possession et l'intègrent dans leur vie quotidienne. L'espace est une construction sociale qui ne vit de l'usage qui est en fait.

L'espace n'est public que s'il est accessible à tous, sans restriction aucune, et qu'il est utilisé par des groupes de toutes sortes. La place du Brill n'est pas un espace public ayant une finalité spécifique (comme les cimetières, les terrains de sport ou les jardins ouvriers), mais une place où peut se déployer publiquement la diversité des modes de vie, tels qu'ils existent en général à Esch/Alzette et dans le quartier du Brill en particulier.

Chacun peut ainsi, pour soi ou comme membre d'un groupe, faire de la place du Brill son environnement familier, s'identifier à lui, y vivre les rituels de la routine quotidienne, s'y rendre régulièrement, y prendre ses habitudes. Mais l'appropriation de l'espace peut aussi se dérouler tout autrement, par l'éviction ou la réaffectation, si des enfants y jouent par exemple ou que des jeunes s'y installent.

En outre, l'espace public laisse une empreinte décisive sur l'image d'un lieu, d'un quartier et même sans doute de toute une (petite) ville. Il devient facteur important dans le choix d'un logement ou pour les investisseurs. Il fait fonction de « carte de visite » et se doit donc d'être attractif, générateur d'identité, intégratif et polyvalent. C'est tout ce à quoi Kamel Louafi est parvenu.

Attendons maintenant de voir la fonction et la signification que l'espace public urbain, compte tenu des transformations sociétales, jouera à l'avenir en termes d'utilisation et d'aménagement.

André Heller
1. Prolog

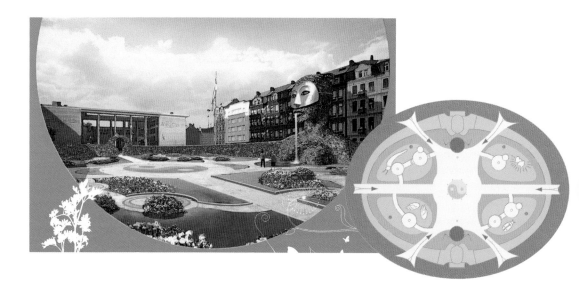

Idee zum Platz

1. Prolog

Eines der Ergebnisse der planerischen Diskussion war ein Landschaftsplan von Müller, Knippschild, Wehberg Landschaftsarchitekten aus Berlin von 1989. (Kamel Louafi war damals als Mitarbeiter daran beteiligt.) Mit diesem wurde ein ausbaufähiges Gesamtkonzept für Freiräume vorgelegt, das Ansätze einer städtebaulichen kritischen Rekonstruktion im Sinne der Ergebnisse einer Planungsdiskussion der 1980er- und 1990er-Jahre mit Aspekten einer weiträumigen Landschaftsgestaltung kombinierte.

Der erste Versuch in dieser Hinsicht wurde am Place de la Résistance mit einem Entwurf des Event-künstlers André Heller durchgeführt. Dieser veranschaulichte die Idee eines opulenten Stadtgartens, einer grünen Insel, die als Schmuckplatz in vehementem Kontrast zur Umgebung in die Mitte des Platzes wie auf ein Tableau gesetzt werden sollte. Umgeben von grünen Laubengängen als Teil einer skulpturalen Inszenierung wären hier die Besucher beim Betreten in eine andere Welt „eingetaucht": „Alles überragend erobern ein weiblicher und ein männlicher Riese den Platz. Die zwei überdimensionalen Skulpturen sind über 8 Meter hoch und residieren am Place de la Résistance in der Stadtgemeinde Esch. Die beiden Wesen reichen einander die Hände und bilden so eine Einheit. Der hierdurch entstehende Raum hat eine Fläche von 1.700 m², die zum Garten wird, die Arkadengänge belegen 500 m². Die gesamte den Garten umgebende Fläche ist beachtliche 5.000 m² groß. Ausreichend Platz für große und kleine Veranstaltungen der Stadt" (aus André Hellers Entwurfsbroschüre). André Hellers Idee warf viele Diskussionen auf und führte zu Protesten, die letztlich in der Ablehnung des Projektes und der Auslobung eines internationalen Wettbewerbs zur Freiraumgestaltung in Kombination mit Architektur, Lichtplanung und Kunst mündeten.

Louafi Landschaftsarchitekten und Kunst (federführend im Team mit Reimar Herbst Architekten und Jan Dinnebier Lichtdesign) konnten sich in dem Wettbewerb mit einem gartenkünstlerischen Konzept durchsetzen.

Idea for the Plaza

1st Prologue

One of the results of planning discussions in Esch-sur-Alzette was a landscape plan developed by the Berlin office of Müller, Knippschild, Wehberg Landscape Architects in 1989 (where Kamel Louafi was involved with the planning as an employee). This plan provided an open space concept that could be expanded upon as needed, and which combined aspects of large-scale landscape architecture with approaches to the critical urban reconstruction broached in earlier planning discussions during the 1980s and 1990s.

The first attempt at the Place de la Résistance in this regard was a design by event artist André Heller. He developed the idea of a green island, i.e. a decorative square set like a tableau in the centre of the plaza that would serve as a strong contrast to the surrounding area. Surrounded by green arcades that would serve to underscore the sculptural character, visitors to the plaza would find they had become "immersed" in another world. "A female and a male giant tower over the plaza. The two giant sculptures are over eight metres tall and reside at the Place de la Résistance in the municipality of Esch. Both figures join hands, thus becoming a single entity. The garden created has an area of 1,700 m² while the arcades take up another 500 m². The area surrounding the garden is of considerable size at 5000 m², and there is plenty of space for both large and small events in the city." (an excerpt from André Heller's design brochure).

André Heller's idea provoked a great deal of discussion and led to protests that ultimately led to the rejection of the project and the organising of an international open space design competition in combination with architecture, lighting design and art. Louafi Landschaftsarchitekten und Kunst (the lead firm in a team with Reimar Herbst.Architekten and Dinnebier Licht) then won the competition with its landscape architectural and artistic concept.

Le concept pour la place

1er Prologue

L'un des résultats amenés par la discussion de planification fut un plan paysager de Müller, Knippschild, Wehberg architectes-paysagiste de Berlin de 1989 pour Esch-sur-Alzette. (Kamel Louafi y avait alors participé en tant qu'employé de ce bureau.) Ce plan présentait un concept général de base pour les espaces libres et combinait les contraintes d'une reconstruction urbaine critique telles qu'élaborées lors d'une discussion de planification dans les années 1980 et 1990, prenant en compte les aspects d'un plus large aménagement du paysage.

Le premier essai pour la place de la Résistance s'inscrivant dans cette veine fut celui de l'artiste événementiel André Heller. Il développait l'idée d'un jardin urbain opulent, d'une île verte qui devait en tant que place ornementale et dans un fort contraste avec l'environnement être placé au centre de la place comme dans un tableau. Entouré de chemin au feuillage vert faisant partie d'une mise en scène sculpturale, les visiteurs auraient pénétré dans « un autre monde ». « Dépassant tout, un géant femme et un géant homme auraient dominé la place. Les deux sculptures surdimensionnées mesurent plus de huit mètres de haut et résident place de la Résistance dans le quartier d'Esch. Les deux êtres se tiennent la main et forment ainsi une unité. L'espace ainsi créé, un jardin, a une surface de 1700 m². Les allées en arcades occupent quant à elles 500 m². La surface entourant le jardin est de pas moins de 5000 m², offrant suffisamment de place aux petites comme aux grandes manifestations de la ville » (extrait de la brochure du projet d'André Heller). Le concept d'André Heller provoqua de nombreuses discussions et protestations qui débouchèrent finalement sur le rejet du projet et la mise en place d'un appel d'offres public pour l'aménagement d'un espace combinant architecture, planification de l'éclairage et art. Louafi Landschaftsarchitekten und Kunst (chef de projet pour une équipe avec Reimar Herbst Architekten et Jan Dinnebier Licht) remporta le concours avec son concept artistique de jardin.

Kamel Louafi
2. Prolog

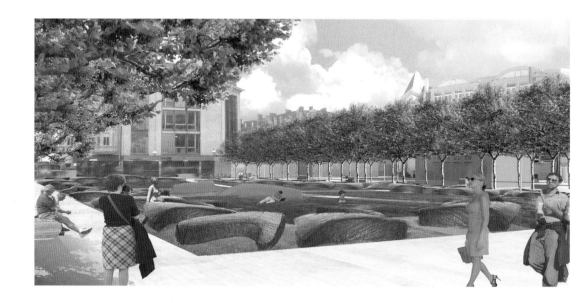

Internationaler Wettbewerb

2. Prolog

Aus der Auslobung für den Wettbewerb: „Gegenstand des [internationalen] Wettbewerbs ist die Gestaltung des Platzes im Zentrum der Stadt Esch-sur-Alzette und die Aufwertung des Stadtkerns. Der Platz ist das Pendant zum Rathausplatz und befindet sich am oberen Ende der Hauptgeschäftsstraße des Ortes. Das Theater, die Brill-Schule, das ‚Musée National de la Résistance', Wohnhäuser und Geschäftslokale grenzen an den Platz. In Anbetracht der geringen Anzahl an Grünflächen im Brillviertel soll bei der Gestaltung des Platzes ein besonderes Augenmerk auf Grünflächen, Bepflanzung, künstlerische Gestaltung sowie einen hohen Identifikationswert gelegt werden. Neben Architekten, Freiraumplanern/Landschaftsarchitekten und Lichtplanern sind Künstler in die jeweiligen Wettbewerbteams zu integrieren."

Der internationale Wettbewerb war zweistufig angelegt. Jedes Team bestand aus einem federführenden Landschaftsarchitekten sowie zugeordnet je einem Architekten, Lichtplaner und Künstler. Für das Team Louafi wurde – vor dem Hintergrund der bisherigen Arbeiten – Kamel Louafi sowohl als Landschaftsarchitekt als auch als Künstler akzeptiert. Reimar Herbst Architekten und Studio Jan Dinnebier Lichtplaner bildeten mit Kamel Louafi zusammen das Team Louafi. Nach einer dritten Stufe mit zwei anderen Teilnehmern führten letztlich drei statt zwei Präsentationen zu der Prämierung des Teams Louafi und der Ausführung der Arbeiten. Die Jury entschied, dass es drei erste Preise geben und eine endgültige Festlegung nach einer Überarbeitung der Konzepte in einer dritten Phase erfolgen sollte. Die drei ersten Preise gingen an Gil Clement (Esch, Luxemburg), Okra (Utrecht, Niederlande) und Louafi Landschaftsarchitekten (Berlin, Deutschland). Nach der dritten Phase wurde die plastisch-skulpturale Form der Hecken und Heckenbronzen entwickelt, mit dem Konzept „Die fünf Kontinente" der räumliche und kontextuelle Zusammenhang des Platzes mit seiner Umgebung gestärkt – daraufhin wurde das Team Louafi einstimmig für die Realisierung gewählt.

International Design Competition
2nd Prologue

An extract from the competition brief: "The objective of the (international) competition is the design of the plaza in the centre of the city of Esch-sur-Alzette and an improvement of the city's centre. The plaza is the counterpart of the city hall plaza and is located at the upper end of the city's main shopping street. The city's theatre, the Brill School, the National Resistance Museum, residential buildings and retail stores are all directly adjacent to the plaza. Considering that there is little public open space in the Brill neighbourhood, the design of the plaza should focus in particular on green open space, planting, artistic design and a high degree of identification for the city's inhabitants. Artists should be part of each competition team in addition to architects, landscape architects and lighting planners."

The international competition had two stages. Each team consisted of a landscape architect as the lead member, as well as the aforementioned architects, lighting planners and artists. In light of the fact that Kamel Louafi had already worked on the project, he was accepted as both the landscape architect and artist. The other members of the team were Reimar Herbst.Architekten and Dinnebier Licht from Berlin. After competing with two other participants in a third stage and making three presentations instead of the planned two, Team Louafi was awarded both the first prize and a contract to develop construction documents for the plaza. After the second stage, the jury decided to award three first prizes and to then make a final decision after the concepts were revised in a third stage. The three first prizes were awarded to Gil Clement (Esch, Luxembourg), Okra (Utrecht, the Netherlands) and Louafi Landschaftsarchitekten (Berlin). After the third stage, the sculptural hedge shapes and hedge-shaped bronze statues were developed, the Five Continents developed in order to strengthen the plaza's spatial and contextual cohesion and Team Louafi unanimously chosen to continue working on the project.

Concours international
2e Prologue

Voici les spécifications décrites dans l'appel d'offres : « L'objet du concours [international] est l'aménagement de la place au centre-ville de la ville d'Esch-sur-Alzette et la revalorisation du centre historique. La place est le pendant de la place de la mairie et se trouve à l'extrémité supérieure de la principale rue commerçante du lieu. Le théâtre, l'école Brill, le Musée National de la Résistance, des bâtiments d'habitation et des boutiques jouxtent la place. Vu le faible nombre d'espaces verts dans le quartier de Brill, le projet d'aménagement de la place devra particulièrement tenir compte de la question des espaces verts, des arbres, de l'agencement artistique ainsi que sur le potentiel d'identification. Outre les architectes, les spécialistes de l'aménagement des espaces extérieures/architectes paysagistes et ceux de l'éclairage, il faut intégrer des artistes dans les équipes des projets. »

Le concours était conçu en deux étapes. Chaque équipe était centrée autour d'un architecte-paysagiste et comprenait un architecte, un spécialiste de l'éclairage et un artiste. Dans l'équipe Louafi, Louafi fut accepté au vu de ses travaux antérieurs tant comme architecte-paysagiste qu'artiste. Reimar Herbst Architekten, Berlin et le Studio Jan Dinnebier formaient avec Louafi l'équipe Louafi. Après un troisième tour avec deux autres équipes – et donc trois au lieu de deux présentations –, l'équipe Louafi fut primée et les travaux purent commencer. Le jury décida de donner trois premiers prix et ne prononça sa décision définitive qu'après une révision des projets et donc une troisième phase. Les trois premiers prix furent remis à Gil Clement (Esch, Luxembourg), Okra (Utrecht, Pays-Bas) et Louafi Landschaftsarchitekten (Berlin, Allemagne). C'est à l'issue de la troisième phase que les formes sculpturales des haies et des bronzes pour la haie virent le jour, le concept « des cinq continents » renforça l'ancrage spatial et contextuel de la place et l'équipe Louafi fut choisie à l'unanimité.

Luc Everling
Stadtarchitekt, Esch-sur-Alzette

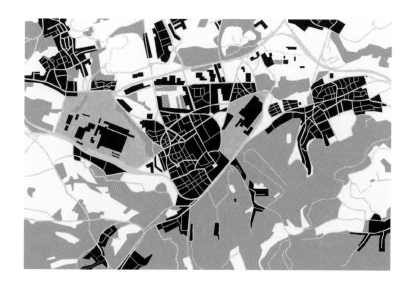

Die Bedeutung des öffentlichen Raums in Esch-sur-Alzette

Die Bedeutung des öffentlichen Raums kann nicht in einem Augenblick bestimmt werden. Eine Reihe von Vorüberlegungen müssen getroffen werden. So müssen wir uns zunächst fragen, was man allgemein unter „öffentlichem Raum" versteht. Dann scheint es notwendig zu wissen, wie dieser Raum erzeugt wird. Schließlich ist die Frage des Zwecks von großem Interesse, um nicht zu sagen wesentlich.

Die erste Reaktion betrachtet den öffentlichen Raum als Allgemeingut der Gemeinschaft. Dies ist jedoch eher der öffentliche Bereich, der gemeint ist. Kann man den öffentlichen Raum definieren als alles, was der Öffentlichkeit zugänglich ist?

Das ist die Ansicht, die Giambattista Nolli vertreten hat. Als er seine urbane Erfassung der Stadt Rom im Jahre 1748 anfertigte, wurde alles was zugänglich war, das heißt nicht durch eine Mauer oder eine Einzäunung geschlossen war, in weiß auf seinem Plan markiert. Er hat sich dabei nicht nur auf Plätze und Straßen beschränkt, auch die Innenhöfe oder zugänglichen Gebäude wie das Pantheon wurden weiß eingezeichnet.

Ich persönlich würde noch weiter gehen: Die unmittelbare Umgebung – seien es Gebäude, die Vegetation oder andere Strukturen oder Elemente, die diesen Raum definieren – haben einen direkten Einfluss auf den öffentlichen Raum, den sie erzeugen, und gehören folglich dazu.

Der Zweck des öffentlichen Raums kann nicht von seiner Bedeutung losgelöst werden. Wenn auch der Zweck je nach Ort und Zeit sich ändern kann, muss doch die Bedeutung oder vielmehr der Wert größtmöglich erhalten bleiben. So müssen sämtliche Planer und alle Verantwortlichen den höchsten Anspruch an die Qualität des Raumes haben.

Die Stadtverwaltung mit ihren politischen Entscheidungsträgern hat daher eine sehr große Verantwortung gegenüber seinen Bürgern. Sie soll nicht nur qualitativ hochwertige Projekte mit einem größtmöglichen Mehrwert ausführen, sondern die Bevölkerung auch in ihren architektonischen Entscheidungen

führen und alle Arbeiten regulieren, welche die Öffentlichkeit beeinflussen. Wenn es in der Menschen-rechtserklärung heißt, dass „die Freiheit darin besteht, alles tun zu können, was keinem anderen scha-det", müssen wir uns sagen, dass jedes Mal, wenn wir nicht an die Auswirkungen einer Entscheidung über den öffentlichen Raum nachdenken, dies schädlich sein kann.

Das Aussehen (Erscheinungsbild) ist sehr wichtig, sei es der öffentliche Bereich oder die Eigenschaf-ten, die diesen generieren. Aber das Aussehen (Erscheinungsbild) allein genügt nicht als Ziel, wir müs-sen auch über die Funktion nachdenken. Und es ist die passende Funktion, die jedes Mal gesucht wer-den muss.

Wir kommen aus einem Jahrhundert, in dem das Auto eine wichtige Rolle spielte und wo es seit Lan-gem einen großen Einfluss auf fast jeden öffentlichen Raum hat. Das Auto war maßgebend bei der Gestaltung von Straßen und Plätzen. Man konnte sie sogar mitten in den Häuserblöcken und Gärten finden. Die Straßen sind jetzt mit Garagen gesäumt. Dort, wo es einst noch Geschäfte, Cafés und auch Wohnräume von Einfamilienhäusern gab, sind jetzt häufig Garagentore. Seit Jahrzehnten haben wir dem Auto die Priorität gegeben. Ist es nicht Zeit, die Autos von Plätzen zu verbannen und den Men-schen eine Chance zu geben, diese Räume zurückzuerobern? Man sollte dem motorisierten Verkehr nicht die Priorität geben, wenn die Chance besteht, den Menschen mehr Wohnraum zurückzugeben. Könnten Autos, Taxis oder Busse nicht einen kleinen Umweg machen? Warum sollten sie den maxima-len Komfort und alle Privilegien erhalten, wenn die Möglichkeit besteht, ein bisschen Platz für eine Ter-rasse, Bänke, einige Bäume zu schaffen?

Wenn auch eine der Funktionen des öffentlichen Raums der Verkehr ist, sollte man nicht aus den Augen verlieren, dass dies nicht die ausschließliche Funktion ist; man muss über alle anderen Möglich-keiten nachdenken, um einen Mehrwert zu schaffen.

Lassen Sie uns nicht vergessen, dass jeder öffentliche Raum eine Visitenkarte ist. Wenn der öffentli-che Raum von hoher Qualität ist, sei es durch eine schöne Allee, durch einen schönen Ort oder einen Park, wollen die Menschen eben dort leben, die Geschäfte möchten sich genau dort ansiedeln, die Bistros dort ihre Terrasse haben und die Unternehmen möchten dort ihre Adresse auf der Visitenkarte haben! Immer, wenn eine Verwaltung in diese Räume investiert, muss sie sich den vollen Auswirkun-gen im Klaren sein, die diese Investition an diesem Ort auf das Aussehen und das Image der Stadt im Allgemeinen haben kann.

Der letzte Punkt, den ich ansprechen möchte, ist die gesellschaftliche Bedeutung des öffentlichen Raumes. In Esch-sur-Alzette, vor allem in der Innenstadt, verbringt ein Großteil der Bevölkerung seine Zeit außerhalb der eigenen Wohnung. Dieser Trend existiert nicht nur aufgrund der kulturellen Gewohn-heiten von dutzenden verschiedenen Nationalitäten, die dort leben, sondern auch, weil es viele Leute gibt, die aus Geldmangel in zu kleinen Wohnungen leben.

Eine gute Funktionalität des öffentlichen Raums, aufgewertet durch qualitätsvolle städtische Interventi-onen, trägt zu einem guten Zusammenleben bei. Erholungsorte, Spielplätze, Durchgangsorte, Terras-sen: Man darf nicht vergessen, dass es die Leute sind, die sich einen Raum aneignen und die bewirken, ob er funktioniert oder nicht. Deshalb muss man dafür sorgen, dass sie sich mit Orten identifizieren können, um den öffentlichen Räumen die richtige Bedeutung zu geben.

Die Tatsache, die öffentlichen Räume erleben zu können, ihre Wahrnehmung und ihre ästhetische Qua-lität zu genießen, verleiht ihnen ihre Bedeutung und prägt die Stadt.

Luc Everling, municipal architect, Esch-sur-Alzette
The Importance of Public Space in Esch-sur-Alzette

The importance of public space cannot be determined in a single moment. A number of considerations have to be taken into account. We therefore have to ask ourselves what is generally meant by "public space". And then it seems to be important to know just how this space is created. And finally, the question of the purpose of public space is of great interest, if not to say essential.

Our first reaction is to think about public space as a common good belonging to an entire community. But this really refers more to public areas. Is it possible to define public space as everything that is accessible to the public? This is certainly the opinion that Giambattista Nolli held. When making his urban observations of the city of Rome in 1748, everything not enclosed by walls or fences was considered accessible and was marked in white on his plan. He didn't merely limit himself to plazas and streets, but included courtyards and accessible buildings such as the Pantheon.

Personally, I would go even further: The area immediately surrounding a space – whether it be buildings, vegetation or other structures and elements that define this space – have a direct impact on the public space they create and are therefore a part of.

The purpose of public space cannot be separated from its importance. Even if, dependant on time or place, a space's purpose can be changed, its importance, or rather value, must be maintained to the greatest degree possible. And thus planners and all those responsible for a space must set the highest possible standards for its quality.

Municipal administrations and their political decision makers therefore have a huge responsibility with regards to their citizens. They should not only create high quality projects that are of maximum value, but must involve citizens in their architectural decisions and regulate all projects that affect the public. If, in the Declaration of Human Rights it says that "liberty consists of being able to do anything which does not harm others", we have to tell ourselves that every time we don't consider the effects a decision has on public space, harm can be done.

Appearance is very important, whether it be that of public areas or attributes that generate it. But appearance itself is not enough as a goal; we also have to think about function. And it must always be an appropriate function that we search for.

We come from a century in which the automobile played an important role and had an enormous influence on almost every public space. Automobiles were long the decisive element in the design of streets and plazas. It was even possible to find them in the middle of blocks of houses and gardens, and streets are lined with rows of garages. Where there were once shops, cafés and living rooms we now often find garage doors. For decades we have given automobiles priority over everything else. Isn't it time that we banished automobiles from plazas and gave people a chance to reclaim these spaces? We shouldn't prioritise motorised transport as long as there is a chance to give people more living space. Shouldn't it be possible for cars, taxis and buses to take a small detour? Why should we make it convenient for them and give them privileges if it is possible to create a bit of space for a terrace or a bench and a few trees?

Even though one of the functions of public space is traffic, we should not lose sight of the fact that this is not its exclusive function. It is therefore especially important that we consider all the possible ways of making the space more attractive, of increasing its value.

Let us not forget that every public space is a calling card. If public space is of high quality, whether it be an impressive avenue, a beautiful open area or a park, people want to live there,

stores want to do their business there, bistros want to have their terraces there and companies wish to have these addresses on their business cards. Whenever a public authority invests in this space, they have to understand the overall impact this investment will have on the area's image and the image of the city in general.

The final point I would like to raise is that of the social significance of public space. In Esch-sur-Alzette, and especially in the city's centre, a majority of the population spends a great deal of its time away from home. This trend is not only due to the cultural habits of the many different nationalities who live there, but rather to the fact that there are many people who live in small apartments due to a lack of money.

Public space that functions well and that is enhanced through high quality urban interventions contributes to successful coexistence. Places to relax and play in, to pass through and and linger in: We should not forget that it is people who will begin to consider a space their own and prove whether it functions or not. This is the reason we have to make sure people can identify themselves with an area, in order to give public space the importance it deserves. The fact that public space can be experienced and its aesthetic quality enjoyed gives it meaning, which in turn influences and defines the city in which it is located.

Luc Everling, Architect de la ville d'Esch-sur-Alzette
La signification de l'espace public à Esch-sur-Alzette

Déterminer la signification de l'espace public ne peut pas se faire en un clin d'œil. Un certain nombre de réflexions préliminaires doivent être faites. Ainsi, il faut d'abord se demander ce qu'on entend communément par « espace public ». Ensuite, il paraît nécessaire de savoir comment cet espace est généré. Enfin, la question de sa finalité est intéressante, voire primordiale.

La première réaction de la plupart des gens serait de dire que l'espace public est celui qui appartient à la communauté. Néanmoins il s'agit là plutôt du domaine public. Est-ce que l'espace public pourrait alors être défini par tout ce qui est accessible au public ? C'est le point de vue défendu par Gianbattista Nolli. Quand il a fait son relevé urbain de la Ville de Rome en 1748, tout ce qui était accessible, donc non fermé par un mur ou une clôture, était marqué en blanc sur son plan. Il ne s'est pas limité aux places et rues, car même les cours intérieures ou les bâtiments accessibles comme le Panthéon étaient dessinés en blanc.
Personnellement, j'irais encore plus loin : les alentours immédiats – que ce soient les bâtiments, la végétation, ou d'autres structures ou éléments qui délimitent cet espace – ont un impact direct sur l'espace public qu'ils génèrent et en font par conséquent partie intégrante.

En ce qui concerne la finalité de l'espace public, elle ne peut être détachée de sa signification. Si la finalité peut changer selon le lieu et dans le temps, la signification ou plutôt la valeur doit toujours rester la plus grande possible. C'est ainsi que tout planificateur et tout responsable doit avoir la plus haute prétention quant à la qualité de cet espace.

L'administration de la Ville, avec ses décideurs politiques, a donc une très grande responsabilité vis-à-vis de ses citoyens. Elle ne doit pas seulement exécuter des projets de qualité, avec la plus grande valeur ajoutée possible, mais également guider la population dans ses choix architecturaux et réglementer tous les travaux ayant un impact sur le domaine public. Si dans la déclaration des droits de l'homme on peut lire que la « liberté consiste à pouvoir faire tout ce qui ne nuit pas à autrui », il faut se dire qu'à chaque fois qu'on ne pense pas aux répercussions d'une décision sur l'espace public, on risque de nuire.

L'aspect est donc très important, que ce soit celui du domaine public ou celui des propriétés qui le génèrent. Mais l'aspect seul ne suffit pas comme finalité, il faut encore réfléchir sur la fonction. Et c'est la fonction juste, qui doit être recherchée à chaque fois.

Nous venons d'un siècle où la voiture a joué un très grand rôle et où elle a longtemps eu un très grand impact sur quasiment tout l'espace public. La voiture a été déterminante pour la conception des rues et des places. On pouvait même la trouver dans les cœurs d'îlots et les jardinets. Les rues sont désormais bordées de garages. Là, où jadis il y avait encore des magasins, des cafés et même les salons des maisons unifamiliales, se trouvent à présent souvent des portes de garage. Pendant des décennies, nous avons donné la priorité à la voiture. N'est-il pas temps de bannir les voitures des places et de donner une chance aux gens de se réapproprier ces espaces ? Il ne faut pas non plus donner priorité à la circulation motorisée, à chaque fois qu'on peut avoir la chance de redonner plus d'espaces de vie aux gens. La voiture, le taxi, le bus, ne pourraient-ils pas faire un petit détour, pourquoi devraient-ils avoir le maximum de commodité et de privilèges si on a la possibilité de libérer un peu d'espace pour une terrasse, des bancs, quelques arbres ?

Si une des fonctions d'un espace public est celle de la circulation, il ne faut pas perdre de vue que ce n'est pas la fonction exclusive et il faut réfléchir sur tout autre moyen de pouvoir créer des plus-values.

Car n'oublions pas que tout espace public constitue une carte de visite. Si l'espace public est de grande qualité, parce que c'est une belle avenue, parce qu'il y a une belle place, ou un parc, eh bien, les gens veulent y vivre, les magasins veulent s'y installer, les bistrots y avoir leur terrasse, et les entreprises veulent marquer l'adresse sur leur … carte de visite ! A chaque fois qu'une administration investit donc dans ces espaces, elle doit se rendre compte de tous les impacts que cet investissement peut avoir sur ce lieu et sur l'aspect et l'image de marque de la Ville en général.

Le dernier point que j'aimerais aborder est celui de la signification sociale de l'espace public. A Esch-sur-Alzette, surtout dans le centre-ville, une grande partie de la population passe souvent son temps à l'extérieur de son logement. Cette tendance n'est pas seulement due aux habitudes culturelles des dizaines de nationalités différentes qui y vivent, mais aussi au fait que bon nombre de gens n'y disposent que de logements beaucoup trop petits, faute de moyens financiers.

Une bonne fonctionnalité de leur espace public revalorisé par des interventions urbaines de qualité contribue à une bonne cohabitation. Aires de repos, places de jeux, lieux de passage, terrasses : il ne faut pas oublier que ce sont les gens qui s'approprient un espace et qui font en sorte qu'il fonctionne ou non. C'est pourquoi il faut veiller à ce qu'ils puissent s'identifier à des lieux pour donner la vraie signification aux espaces publics.

Le fait de pouvoir vivre les espaces publics, de jouir de leur perception et de leur qualité esthétique, c'est leur donner leur signification et contribuer à l'empreinte d'une Ville.

PLATZ DER FÜNF KONTINENTE
Brillplatz, Esch-sur-Alzette
Bronze- und Heckenskulpturen

PLACE OF THE FIVE CONTINENTS
Brillplatz, Esch-sur-Alzette
Bronze and hedges sculptures

PLACE DES CINQ CONTINENTS
Place de Brill, Esch-sur-Alzette
Sculptures de bronze et de haies

ENTSTEHUNG DER IDEE

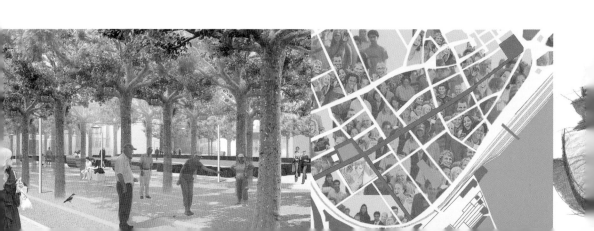

Der Place de la Résistance ist entsprechend der europäischen Tradition repräsentativ und grün gestaltet. Er beinhaltet ein zeitgenössisches künstlerisches Konzept, das sich auf die vielfältige Bevölkerungsstruktur des Brill-Quartiers bezieht. Der grüne Platz ist über Raumbildung und Funktionen innerhalb der Stadt vernetzt; er spiegelt die Lebendigkeit und Vielfalt des Quartiers und bietet dabei Freiraumqualitäten und Gartenkunst zugleich. Absicht ist, an diesem Ort einen Begegnungsraum für alle Altersstufen zu schaffen und eine Nutzung während aller vier Jahreszeiten sowie bei Tag und am Abend zu ermöglichen.

The Birth of the Idea

Designed as a traditional European plaza, the Place de la Résistance is expressive and green. It also includes a contemporary artistic concept that refers to the diverse demographics of the surrounding 'Brill' neighbourhood. Through its spatial concept and function the green plaza is well integrated within the city; it reflects the neighbourhood's vitality and diversity while at the same time providing valuable open space and garden art. The intention was to use this location to create a meeting place for people of all ages and to design a space that could be used during all four seasons, both day and night.

Naissance de l'idée

Fidèle à la tradition européenne, la place de la Résistance est prestigieuse et verdoyante. Sa conception contemporaine prend en compte la diversité de la structure sociale hétérogène du quartier « Brill ». La place verte est ancrée dans la ville par l'espace et les fonctions qu'elle occupe. Elle reflète la diversité et l'animation du quartier et propose à la fois des espaces libres de qualité et une contribution à l'art des jardins. L'objectif est d'y créer un espace de rencontre pour tous les âges, praticable en toute saison, aussi bien dans la journée que le soir.

KUNST
Gärten und Skulpturen

Gartenkunst

Die umlaufenden immergrünen Heckenwellen geben dem Platz einen eigenständigen Charakter. Als Gartenkunst moderner Prägung sind sie ergänzt mit wie die Hecken geformten Bronzen. Der Hecken-rahmen in Kombination mit Heckenskulpturen richtet das Augenmerk auf „Gartenkunst" an sich, mit ihrer Affinität und den Überschneidungen zu anderen Kunstgattungen – sowie im Sinne von Kunst im Garten auf die Tradition von Skulpturen in Gärten und Parks. Als Leitfiguren zeigen die Bronzen den angestrebten Heckenschnitt (auch in 100 Jahren), die Gestaltung mit lebendigem Material, dem die Haptik der Bronze entspricht, in weich fließenden Formen. Den Platz überspannt ergänzend die Instal-lation „Fünf Kontinente". Sie besteht aus fünf Bronzeskulpturen im Platzzentrum, die die Begegnung der Kontinente darstellen. Figurenreliefs an der Oberfläche der Objekte verweisen auf die verschiede-nen Regionen. Von dort aus erstrecken sich Wege an die Platzränder. Inmitten dieser Installation befin-den sich „Wasserfenster". Die Beleuchtung wird dieses Bild bei Dunkelheit unterstreichen.

ART – Gardens and Sculptures
Garden Art

The surrounding wave-shaped evergreen hedges give the plaza its unique character. As mod-ern garden art, they are complemented by bronze statues shaped like the hedges. The edge formed by the hedges combined with the hedge sculptures draws one's attention to "garden art", with its affinity to, and overlap with, other forms of art – as well as within the sense of art

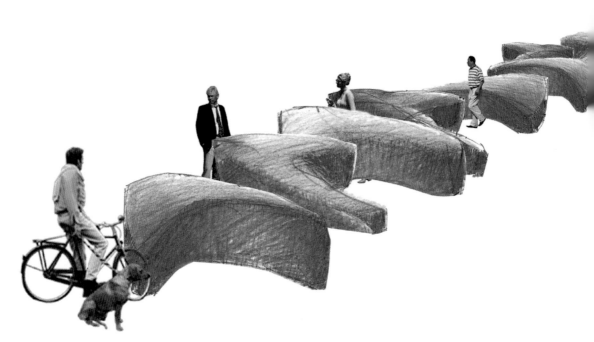

in gardens in the tradition of sculptures in gardens and parks. As central elements the statues indicate the intended height of the hedge (in 100 years as well), and the design with living material, which corresponds to the look and feel of the statues, in soft flowing forms. The installation art project Five Continents is also located at the plaza. It consists of five bronze sculptures at the centre of the plaza which represent friendship among the five continents. Relief figures on the surface of the sculptures refer to different regions. Paths extend to the edge of the plaza from its centre. "Water windows" are located at the centre of the installation. Lighting will emphasise the overall image at night.

ART – Jardins et sculptures
Art des jardins
Les haies à feuilles persistantes, taillées en forme de vagues et encadrant la place, lui donnent un caractère particulier. Elles se marient à des sculptures en bronze de formes identiques, qui font fonction de citation contemporaine de l'art des jardins. Haies et sculptures attirent notre attention sur l'art des jardins au sens propre du terme, sur son affinité et ses recoupements avec d'autres arts. Dans le sens plus large, celui de l'introduction de l'art dans le jardin, elles évoquent la tradition des sculptures placées dans les parcs et jardins. Les modèles en bronze montrent la forme taillée à atteindre (peut-être dans 100 ans !), illustrent la création à partir de matériaux vivants auxquels le touché du bronze fait écho par ses formes douces et fluides. L'installation « cinq continents » vient se poser sur cette trame. Cinq sculptures en bronze sont regroupées au centre de la place et symbolisent la rencontre des continents. Des références aux différentes régions sont appliquées en bas-reliefs à la surface des sculptures. Un réseau de chemins y prend sa source et rejoint les côtés de la place. Au centre se trouvent des « fenêtres d'eau » (de l'eau courante derrière des vitres encastrées dans le sol), qui l'hiver doivent se transformer en installation de brume. L'éclairage permettra de mettre en valeur cette composition dans l'obscurité.

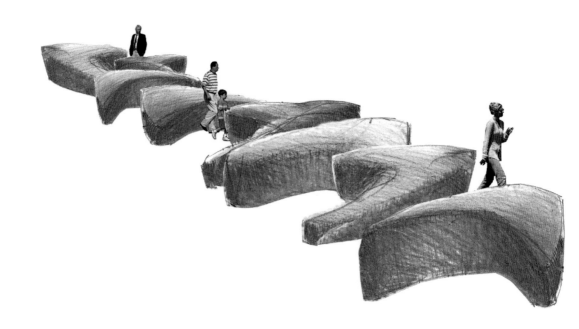

Die Formen, die Höhen, die Breiten und die Ausrichtung der Buxushecken und der Hecken-Bronzen sind fein abgestimmt. Die Schnittformen werden sich immer wieder an der Form der Heckenplastiken orientieren, sodass die Bronze die Leitform in all den folgenden Jahren darstellt – in 10, 100 oder 200 Jahren.

The shapes, heights, widths, and alignment of the boxwood hedges and the bronze hedge sculptures have been carefully designed and adapted to one another. The pruned shape of the hedges will always reflect the shapes of the bronze hedges, so that the hedge sculptures will always serve as the templates for the living hedges – in ten, one hundred and in 200 years.

Les formes, hauteurs, largeurs, et l'alignement des haies des buis soigneusement conçus et adaptés entre les sculptures en bronze. La forme des haies reflétera les formes des couvertures de bronze, de sorte que les sculptures de bronze servirons de modèles pour les haies vives – sur dix, cent et dans 200 ans.

Skulpturen im Schlosspark Friedrichsfelde, Berlin

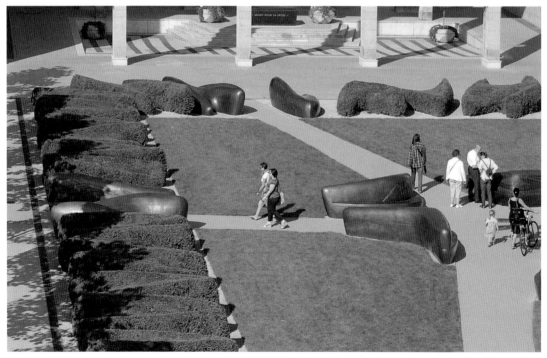

Skulpturen am Brillplatz/Platz der fünf Kontinente, Esch-sur-Alzette

SKULPTUREN IM PARK
Bronzeskulpturen am Brillplatz

SCULPTURES IN THE PARC
Bronze Sculptures at Brillplatz

SCULPTURES DANS LE PARC
Sculptures de bronze dans la place de Brill

Die Kontinente

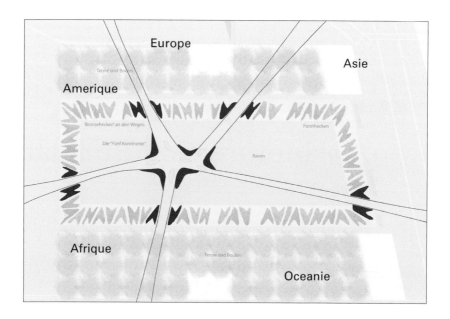

Internationalität und Lokalität der Kontinente

Mit der dritten Phase entstanden auch die „Fünf Kontinente", die den Gesamtplatz umfassen. Der räumliche Zusammenhang des gesamten Freiraumes als Platz wird damit durch eine homogene Bodengestaltung bis zu den Gebäudekanten betont. Geschwungene Wege mit einem künstlichen Belag mit der Anmutung von Parkwegen teilen den Platz in fünf „Kontinentflächen", indem sie sich von den Gebäuden aus in „fünf Himmelsrichtungen" ins Innere ziehen. Am Schnittpunkt der Wege im Platzzentrum treffen fünf Bronzeplastiken aufeinander: die Begegnung der Kontinente. Die körperhafte Wirkung der Rauminstallation wird auf allen Bronzen ergänzt mit allegorisch besetzten, zum Thema passenden Bildern, die das Motiv der fünf Kontinente einfacher lesbar machen und dem Platz einen spielerischen, dem Leben zugewandten Charakter verleihen. Die Installation „Fünf Kontinente" fügt der formalen Ortsbezogenheit der Gestaltung eine inhaltliche Komponente hinzu. Der Globalität der Migrantenfamilien, die von überall aus der Welt nach Esch kamen, wird mit einem Werk entsprochen, das über Esch hinaus auf die Kontinente und ihre Landschaften verweist – über die Stahlproduktion trug Esch seinen Teil zur Globalisierung bei. So wurde das Landschaftsthema mit dem Thema der Internationalität verbunden.

The Continents
The International Character and Locality of the Continents
The Five Continents, which encompass the entire plaza, were also created during the third stage of the competition. This element, through its homogeneous design of the ground plane, enhances the spatial coherence of the entire open space as a plaza, right up to the buildings on the periphery. Flowing paths paved with artificial materials take on the appearance of paths through a park and divide the plaza into five "continents" by stretching from the buildings into the plaza from five different "compass points". Five bronze sculptures are located at the point where the paths intersect at the centre of the plaza: A meeting of the continents. The physical effect of this spatial installation is complemented through the use of allegorical images on the sculptures that refer to the particular themes that each continent represents. These images make the themes more tangible and give them a playful, life-filled character. The Five Continents add a substantive component to the design's formal, site-specific orientation. The globalism of the migrant families who have come to Esch from around the world is addressed by this installation, which uses the city as a reference to the continents and their landscapes, especially as Esch's production of steel played a part in the city's contribution to "globalisation". And thus the issue of landscape has been used to strengthen the association to the city's internationality.

Les continents
Internationalité et localité des continents
Les « cinq continents » qui entourent toute la place ont vu le jour durant la troisième phase. L'étendue spatiale de la place est démarquée par un revêtement au sol homogène jusqu'au pied des bâtiments. Des chemins couverts d'un revêtement artificiel aux ondulations rappelant ceux des parcs partagent la place en cinq « parties du monde ». Les chemins partent des bâtiments dans cinq directions pour converger au centre. Au point d'intersection au centre de la place, des statues de bronze sont mises en regard : les cinq continents. Les bronzes, incarnation corporelle de l'installation spatiale, sont agrémentés d'images allégoriques représentant les continents : le thème est ainsi plus lisible et revêt un caractère plus ludique, plus vivant. L'installation des cinq continents ajoute à l'ancrage local de l'agencement une composante idéelle. Les origines diverses des familles de migrants venues des quatre coins du monde à Esch se reflètent dans une œuvre qui renvoie au-delà d'Esch aux cinq continents et à leurs paysages. Par le biais de l'activité sidérurgique, Esch a aussi contribué à la mondialisation. Au thème du paysage on a ainsi pu lier celui de l'internationalité.

Skulpturen im Park

Sculptures in the Parc
Sculptures dans le parc

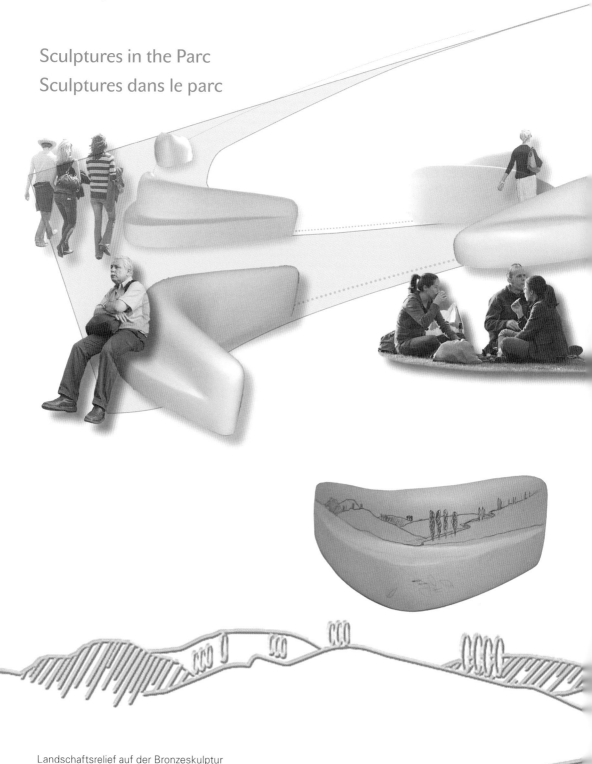

Landschaftsrelief auf der Bronzeskulptur

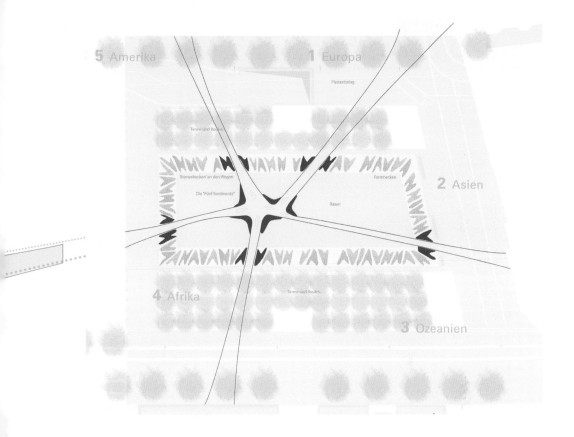

5 Amerika 1 Europa

Plastenbelag

Tenne und Boules

'Bronzehecken' an den Wegen

Die "Fünf Kontinente" Formhecken

2 Asien

Rasen

4 Afrika

Tenne und Boules

3 Ozeanien

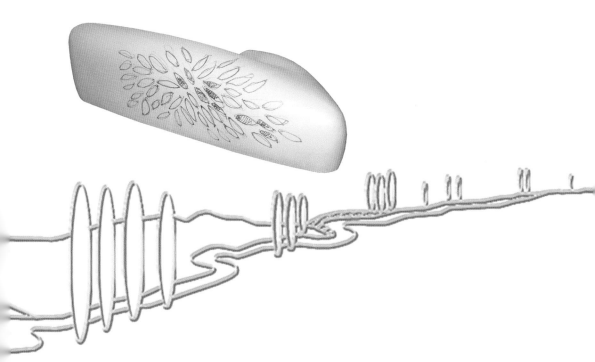

Die Antipode und das Licht

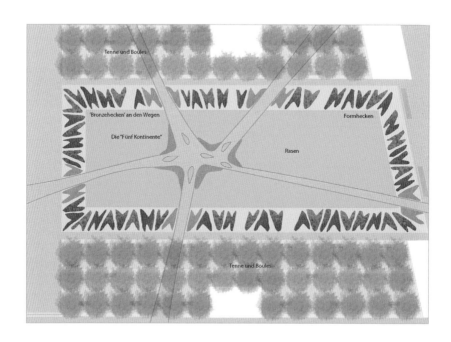

Tenne und Boules

'Bronzehecken' an den Wegen

Formhecken

Die "Fünf Kontinente"

Rasen

Tenne und Boules

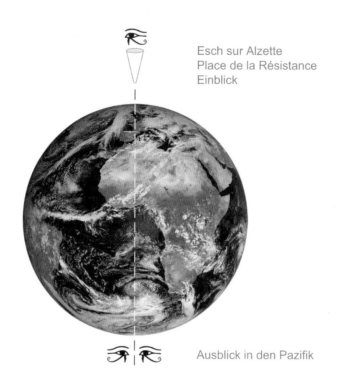

Esch sur Alzette
Place de la Résistance
Einblick

Ausblick in den Pazifik

Im Zentrum der Installation „Fünf Kontinente" befinden sich „Lichtfenster" mit Abbildungen des auf dem Globus geografisch gegenüberliegenden Landes Neuseeland. Die Beleuchtung unterstreicht die Bilder bei Dunkelheit. Die Ausformulierung der Skulpturen und Plastiken des Heckenrahmens war von dem Bedürfnis beeinflusst, eine Dynamik, eine bewegte Landschaft zu artikulieren. Zwischen den Hecken, umgeben von den geschnittenen Heckenpflanzen, variieren auch die Bronzeplastiken spielerisch in Höhe und Neigung. Sie sind zugleich Markierungen der Zugänge zum Platzzentrum und Begrenzung der Kontinentflächen. Die dynamische Form der Plastiken im Zentrum ergab sich aus dem Thema „Begegnung". Aber viel wichtiger sind die Beziehungen der Hecken und Plastiken zueinander. Die Bronzeskulpturen zwischen den Hecken erlauben nach zehn, 50, 100, 200 Jahren und mehr den Gärtnern, die Formschnitte korrekt durchzuführen.

The Antipode and the Light
Windows with images of New Zealand on them are located in the centre of the Five Continents installation, as this country is located on the opposite side of the world. Lighting emphasises this image during the night. The formulation of both the central sculptures and hedge sculptures was influenced by the need to articulate the dynamism of a vivid landscape. Between the pruned hedges, and surrounded by them, these bronze sculptures vary in height and inclination. They help define the borders of the individual "continents" and also mark the entrances and paths into the centre of the plaza. The dynamic shape of the sculptures at the centre is a result of the theme of "encountering", but even more important is the relationship between the hedges and the sculptures themselves. The bronze sculptures located between the hedges allow the gardeners of the future, be it in 10, 50, 100 or 200 years, to create topiaries of the desired shape and height.

L'antipode et la lumière
Au centre de l'installation « cinq continents », on trouve des « fenêtres de lumières » dotées d'illustration de la Nouvelle-Zélande, la région géographiquement aux antipodes sur le globe terrestre. L'éclairage souligne cette image lorsqu'il fait nuit. L'agencement des sculptures et statues du cadre que forme la haie était soumis au besoin de créer une dynamique, un paysage animé. Entre les haies, entourées par les bordures végétales, les statues de bronze se livrent à un jeu de hauteurs et d'inclinaisons. Elles servent à la fois à délimiter les chemins menant au centre de la place et à séparer des continents. La forme dynamique des statues au centre suit le thème de la rencontre. On relèvera l'importance des relations entre les haies et les statues. Les sculptures de bronze entre les haies permettront aux jardiniers dans 10, 50, 100 ou 200 ans de toujours les tailler selon la forme prévue.

Lichtfenster mit Rutschhemmung

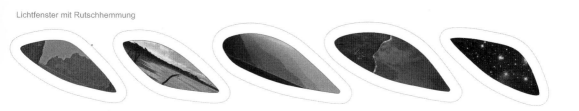

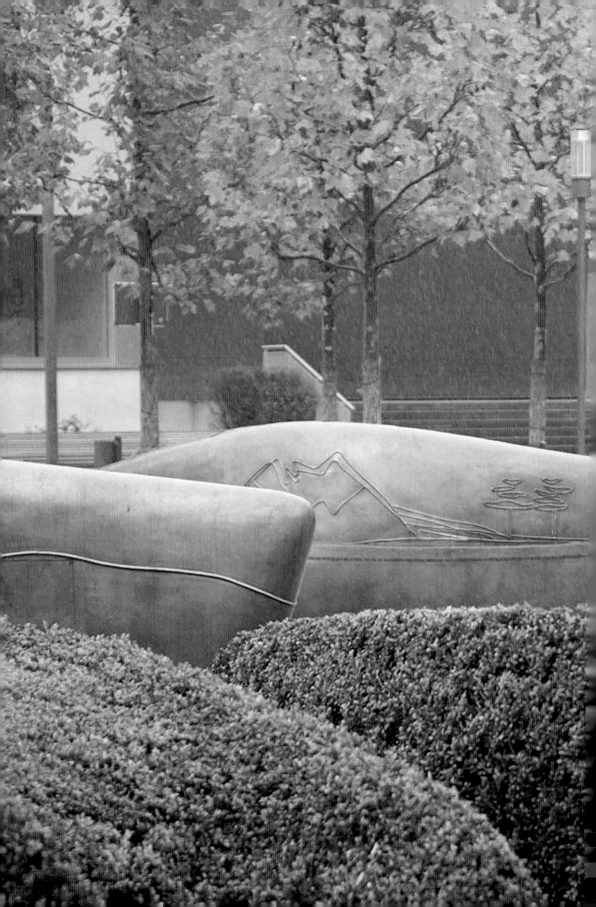

Herbst

Essay: Stadtleben am Brillplatz

Früh am Abend kommen Fadoklänge aus der Kneipe gegenüber vom neu gestalteten Brillplatz. Mathilde stammt aus Esch, wohnt aber seit Beginn des Studiums in der Stadt in Luxemburg. Heute ist sie mit ihrem Freund Vincent zu Besuch bei den Eltern und Großeltern. „Das war ein Parkplatz", sagt sie zu Vincent. „Ein Parkplatz?", fragt Vincent, „und wo sind die Autos jetzt?" „Unten auf drei Niveaus – hier ist die Einfahrt." „Oh je, oh je, da wachsen Bäume auf der Tiefgarage!" Vincent kommt aus dem Norden aus Elven und ist zum ersten Mal in Esch-sur-Alzette. Mathilde zeigt ihm die Fußgängerzone, das Theater, das Museum und die Brillschule, wo sie eingeschult wurde. Sie erzählt ihm von der Vielfalt im Brillviertel und von den Migranten, die zur Metallherstellung nach Esch kamen. Stolz sagt sie mitten auf dem Platz: „In Esch treffen sich alle Kontinente", und merkt, dass im Zentrum des Platzes fünf Landschaften als Reliefs auf den Bronzefiguren erscheinen. Vincent sagt: „Das ist ja die Toskana … aha … die Reisfelder, ein Berg … der Kilimandscharo." „Das da", sagt sie, „sieht aus wie der Amazonas-Fluss … schau mal Vincent, ist das nicht der rote Berg, der Ayers Rock, in Australien?". „Ja stimmt", und er zählt auf: „Europa, Asien, Afrika, Australien und Amerika. Du hast Recht, eine Begegnung der Kontinente." „Schau mal, die Skulpturen am Eingang bei den Hecken, die haben andere Zeichnungen." Sie gehen an den Rand des Platzes, um diese näher sehen zu können. Zwei junge Mädchen aus Afrika erzählen ganz stolz: „Das ist der afrikanische Kontinent und das ist der europäische Kontinent. Man erkennt an den Blättern, um welchen Baum es sich handelt. So kann man die Kontinente zuordnen: Die Eiche für Europa, ein Bananenbaum für Afrika, ein Tulpenbaum für Amerika, Bambus für Asien und der Brotfruchtbaum für Australien. Wir wohnen da oben und sehen jeden Tag auf den Platz." Sie führen ihre professionelle Führung für die beiden fort und erzählen mitten auf dem Platz, dass die Bilder der fünf Sichtfenster am Boden das Sternbild und die Landschaften auf der anderen Seite der Weltkugel zeigen. „Das ist viel weiter als die Heimat von meiner Mama und meinem Papa." Mathilde und Vincent holen für sich und die beiden ein Eis und sie legen sich alle gemeinsam auf den Rasen und denken: „Der Himmel ist überall gleich."

Essay: Urban Life at Brillplatz

Early in the evening the sounds of fado came from the bar opposite the newly designed Brillplatz. Mathilde is from Esch, but moved to the city of Luxembourg when she began her studies. Today she and her friend Vincent are visiting her parents and grandparents. "That used to be a parking lot" they say to Vincent. "A parking lot?" asks Vincent, "and where are the cars now?" "They're below ground, on three levels. Here's the entrance." "Hey, wait a minute, but there are trees growing on top of the parking garage!" Vincent is from Elven in the north and is in Esch-sur-Alzette for the first time. Mathilde shows him the pedestrian zone, the theatre, the museum and the Brill School, which she went to. She tells him about the diversity of the Brill neighbourhood, and about the migrants that came to the town because of the steel industry. As she is standing on the Plaza, she proudly says "In Esch, all of the continents come together", and she notices that in the centre of the plaza five landscapes created as reliefs on bronze figures are visible. Vincent says, "There's Tuscany … a ha … rice fields, a mountain … Kilimanjaro." "This," she says, "looks like the Amazon River. Look Vincent, isn't that that red hill, Ayers Rock in Australia?" "Yes, that's right." he says, and he counts: "Europe, Asia, Africa, Oceania and America. You're right, the continents meet here. Look, the sculptures near the entrance, next to the hedges, have different markings." They walked to the edge of the plaza in order to get a better look at these. Two girls from Africa who are 12 and 13 years old say proudly: "This is the African continent and that is the European continent. The leaves help you find out which trees there are, so you can figure out the continents: the oak for Europe, and a banana tree for Africa, a tulip tree for America, bamboo for Asia and a breadfruit tree for Oceania. We live up there and can see

the plaza every day." The girls continued with their guided tour for Mathilde and Vincent, and, while standing in the middle of the plaza said that the images of the five viewing windows in the ground show constellations and landscapes on the other side of the globe. "That's a lot further away than my mother's and father's home." Mathilde and Vincent buy some ice cream for themselves and the girls. Lying down on the grass together, they think "The sky is really the same everywhere".

Essai : Vie urbaine à la place de Brill

En début de soirée en face de la place de Brill redessiné retentissent des sons de Fado. Germaine est originaire d'Esch, vit depuis le début de ses études dans la ville de Luxembourg. Elle visite aujourd'hui avec Luc son ami ses parents et grands-parents à Esch.

Ce fut un parking dit elle à Luc, « Parking ? », répond Luc, « et où sont les voitures maintenant ? » « sur trois niveaux au sous sol – ici c'est l'entrée ». « Oh, oh les arbres poussent sur le garage! », s'exclame Luc. Luc est natif du nord de Elven, il est pour la première fois à Esch-sur-Alzette. Germaine lui montre la zone piétonne, le théâtre, le musée et l'école de Brill où elle a fait sa scolarisation. Elle lui parle de la diversité dans le quartier Brill et des migrants qui sont venus à Esch pour la production du métal. Elle dit fièrement au milieu de la place : « Tous les continents se rencontrent à Esch et a remarqué en même temps les cinq différents paysages qui apparaissent sur les sculptures de bronze. » Luc dit: « ceci c'est la Toscane, oh! les champs de riz, une montagne … le Kilimandjaro. » « Oh », dit-elle, « ca ressemble au fleuve d'Amazonie ».

Regarde Luc s'exclame t'elle, es ce la montagne rouge en Australie? « Oui », repondit t'il. Il compte sur les doigts : « L'Europe, l'Asie, l'Afrique, l'Australie et l'Amérique. Tu as raison, une rencontre des cinq continents. » Regarde s'exclame Germaine, les sculptures à l'entrée a coté des haies avec d'autres dessins. Ils courent vers le nord, afin de voir plus de plus prêt. Deux enfants originaires d'Afrique (12 et 13 ans) leurs disent fièrement : « ceci est le continent africain et ceci le continent européen, on reconnait cela grâce au feuillage et aux arbres qui a leur tour déterminent le continent. Nous habitons là-haut au 3eme étage et on observe tout les jours la place. » Elles ont joués les guides professionnels et racontent au milieu de la place que les images des cinq fenêtres de verres au sol visualisent des paysages de l'autre côté du globe. « Cela est beaucoup plus loin que la patrie de ma mère et de mon père. » Germaine et Luc ont acheté des glaces pour eux et les filles et se sont allongé tous ensemble sur le gazon en pensant que « le ciel est partout le même ».

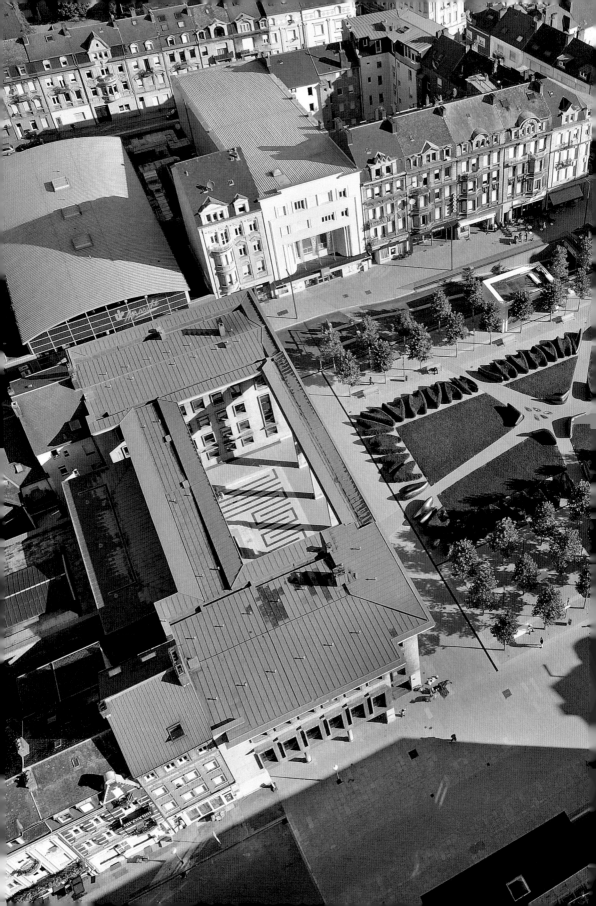

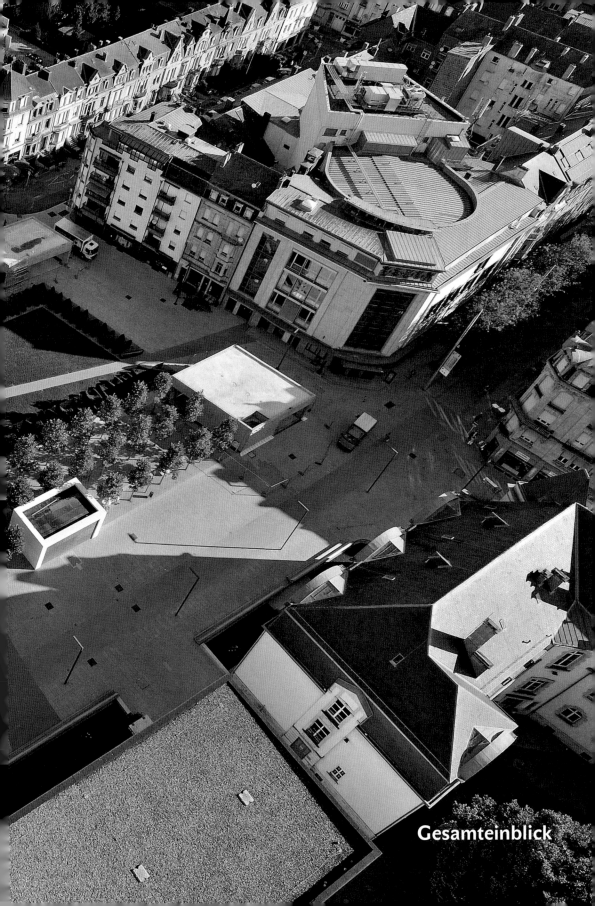

Gesamteinblick

Hecken und Bronze

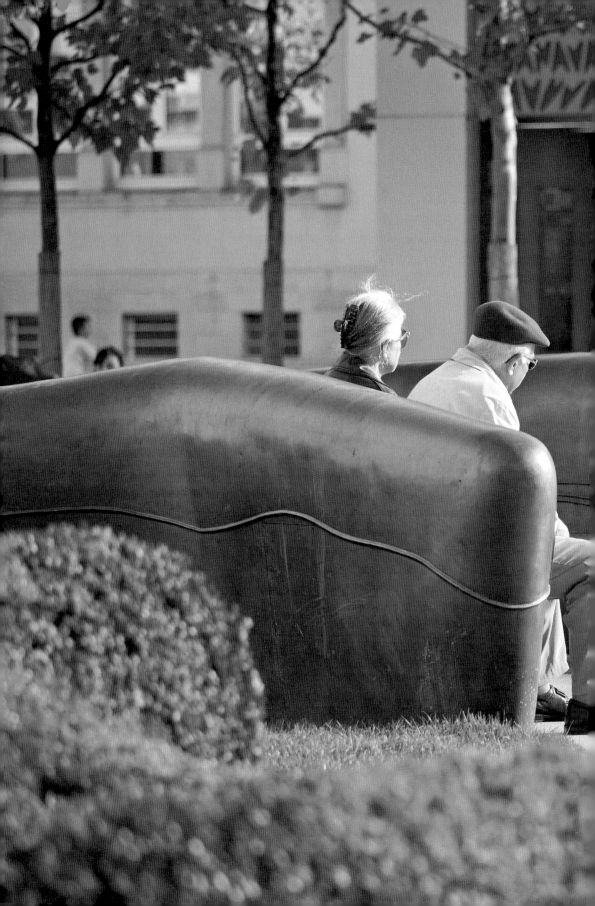

Kontinent auf Bronze

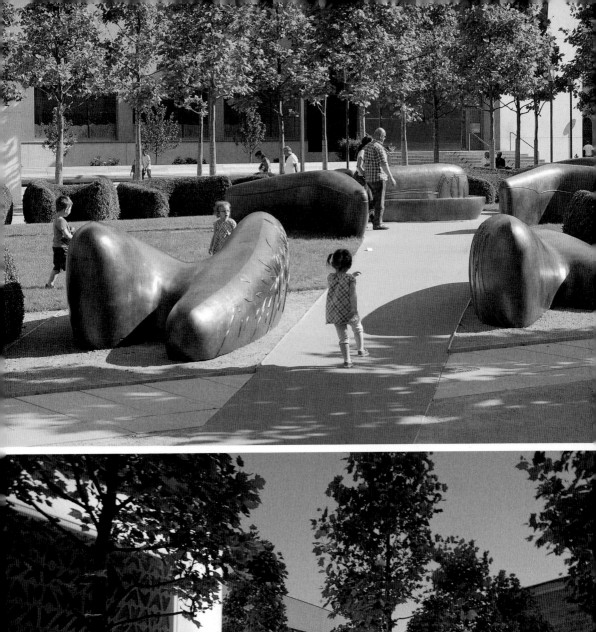

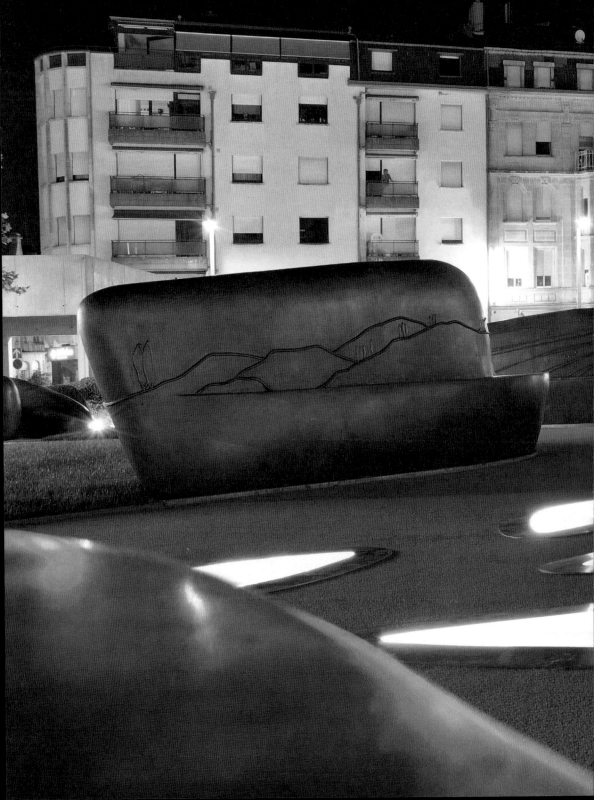

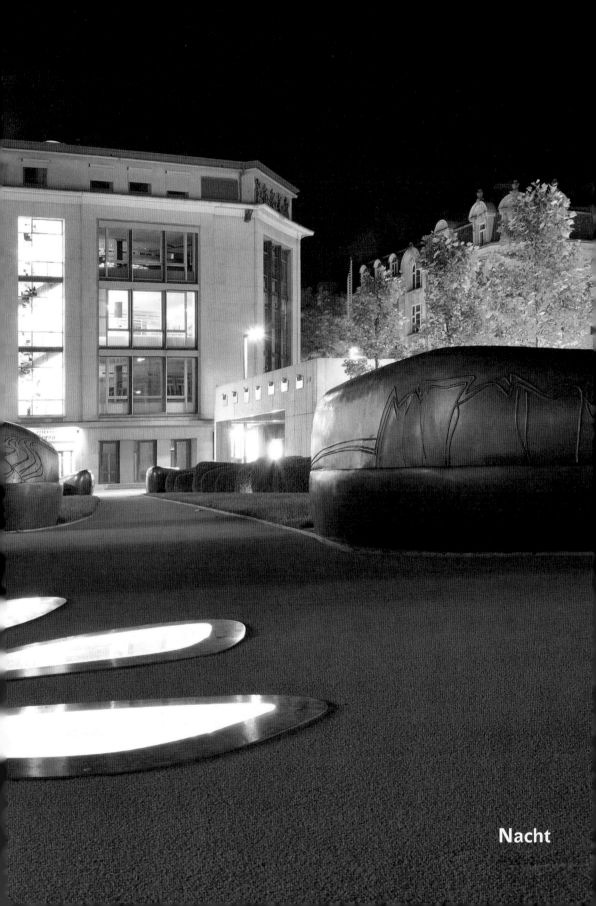

Nacht

Lichtfenster

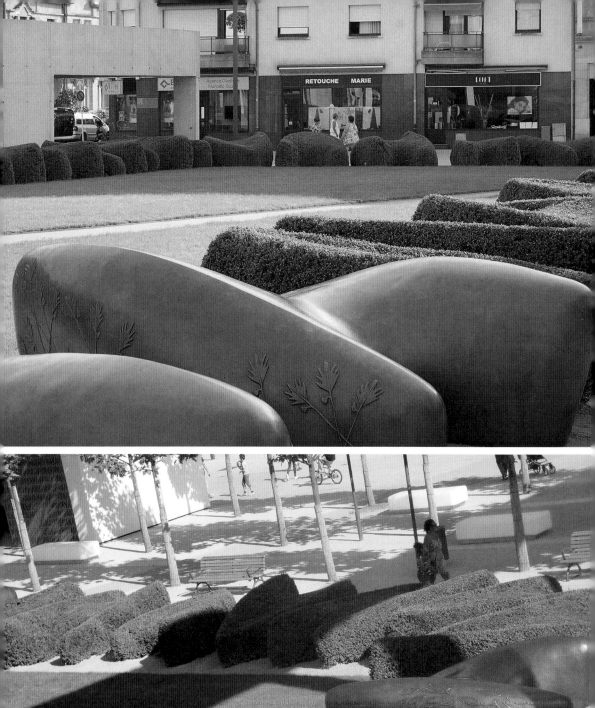
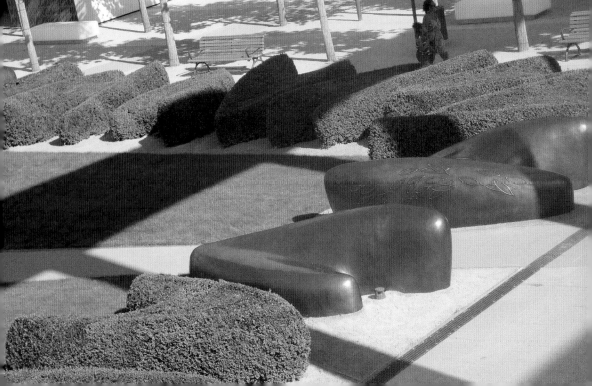

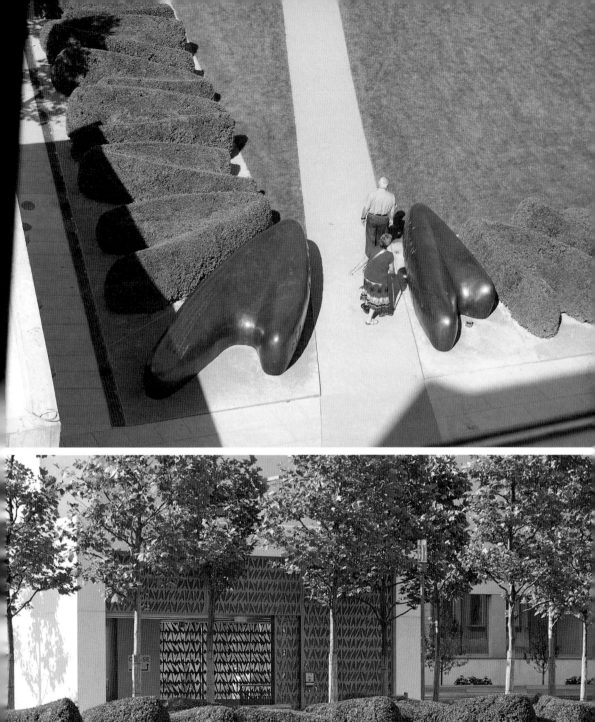
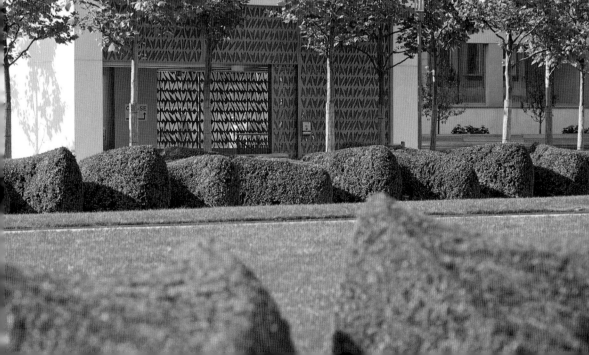

Die Nutzer

Der Place de la Résistance steht zum einen in der Tradition von Garten- und Landschaftskunst, zum anderen in der Tradition der öffentlichen Stadtplätze. Zwar liegen dem Platz formal ähnliche Gestaltungsprinzipien zugrunde wie historischen gartenkünstlerischen Anlagen, gebaut wurde er aber nicht für die private Nutzung einer wohlhabenden Elite, sondern als öffentlicher Platz für alle Bewohner. Und das scheint zu funktionieren. Im gesamten Gebiet von Al-Esch (dem alten Kern von Esch) fanden sich bisher keine Liegerasen. Die neu aufgewerteten Stadtplätze vernetzen zumeist Verkehrsflächen und sind traditionell gehalten: So ist zum Beispiel der Rathausplatz als klassischer, steinerner Marktplatz mit wenigen Bäumen und einem Wasserspiel konzipiert, der Place Boltgen als kleiner Stadtplatz mit Restaurants und Brunnen und der Place Saint-Michel bietet einen Baumhain. Die Tradition der betretbaren Rasenfläche befindet sich nur in den Parkanlagen jenseits des Ortskerns. Zur Steigerung der Aufenthaltsqualität in der Innenstadt wurde mit dem Wettbewerb ein grünes Pendant zum Rathausplatz gesucht.

Mit dem realisierten Entwurf für den Place de la Résistance bieten sich nun Flächen, die eine Nutzung im Sinne des von Monet gemalten „Frühstücks im Grünen" ermöglichen.

The Users

On the one hand, the plaza continues the tradition of garden and landscape art, while on the other it is an example of the traditions of public urban open space. Although the Place de la Résistance exhibits the formal design principles of historic parks and garden art, it was not built for the private use of wealthy elites, but as a public space for all of the city's residents. And this appears to work: The entire inner-city of Esch (the old core area) has no other sunbathing lawns. Other recently improved urban plazas serve as links between traffic areas and are rather traditional. For instance, City Hall Plaza is a classic, paved market area with a water feature and few trees, the Place Boltgen is a small urban plaza with restaurants and fountains, and the Place Saint-Michel offers little more than a grove of trees. The tradition of accessible lawn areas is only to be found in parks located outside the city centre. The objective of the competition was to provide a green counterpart to City Hall Plaza as a way of increasing residents' quality of life in the city.

The built design at Place de la Résistance now offers such space, a space that can be used in the sense of Monet's painting "Luncheon On The Grass".

Les usagers

La place s'inscrit d'une part dans la tradition de l'art de l'agencement des jardins et des paysages et d'autre part dans la tradition des places publiques. Si la place de la Résistance est construite sur le plan formel selon les principes des jardins historiques, elle n'est pas conçue pour l'usage privé d'une élite aisée, mais bien comme une place publique pour tous les habitants d'Esch, ce qui semble se confirmer : dans le quartier d'Al-Esch (l'ancienne ville d'Esch), il n'y avait pas encore d'espace de repos. Les places publiques récemment réhabilitées relient la plupart du temps des zones de circulation et restent traditionnelles. Ainsi, la place de la Mairie par exemple est une place de marché pavée traditionnelle avec peu d'arbres et un jet d'eau, la place Boltgen est une petite place avec des restaurants et une fontaine et la place Saint-Michel compte seulement quelques arbres. La tradition des pelouses sur lesquelles on peut marcher se retrouve uniquement dans les parcs hors du centre-ville. Pour améliorer la qualité de vie dans le centre, on cherchait justement avec l'appel d'offres public à créer un pendant vert à la place de la Mairie.

Le projet ainsi réalisé pour la place de la Résistance offre des espaces qui permettent une utilisation dans le sens du tableau de Monet, Le déjeuner sur l'herbe.

DER PROZESS,
die Realisierung

Die Realisierung der Entwürfe mit einem Höchstmaß an Präzision in der Geometrie schien für viele Beteiligte übertrieben. „Es ist ja nur ein Garten! Ein Vorplatz!", waren die Kommentare. Das Beharren auf der Entwurfsgeometrie und deren präzise Einhaltung spielten eine wichtige Rolle bei der Herstellung der Bronzeskulpturen für das Projekt Place de la Résistance in Esch-sur-Alzette in einer Gießerei in Straubing, Bayern und der Herstellung der Steinskulpturen für den Trammplatz in Hannover in Spanien, insbesondere in Zusammenhang mit den anderen Gewerken in der Einbauphase. Sowohl in Esch als auch in Hannover wurde unser Beharren auf Präzision oft erst beim Einbau verstanden.

Oft waren die Durchsetzung unserer gestalterischen Ansprüche und die dazugehörigen Dialoge mit anderen Planern mühsam und langatmig. Für uns galt es, diesen Anspruch nicht aufzugeben und auch offensiv zu agieren und Präsenz zu zeigen.
Beispielsweise erfuhren wir zwei Jahre lang nicht von den regelmäßigen Planersitzungen in Esch-sur-Alzette. Das Bestreben der Kollegen und Planer vor Ort war es, uns vom Geschehen fern zu halten. Es wurde uns immer wieder von der Projektsteuerung mitgeteilt, dass wir keine Zuständigkeit hätten, mit den ausführenden Tiefbaufirmen vor Ort zu sprechen bzw. korrektiv zu agieren. Das offensive Beharren auf „gestalterischen Inhalten" auf höchster Ebene wie auch die intensive Präsenz vor Ort hat sich aber über alle Maßen gelohnt. Die Zuständigkeit für das Projekt wanderte rechtzeitig vom Tiefbauamt an die Architekturabteilung der Stadt und das Projekt reüssierte.

Das Abwenden von Änderungen am gestalterischen Inhalt ist oft sehr schwierig, vor allem wenn die anderen Parteien nicht verstehen, dass eine Entwurfsidee immer eine persönliche geistige Schöpfung ist und mit keinem anderen geteilt werden kann. Das Beharren auf der eigenen Idee oder gar dem eigenen Gestaltungsverständnis führt oft dazu, dass der Verfasser als „schwierig" gilt.

Der Place de la Résistance/Platz der fünf Kontinente in Esch-sur-Alzette und der Rathausvorplatz/ Trammplatz in Hannover standen von Anfang an – auch in unserem Gestaltungsverständnis – zum einen in der Tradition von Garten- und Landschaftskunst, zum anderen in der europäischen Tradition der öffentlichen Stadtplätze. Zwar liegen den beiden Plätzen formal ähnliche Gestaltungsprinzipien wie bei historischen gartenkünstlerischen Anlagen zugrunde, gebaut wurden sie aber nicht für die private Nutzung einer wohlhabenden Elite, sondern als öffentliche Plätze. Und das scheint zu funktionieren. Die Reflexionen in unserem alltäglichen Schaffen sollen vielfältig, poetisch und visionär sein, die Ansätze sollen immer stellvertretend für die ganze Profession der Landschaftsarchitekten den Umgang im urbanen Kontext reflektieren. Die Entwürfe sollen die Einbindungskraft und die Fähigkeit der Gestalter zeigen, sich auch an einem abstrakten Ort zu positionieren, nach dem Motto: „Es gibt keinen Ort, an dem es nichts gibt." Wie die meisten Planer lassen auch wir uns für unsere Entwürfe von Ort und Kontext inspirieren. In Hannover wurde zum Beispiel die Leitidee für das Platzdesign des Trammplatzes aus einem Pflanzenmotiv des Stadtwappens am städtischen Rathaus abgeleitet – der Klee als Gestaltungselement, das auch das angrenzende Maschparkensemble sowie die Leitlinien der Stadt Hannover als „Stadt der Gärten" mit einbezieht. In Esch-sur-Alzette, der Stadt der Eisenerze und der Immigration, waren dies die Motive aus denen die Gestaltungselemente abgeleitet wurden; es entstand ein Platz der fünf Kontinente mit Skulpturen aus dem Edelmetall Bronze.

Somit speist sich die Faszination des Berufs unter anderem aus der Vielschichtigkeit der Aufgaben bei der Gestaltung von immer wieder anderen Orten auf unterschiedlichen Maßstabsebenen und mit unterschiedlichen Zielsetzungen: mal repräsentativ, mal nutzerorientiert.
„Wenn die Musik [laut Daniel Barenboim] die Beziehung von Klang und Stille ist, den Raum zwischen Leben und Tod füllt, dann gilt dies auch für die Gartenkunst. ‚In der Musik ist man ständig mit Phänomenen konfrontiert, über die man keine Kontrolle hat.' In der Gartenkunst ist es ähnlich. In einem Kon-

zert ist nicht der Applaus das Entscheidende für den Künstler, sondern die Stille mit der seiner Musik begegnet wird. Man muss allerdings die Musikwahrnehmung erlernen, wie man auch die Gartenwahrnehmung erlernen muss." [5]

The Process, the Realisation

The construction of the designs involved a high degree of precision with regard to the geometry, which seemed exaggerated too many of those involved: "It's only a garden! A forecourt!" were some of the comments. Insistence on the precise adherence to the design's geometry at a foundry in Straubing, Bavaria was very important during the creation of the bronze sculptures for the Place de la Resistance project in Esch-sur-Alzette and the production of the stone sculptures in Spain for the Trammplatz in Hanover. This was especially important in conjunction with the other trades who were to work on this phase of installation. In both Esch and Hanover the client often first understood our intent when the installation was completed.

Getting everyone to accept our design requirements, and the accompanying dialogues with other planners were often painstaking and lengthy. For us it was important to remain defiant and insist on our demands, but we had to actively argue our case and have a strong local presence.
For example, for two years we were not informed of regularly held planners' meetings in Esch-sur-Alzette. Local planners and colleagues tried to keep us away from the action. Project managers told us time and time again that we had no authority that would enable us to talk with construction firms on site or try to improve their work. Our active insistence at high levels with regard to the creative content and our intensive presence on the site paid off beyond measure. Responsibility for the project was transferred from the city's civil engineering department to its architecture department at an early point in time and the project was successful in the end.

Preventing changes from being made to the design content is often very difficult, especially when other parties fail to understand that a design idea is always a very personal intellectual creation which cannot be shared with anyone else. Insisting on one's own idea or understanding of design often results in the designer being labelled as "difficult".

We always felt that the Place de la Résistance/Plaza of Five Continents in Esch-sur-Alzette and the Trammplatz in front of Hanover's City Hall were part of the tradition of garden and landscape art on the one hand, and part of the European tradition of public urban plazas on the other. Although both plazas formally represent similar design principles and are examples of historic garden design, neither was built for the private use of a wealthy elite, but rather as public plazas. And this appears to work. The reflections we had in our everyday work needed to be diverse, poetic and visionary, and the approaches had to always reflect how the entire profession of landscape architecture deals with an urban context. The designs needed to illustrate the imagination and ability of the designer to position themselves in an abstract place according to the principle of "There is no place where there is nothing". Like most planners, our designs are inspired by the site and the context. In Hanover, for example, we developed the main idea for

5 Aussagen zur Gartenkunst in Beziehung gebracht zu Interviewaussagen Barenboims zur Musik.
 Aus: Beitmann, Bert: *Theorie der schönen Gartenkunst 2009. Geschichte der Gartenkunst* Band XII / I–IV, S. 17.
 www.gartenkunst-beitmann.de

the design of the plaza from the floral motive in the coat of arms at the City Hall – clover as a design element – which also includes both the adjacent Maschpark and the city's guiding principles as the "City of Gardens".

In Esch-sur-Alzette, the city of iron ore and immigration, these two things served as the motive upon which the design elements were based; the Plaza of Five Continents was created with sculptures made from the noble metal bronze. And thus the fascination of the profession feeds on, among other things, the complexity of the task when designing different locations at different scales and with different objectives: sometimes representative and sometimes user-oriented.

"If music [according to Daniel Barenboim] is the relationship between sound and silence that fills the space between life and death, then this also applies to the art of the garden. 'In music one is constantly faced with phenomena that one has no control over'. This is the same case with gardens. The applause at a concert is not the most important thing for the artist, but rather the silence with which his music is received. You have to learn how to perceive music, however, just like you have to learn how to perceive the garden." [5]

Le Processus, la Réalisation

La réalisation du projet avec une extrême précision dans la géométrie semblait exagérée à beaucoup de participants : « Ce n'est qu'un jardin ! Une avant-place ! » – tels étaient les commentaires. S'en tenir fermement et précisément à la géométrie prévue par l'ébauche était très important lors de la réalisation des sculptures en bronze, conçues dans une fonderie bavaroise de Straubing pour la « Place de la Résistance » à Esch-sur-Alzette, et lors de la production en Espagne des sculptures en pierre pour la Trammplatz à Hanovre, surtout en rapport avec d'autres ouvrages dans la phase d'installation. Que ce soit à Esch ou à Hanovre, notre insistance n'a été comprise que lors de l'installation justement.

Il a été souvent long et difficile de faire valoir nos exigences créatrices et de mener les dialogues avec les autres planificateurs. Pour nous, il s'agissait de ne pas renoncer, d'agir de façon offensive et de marquer notre présence.
À titre d'exemple : deux années durant, nous n'avons rien su des réunions qui se menaient régulièrement à Esch-sur-Alzette. Les collègues et planificateurs sur place ont tout fait pour nous tenir à l'écart. Les responsables du projet nous ont communiqué à plusieurs reprises que je n'étais pas autorisé à parler directement avec les entreprises de BTP locales ni à intervenir pour « corriger ». L'insistance tenace sur les « contenus créatifs » au plus haut niveau de même qu'une présence intense sur place ont été plus que rentables. La responsabilité du projet est passée à temps du BTP au département architecture de la ville – et le projet a abouti.

Il est souvent très difficile de désamorcer les modifications du contenu créatif, surtout quand les autres parties ne comprennent pas qu'une conception est souvent une création personnelle de l'esprit qui ne peut être partagée avec d'autres. En insistant sur sa propre idée ou sur son approche créatrice, l'auteur encourt bien souvent le risque d'être qualifié de « difficile ».

5 Statements about gardens as an art form put in relationship to remarks made by Daniel Barenboim in an interview about music. In: Beitmann, Bert, *Theorie der schönen Gartenkunst 2009. Geschichte der Gartenkunst*, vol. XII/I–IV, p. 17. www.gartenkunst-beitmann.de

La Place de la Résistance ou Place des 5 Continents à Esch-sur-Alzette et le parvis de l'hôtel de ville ou Trammplatz à Hanovre s'inscrivaient d'emblée, également par rapport à notre conception créative, d'une part dans la tradition de l'art des jardins et des paysages, de l'autre dans la tradition européenne des places publiques dans la ville. Même si les deux places relèvent de principes créatifs et de conceptions paysagères historiques semblables, elles n'ont pas été construites à des fins d'utilisation privée par une élite aisée mais comme lieux publics. Et il semble que cela fonctionne. Les réflexions dans notre travail quotidien de création doivent être multiples, poétiques et visionnaires ; les approches doivent toujours être le reflet de toute la profession des architectes paysagistes dans leur rapport au contexte urbain. Les projets doivent montrer une force d'intégration et la capacité des planificateurs à se positionner aussi dans un lieu abstrait – selon la devise : « Il n'y a pas de lieu où il n'y a rien. » Comme la plupart des planificateurs, nous nous laissons inspirer par le lieu et le contexte. À Hanovre, par exemple, l'idée qui a dicté le dessin de la place Trammplatz est née d'un motif végétal figurant dans les armes de la ville : le trèfle est ainsi devenu élément de création, englobant aussi l'ensemble adjacent du Maschpark et la notion de « ville des jardins » que prône la ville de Hanovre.

À Esch-sur-Alzette, ville de sidérurgie et d'immigration, offrait par là les motifs repris dans la configuration de la place : ainsi est née les Place des 5 continents, avec des sculptures en bronze.

La dimension fascinante de notre métier est entre autres dans la multiplicité des tâches à accomplir en des lieux les plus divers, aux proportions et finalités les plus différentes : tantôt représentatives, tantôt tournées vers les utilisateurs.

« Si la musique [d'après Daniel Barenboim] est le rapport entre le son et le silence qui remplit l'espace entre la vie et la mort, alors cela vaut aussi pour l'art des jardins. Dans la musique, on est en permanence confronté à des phénomènes que l'on ne contrôle pas. Il en va de même dans l'art paysager. Dans un concert, ce ne sont pas les applaudissements qui sont décisifs pour l'artiste, mais le silence avec lequel sa musique est accueillie. Percevoir la musique s'apprend, tout comme l'on doit apprendre à percevoir les jardins. » [5]

5 À propos de l'art des jardins, en allusion à une interview de Barenboim sur la musique.
 Extrait de : Beitmann, Bert, Theorie der schönen Gartenkunst 2009. Geschichte der Gartenkunst, vol. XII / I–IV, p. 17, www.gartenkunst-beitmann.de

PUBLIC SPACES – WOZU?
Schlussfolgerung

Bereits bei der Eröffnung des Platzes der fünf Kontinente in Luxemburg hörten wir kritische Stimmen, die diese Maßnahme an diesem Ort nicht für gut hießen: „Ein schwieriges Viertel, ob Kunst überhaupt hierher passt?" Die Freude darüber, wie die Kinder und die Einwohner den Platz in Besitz genommen haben, entschädigte uns für die Mühe und die Auseinandersetzungen in den ganzen Jahren der Planung und den Jahren danach.

Ebenso waren zum Trammplatz in Hannover, trotz allgemein positiver Reaktionen, hier und dort Stimmen zu hören, die bemängelten, dass der Platz „zu wenig grün" sei – die Vorgaben zur Gestaltung eines mineralischen Platzes sahen aber vor allem eine Nutzung mit Veranstaltungen wie Marathonläufe mit Ständen oder Stadtfeiern vor.

Es stellt sich die Frage, ob sich Gestaltungsziele für Plätze im öffentlichen Raum trotz all dieser Widersprüche, Thesen, Themen und Verfahren, auch wenn sie kontraproduktiv sind, entwickeln lassen? Wir meinen: ja!

Wir können als Gestalter keine Aussage darüber machen, wie soziale Probleme in den Städten gelöst werden können, wir dürfen uns auch nicht dazu verleiten lassen, in die Position der Stadtsparer zu verfallen, die bewerten, ob dieses oder jenes Viertel eine Veränderung verdient hat. Unser gestalterischer Anspruch soll dazu führen, dass jeder einen Anspruch auf Kontemplation und Erholung im Außenraum hat – soweit dies möglich ist. Unsere Außenanlagen sollen Begegnungen und Aufenthalt ermöglichen. Dabei sollen die vorgesehenen Flächen selbstverständlich robust gestaltet werden, um Beeinträchtigungen durch die Nutzung möglichst gering zu halten. Wir können keine Hundehalter davon überzeugen, dass der Rasen für Kinder und liegende Personen gedacht ist. Grünanlagen und Plätze funktionieren nur dann, wenn die Politik richtungsweisend agiert, sodass eine Anlage für Menschen unterschiedlichen Alters, unterschiedlicher Herkunft und aus verschiedenen sozialen Schichten geeignet ist und sich dadurch alle Nutzer mit dem Ort identifizieren können. Wir können auch nicht die Stadtverwaltung davon abbringen, am Viktoria-Luise-Platz in Berlin-Schöneberg aus Kostengründen (Einsparung von ca. 5000 Euro im Jahr) Staudenflächen in Mulchflächen umzuwandeln, wodurch nach und nach die Gartentradition in der Stadt eliminiert wird. Dr. Klaus-Henning von Krosigk, ehemaliger Leiter der Gartendenkmalpflege beim Landesdenkmalamt in Berlin und wie wir Anwohner am Platz, zeigte in verschiedene Gesprächen seine ganze Frustration über den Abbau der Gartenkultur.

„Die Stadtverwaltung Berlin hat große Pläne für Berlins Mitte. Bausenator Andreas Geisel sucht die Entscheidung im Streit um die Gestaltung der historischen Mitte. Ein ‚öffentliches Dialogverfahren' soll alle einbinden – Experten, Berliner, Touristen, Historiker, Unternehmer, Anwohner – und die besten Ideen zu dessen Nutzung einsammeln. Der Senator Geisel will die Ergebnisse als ‚Manifest' dem Abgeordnetenhaus vorlegen, das dann entscheidet, wie das Areal genutzt wird. Welche Gebäude und Plätze dazu erforderlich sind, entscheiden dann Wettbewerbe: zum Städtebau und zur Architektur… Über die Ergebnisse des ‚Dialogverfahrens' entscheiden letztlich die Machtverhältnisse im Parlament" (Ralf Schönball im Tagesspiegel vom 21.01.2015). Ein partizipatives Verfahren in 2014 für die Umgestaltung am Gendarmenmarkt unter der Leitung von Senatsbaudirektorin Regula Lüscher und Landschaftsarchitekt Till Rehwald war an diesem Dialogverfahren gescheitert und zeigt, wie unstabil solche Verfahren sind.

Hamburg verfolgt ein ähnliches Vorgehen: In dem städtebaulich-freiraumplanerischen Wettbewerbsverfahren in Wilhelmsburg „Auf gute Nachbarschaft – Wohnen und Arbeiten zwischen den Kanälen" wurde durch Einbeziehung von Bürgerinitiativen sowie Anrainern in der Zwischenpräsentation eine durchaus positive Partizipation erreicht, welche die Planer in ihrem Entwurf nicht hemmt, aber es ihnen ermöglicht, Antworten auf die Bedürfnisse der Anwohner zu artikulieren.

Diese Verfahren haben mögliche Konflikte aufgezeigt und können eventuell zu einer Stärkung der Stadtentwicklung und zur Entwicklung eines Leitbilds führen, sodass adäquate Gestaltungsentwürfe entstehen. Daraus ließe sich ein „Manifest" zur Stadtentwicklung ableiten. Es können auch neue Formen der Herangehensweise zur Gestaltung in der Stadtentwicklung entstehen. Neben den gestalterischen

Grundsätzen in der Ideenfindung können im Entwurf Nutzungsansprüche gleichermaßen wie ästhetische Belange mit einfließen und artikuliert werden.

Bei der Gestaltung des öffentlichen Raumes geht es nicht nur um die Stärkung der Aufenthaltsqualität und die Forderungen des sozialen Lebens, sondern auch um die Aufwertung des Stadtbildes, die Attraktivität und Nachhaltigkeit des Ortes sowie die Identifikation möglichst vieler Bürger mit ihrer Stadt. Die Platzgestaltung reflektiert auch die kulturelle Bedeutung und Identität der Stadt.
Aber die Gestaltung des öffentlichen Raumes kann nur erfolgreich für alle Beteiligten sein, wenn im Vorfeld für alle Akteure klare Regeln definiert sind. Die Erfahrung zeigt, dass eine intensive Partizipation vor einer Wettbewerbsausschreibung erfolgen sollte. Es ist durchaus positiv, für jedes Projekt die Wünsche der Beteiligten in der Wettbewerbsaufgabe zu definieren und somit eine größtmögliche Berücksichtigung in den prämierten Arbeiten zu finden. Diese Herausforderung ist von den Planern anzunehmen, um neue Gedanken zur Entwurfsidee zu entwickeln und Entwürfe zu liefern, die einerseits mündige Bürger, Politiker, Investoren, Bürgerinitiativen und Preisgerichte gleichermaßen überzeugen und andererseits auch bei Änderungswünschen stabil genug sind, um am Ende eine Wiedererkennbarkeit zu gewährleisten.
Letztendlich ist es auch wichtig, dass die Kreativen die Lust an der Planung nicht verlieren.

Public Spaces – What for? Conclusion

At the opening of the Plaza of Five Continents in Luxembourg there were already some critical voices; people who did not think the design was appropriate for this area: "This is a difficult neighbourhood, I wonder whether art is appropriate here at all?" The joy of seeing how children and residents claimed the plaza for their own was compensation for all of the effort and conflicts throughout the years of planning and the time afterwards.
And despite the generally positive reaction to the changes at Trammplatz, there were also a few critical voices here and there that felt the plaza had "too little vegetation". The demands of use, however, required us to design a paved plaza at Hannover's City Hall that could be used for long-term events ranging from marathons to city-wide celebrations.
This raises the question of whether the objectives of the design of public space can actually be developed despite all of the contradictions, theories, topics and procedures? We feel strongly that they can.

As designers we can't say much about how social problems in cities should be solved, and we must not let ourselves be put into the position of trying to save cities money, to evaluate whether this or that neighbourhood deserves to be changed. Our design aspirations should always be that everyone has a right to contemplation and relaxation in parks and open areas, if possible. Our open areas should allow people to meet and spend time in them. In designing them, however, we need to create facilities that are robust enough that they can stand up to the wear and tear of use to the greatest extent possible. We won't be able to convince dog owners that the grass is only for children and people who want to sunbathe. Parks and plazas only function when policies are proactive and point the way, so that places are created for people of different ages, backgrounds and social classes. This way, users will be able to identify themselves with the place. And in Berlin-Schöneberg we were also unsuccessful in preventing the city's administration from turning planting beds for perennials into beds of mulch at Viktoria Luise Plaza in order to save about €5000 per year. Transformations like this have gradually led to the elimination of garden culture in cities. Klaus-Henning von Krosigk, former head of the Department for Historic Garden Monuments at the State Monuments Office in Berlin lives next to this plaza, as do we, and at various meetings gave vent to his great frustration at the elimination of this garden culture.

"Berlin's municipal government has big plans for the centre Berlin. The senator in charge of building in the city, Andreas Geisel, is trying to find a solution in the dispute about the design of the historic centre. A 'public process of dialogue' is intended to include everyone involved, i.e. experts, residents, tourists, historians and businesses in order to compile the best ideas for its use. Senator Geisel wants to present the results in the form of a manifesto to the House of Representatives, which will then decide how the area should be used. Design competitions will then be held to decide which buildings and plazas, i.e. urban planning and architecture, are necessary. The balance of power in Parliament will thus ultimately decide what the results of the dialogue process will be" (Ralf Schönball, Tagesspiegel, 21 January 2015). In 2014 a participatory process for the redesign of the Gendarmenmarkt headed by the director of Urban Development Regula Lüscher and landscape architect Till Rehwald failed, illustrating just how unstable such methods are.

Hamburg is attempting a similar process. The urban and open space planning competition in the Wilhelmsburg section of the city called Aiming for a Good Neighbourhood – Homes and Workplaces between the Canals – North-South Axis involved citizens' initiatives and local residents, and the interim presentation was well received. This process didn't appear to limit the planners and allowed them to articulate the needs local residents have in their designs.

These procedures have certainly illustrated what conflicts there are and may possibly lead to a strengthening of urban development, from which a model could be developed that would encourage the use of appropriate design. A manifesto for urban development could then be derived from this. New approaches to design in urban development may also occur as a result of this. In addition to design principles being used in the generation of ideas, both usage requirements and aesthetic concerns could be incorporated in the initial design and further articulated upon.

The design of public space is not only concerned with improving its overall quality and promoting social interaction, but also with an improvement of the cityscape and the attractiveness and sustainability of the site, as well as helping to make it a source of identification with the city for as many residents as possible. Plaza design also reflects a city's cultural significance and identity.

But the design of public space can only be successful for everyone involved if clear rules for all the actors are clarified and defined in advance. Experience shows us that intensive participation should occur before a competition tender is developed. It is certainly positive for every project when the wishes of those involved are defined in the competition in order that they are considered as much as possible in the award-winning submissions. This challenge needs to be accepted by planners in order for them to develop new ideas when going through the process of design, so that they can convince active citizens, politicians, investors, citizens initiatives and juries alike and have designs that are stable enough to deal with desired changes while remaining clearly distinct and recognisable.

And ultimately, it is also important that creative people don't lose their interest in planning.

Public spaces - pourquoi ? Conclusion

Dès l'inauguration de la Place des 5 Continents au Luxembourg, les premières critiques se firent entendre qui réprouvaient les mesures prises en cet endroit : « Un quartier difficile… L'art y a-t-il vraiment sa raison d'être ? » La joie avec laquelle les enfants et les riverains s'approprièrent la place nous consola de tous les efforts et confrontations que nous avions connus pendant les années de planification et même après.

Malgré des réactions positives, il en alla de même pour la Trammplatz à Hanovre : d'aucuns déplorèrent par exemple que la place ne soit pas « assez verte ». Or les consignes prévoyaient pour le parvis de

l'hôtel de ville de Hanovre une place minérale permettant tout type de manifestations, la disposition de stands pour le marathon ou des cérémonies officielles.

La question se pose si les objectifs de l'aménagement d'espaces publics peuvent être maintenus, en dépit des désaccords, thèses et procédures qui peuvent être contre-productifs ? Notre réponse est « oui » !

En tant que planificateurs, nous ne pouvons dire comment doivent être résolus les problèmes sociaux dans les villes ; nous ne devons pas non plus nous laisser entraîner dans la position de ceux qui veulent restreindre les budgets et juger si tel ou tel quartier a mérité une requalification. Notre revendication créatrice doit permettre à chacun, si possible, contemplation et détente dans l'espace extérieur. Nos espaces urbains doivent faciliter les pauses et les rencontres. Les superficies prévues à cet effet doivent bien sûr être suffisamment robustes pour être le moins possible endommagées par l'utilisation. Nous ne sommes pas à même de convaincre les propriétaires de chien que le gazon est prévu pour les enfants et les personnes souhaitant s'allonger un moment. Les espaces verts et les places ne fonctionnent que si la politique montre la direction, de sorte à ce que ces espaces soient pour tous les individus, indépendamment de leur âge, de leur origine et de leur appartenance sociale : il faut que les utilisateurs puissent s'identifier avec le lieu. Nous ne pouvons pas non plus empêcher que la municipalité de Berlin-Schöneberg, pour des raisons financières (et une économie d'environ 5 000 € par an), élimine les plantes vivaces (fleuri) de la Viktoria-Luise Platz pour les remplacer par des graviers, bannissant ainsi progressivement la tradition des jardins en ville. – Dr Klaus-Henning von Krosigk, ancien conservateur responsable des jardins historiques à la Direction générale du patrimoine de Berlin – et riverain de cette place, comme nous – a exprimé à plusieurs reprises, dans diverses interviews, son grand mécontentement à propos de la disparition de cette culture des jardins.

« La mairie de Berlin a de grands projets pour le centre-ville (Mitte) – le senateur à l'urbanisme Andreas Geisel cherche une issue au conflit concernant l'aménagement du centre historique. Un ‹ dialogue public › doit impliquer tout le monde – experts, Berlinois, touristes, historiens, entrepreneurs et résidents – et recueillir les meilleures idées quant à son usage. Le sénateur Geisel entend soumettre les résultats sous forme de ‹ manifeste › aux députés qui décideront ensuite comment sera utilisé ce secteur. Les bâtiments et places nécessaires seront soumis à concours sur l'urbanisme et l'architecture… Mais ce sont en fin de compte les forces en place au parlement qui décideront de l'issue de ce ‹ dialogue › » (Ralf Schönball Tagesspiegel, 21 janvier 2015). En 2014, une procédure participative pour le réaménagement du Gendarmenmarkt, sous la direction de la responsable à l'urbanisme Regula Lüscher et de l'architecte paysager Till Rehwald, a échoué, montrant l'instabilité de ce genre de méthodes.

De même, Hambourg a engagé une procédure analogue. Lors du concours pour l'aménagement de l'urbanisme et des zones non-construites à Hambourg-Wilhelmsburg, sur le thème du « bon voisinage entre habitat et commerces » (entre les canaux, sur l'axe nord-sud), l'implication des initiatives citoyennes et des riverains lors de la présentation intermédiaire a donné une participation tout à fait positive qui ne bloque pas les planificateurs mais leur permet au contraire de trouver et de formuler dans leur projet des réponses aux besoins des habitants.

Ces procédés ont en tout cas révélé qu'il peut y avoir des conflits et que cela peut éventuellement mener à un renforcement de l'aménagement urbain selon des projets adaptés. Un « Manifeste » sur le développement urbain peut ainsi en découler. De nouvelles approches peuvent également voir le jour pour concevoir le développement d'une ville. Outre les principes de création dans la recherche de l'idée, les revendications fonctionnelles peuvent être prises en compte, pendant l'élaboration du projet, au même titre que les questions esthétiques.

L'aménagement de l'espace public ne consiste pas seulement à renforcer la qualité et les exigences de la vie sociale ; il s'agit aussi de valoriser l'image de la ville, d'encourager l'attractivité et la pérennité du lieu, et de favoriser l'identification des citoyens avec leur ville. Une place, dans la manière dont elle est dessinée, reflète aussi l'identité et la signification culturelle d'une ville.

Mais la conception de l'espace public ne peut être réussie pour toutes les personnes impliquées que si les règles sont clairement définies et posées au préalable auprès de tous les acteurs. L'expérience montre qu'une participation intense devrait avoir lieu avant la phase du concours. Car il est positif pour n'importe quel projet de tenir compte des désirs des personnes concernées dans le lancement d'un concours, de sorte que les travaux primés soient au plus près de ces attentes. Les planificateurs doivent relever ce défi pour développer de nouvelles idées et proposer des projets qui, d'une part, sachent convaincre pareillement les citoyens, les politiques, les investisseurs, les initiatives citoyennes et les jurys, et, d'autre part, soient suffisamment stables en cas de modifications pour garantir in fine que tout le monde s'y reconnaisse.

Il est finalement important aussi que ceux qui créent ne perdent pas l'envie de planifier.

Author

Kamel Louafi, born in Batna/Algeria, is an Algerian-German author, topographer, landscape architect and artist. Founding of Kamel Louafi landscape architecture office in Berlin in 1996. Numerous awarded and successfully completed works of landscape architecture and art in public space in Europe, Algeria and Orient. Since 2000 one of several curators at the architecture gallery AEDES Berlin. Jury member for national and international design competitions, teaching at the German Foundation for International Development in Bonn as well as at universities in Berlin, Barcelona, Algiers, Paris, Oslo and Lüneburg. Numerous lectures and publications on the subject of landscape architecture and landscape art.

Individual exhibitions: 1999 Garden Festival Wörlitz; 1999, 2000, 2005 and 2009 in the galleries AEDES East and West in Berlin; 1999 EXPO Café and municipality building departement, Hannover; 2001 in the Centre for Contemporary Art by Breeze of Air/Valkeniersweide Park, Rotterdam.

Project Info

Location: Esch-sur-Alzette/Luxembourg
Place de Brill, Place of the Five Continents
Client: Municipality Esch-sur-Alzette, Luxembourg
Department of Architecture: Luc Everling
Department of Civil Engineering: Lucien Malano,
Steve Falz
Project Management: WW+ Architektur, Esch-sur-Alzette
Author Landscape Architecture and Art: Kamel Louafi,
Berlin
Competition: Kamel Louafi, Dörte Eggert-Heerdegen,
Judith Wacht (1st Phase),
Geraldine Radjeb, Patrick Dorsch (2nd Phase)
Design Planning: Kamel Louafi, Dörte Eggert-Heerdegen,
Geraldine Radjeb, Patrick Dorsch, Karen Zaspel,
Martin Steinbrenner, Marc Pouzol
Architecture Pavilion: ReimarHerbst.Architekten,
Reimar Herbst, Angelika Kunkler
Light Design: studio Dinnebier, Berlin
Civil Engineering Planning: Lux Consult,
Luxembourg
Construction Supervision: Kamel Louafi
Civil Engineering: Lux Consult
Building Contractors: Iso Green Luxembourg,
Ernest Brandenburg/Tralux, Luxembourg
Furniture: Elancia AG, Langelsheim and Frerichs Glas,
Verden (Aller)
Bronze Sculptures Production: Anton Gugg Gießerei
Straubing, Germany

Location: Hanover/Germany
Trammplatz, Town Hall Square
Client: Hanover Municipality (LH Hannover)
Project Accompaniment: Uwe Bodemann, Thomas
Göbel-Groß, Bernd Ebeling, Karsten Bensch, Hans Martens,
Michaelis Bernd, Bernd Konrad: Hanover Municipality
Author Place Design: Kamel Louafi, Berlin
Space Environment Idea: Municipal Planning
Department – Thomas Göbel-Groß
Design Planning and Implementation Planning,
Site and Surroundings: Kamel Louafi, Patrick Dorsch,
Dörte Eggert-Heerdegen, Karen Zaspel, Andrea Louafi
Rendering: Nil Lachkaref
Specifications: Frank Nowak, Karsten Beansch –
Municipality Hanover and Kamel Louafi Landscape
Architects
Construction Supervision: Hanover Municipality:
Torgen Freimuth, Hubert Gollasch, Stefen Dombronski,
Mattias Böttscher, Babel Paul
Construction Design Supervision: Kamel Louafi
Light Design: Studio DL Hildeshein,
Norbert Wasserführt/Hanover Municipality,
Johannes Käppler, Heike Verspermann, Thomas Hoffman
Building Contractors: Strabag Hannover:
Wassili Brause/Janisch Garten- und Landschaftsbau,
Hannover
Stone Production and Delivery: Granilouno,
Galicia Spain/Klinker Emsland
Furniture: Elancia AG, Langelsheim

Public Spaces
Editor/Author Kamel Louafi

Editorial Work
Andrea Louafi: all texts
Susanne Yacoub: Schostok, Bodemann, Spautz

Editors of Texts unless otherwise stated: Kamel Louafi
Texts: 36–39; urbanity, 60, 61; two locations, 104–136;
Esch: Kamel Louafi and Dörte Eggert-Heerdegen
Preface contribution for Trammplatz: Stefan Schostok
Preface contribution for Trammplatz: Uwe Bodemann
Preface contribution for Brillplatz: Vera Spautz
Preface contribution for Brillplatz: Luc Everling

Copy editing German: Anja Bippus
Translations
English: David Skogley
French: Martine Passelaigue

Preparation of Graphics: Louafi Landscape Architects
All Concept and Freehand Sketches: Authors
Graphic Concept and Layout: Kamel Louafi

Production: HillerMedien, Berlin
Typesetting: Uta-Beate Mutz, Leipzig
Lithography: Bildpunkt, Berlin
Printing and Binding: Graspo CZ, a.s., Zlín

Bibliographic information published by the Deutsche
Nationalbibliothek
The Deutsche Nationalbibliothek lists this publication in
the Deutsche Nationalbibliografie; detailed bibliographic
data are available on the Internet at http://dnb.d-nb.de

jovis Verlag GmbH
Kurfürstenstraße 15/16
10785 Berlin
www.jovis.de

ISBN 978-3-86859-446-1